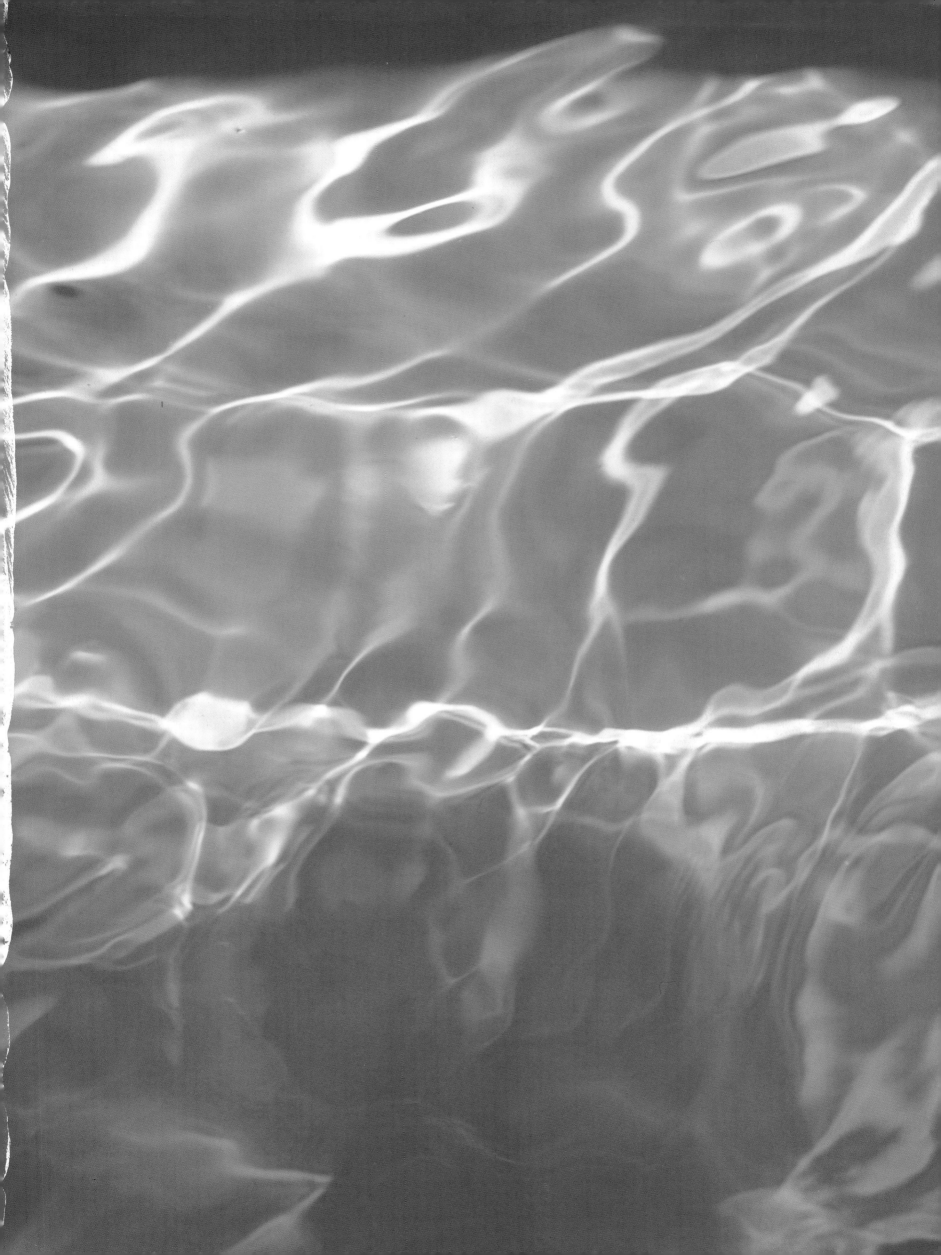

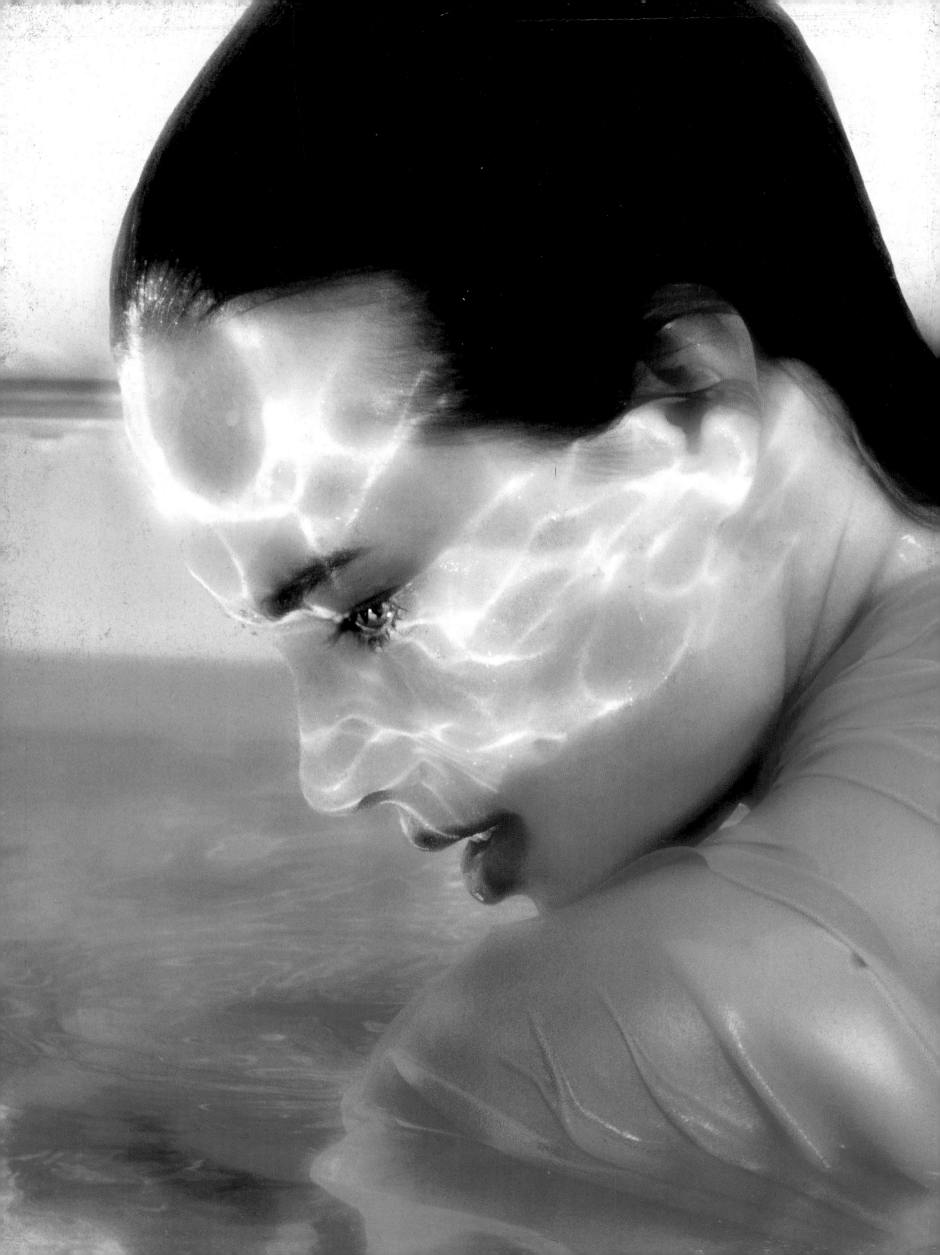

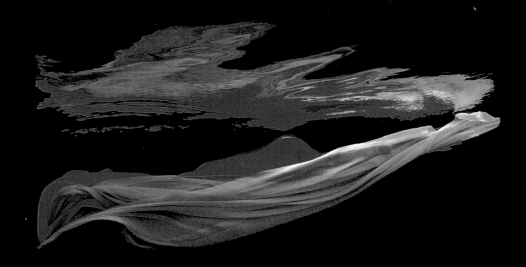

PoolLight

Photographs by Howard Schatz

Project Director, Editor: Beverly Ornstein
Foreword: Owen Edwards
Book Design: B. Martin Pedersen,
Massimo Acanfora

Library of Congress: ©1998 by Graphis Press 141 Lexington Avenue New York, New York 10016 USA All photographs © Howard Schatz and Beverly Ornstein, 1998
All rights reserved. No part of this book may be reproduced in any form without written permission. Printed and bound by DNP in Hong Kong. ISBN: 1-888001-47-X

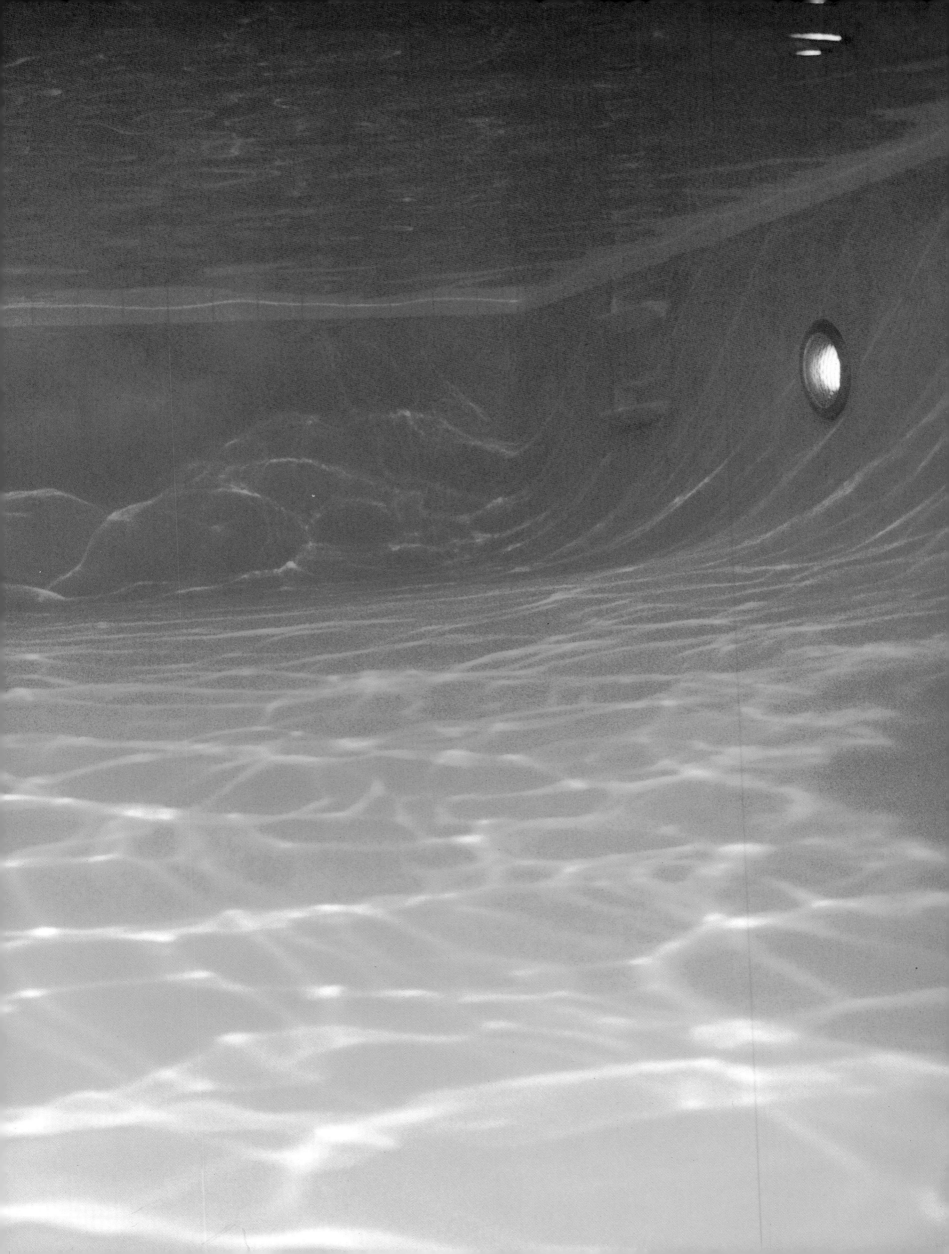

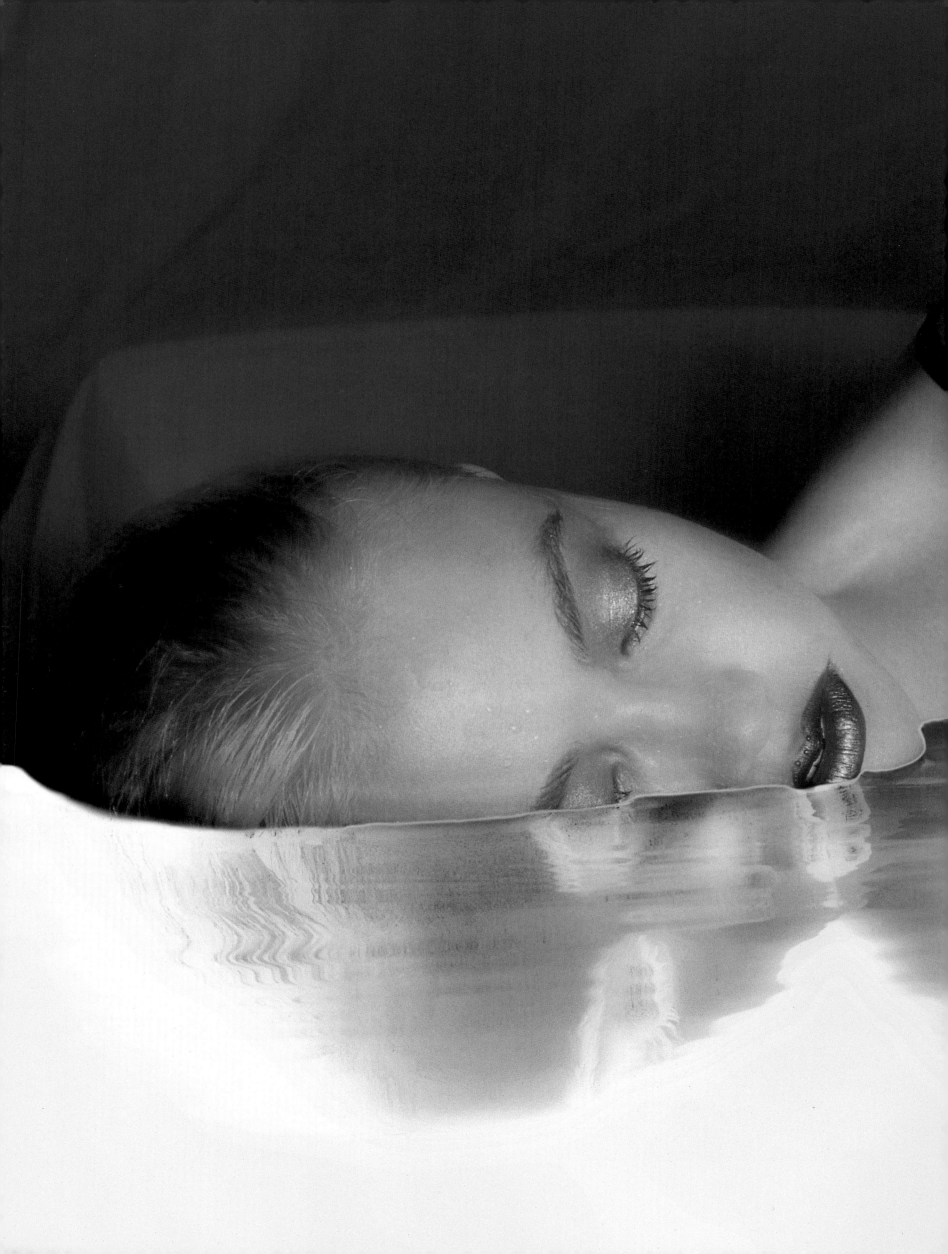

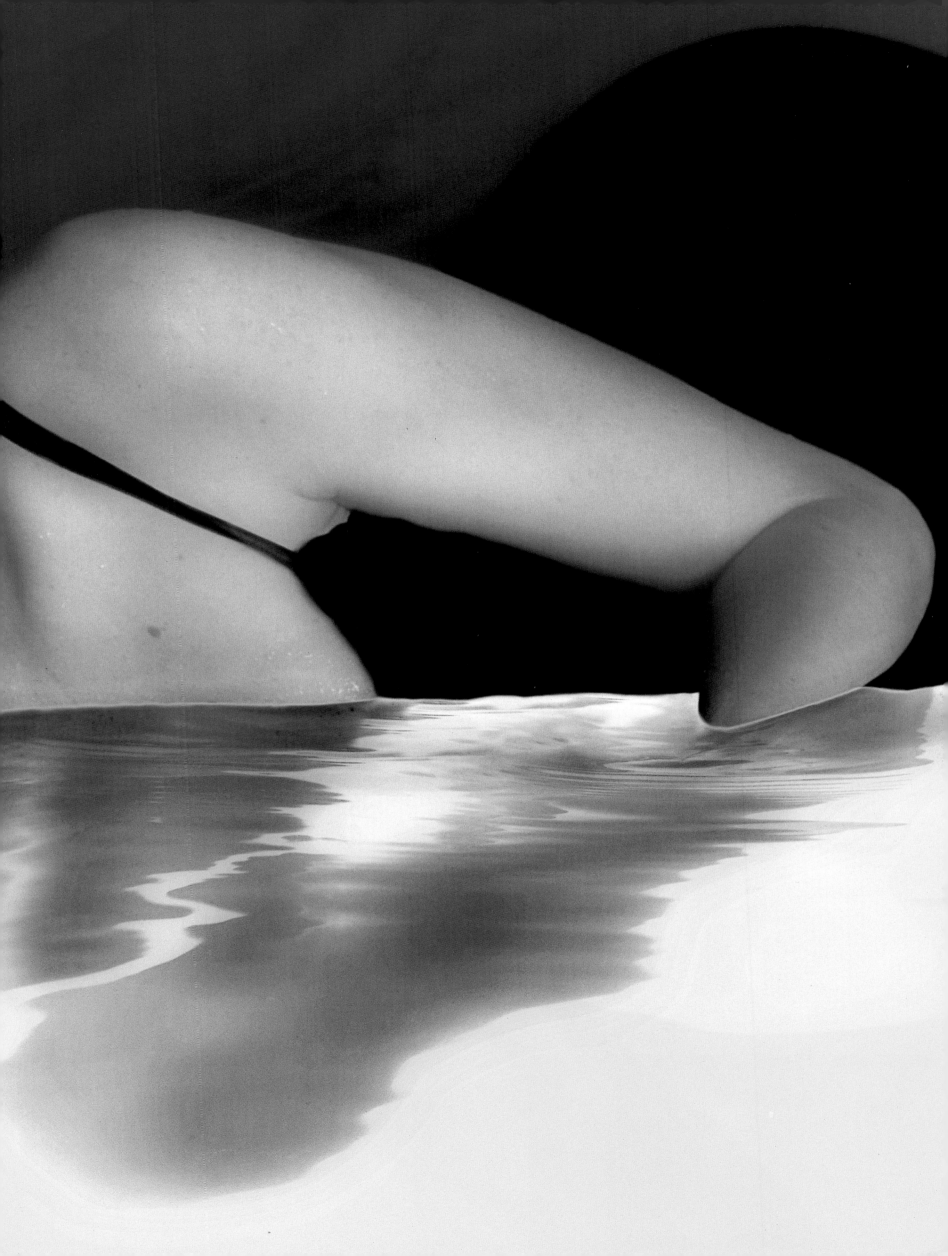

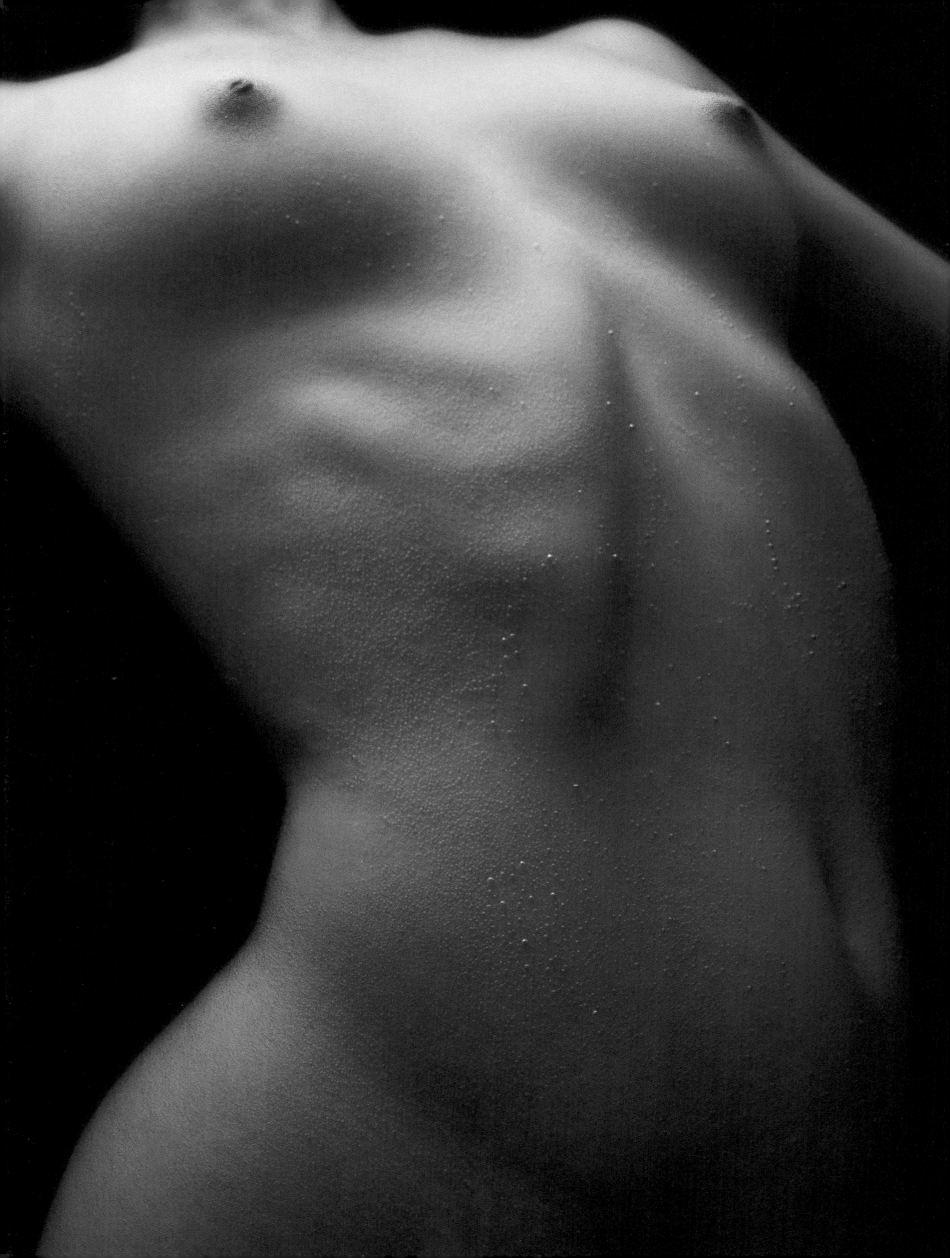

Depth Perception

There is something uncanny about the photograph, though at first you can't be sure what it is. The nude torso of a woman's body rises toward the top of the frame, curving backward, an other-worldly light cascading down over her breasts and rib cage. Lithe and athletic, exquisitely real, the body seems nevertheless like something seen in a dream, weightless and rising. A provocateur of yearning, this spectral creature seems to yearn herself...but for what? Beads of moisture cling to her skin. Could anyone so pale and perfect perspire? The drops glow, like a constellation of small, bright stars. Then you realize what it is that's different: the drops are bubbles; the woman is underwater. She is in a dreamscape, an object of desire, out of reach, as elusive as she is erotic. Aphrodite was born out of the sea. Howard Schatz has taken her back home.

Schatz is not the first photographer to take a deep breath and go under water to see how people look in the alien world created when hydrogen and oxygen atoms combine. Brett Weston made graceful figure studies in a California swimming pool. Toni Frissell submerged models wearing expensive dresses for a damp diversion from the standard fashion poses. Larry Sultan peeked just below the surface for a sly look at the unseen antics of swimmers in public pools. And in some of the most dazzling "beauty" work ever done with aquatic subjects—work evoked by some of the photographs in this extraordinary book—Hiro collected a brilliant menagerie of Siamese fighting fish (subbing spectacularly for the fashion models he usually works with) and had them spar for his camera. But Schatz has gone further to make art underwater. So far, in fact, that he has produced some of the most ravishing work ever done with or without benefit of breathable air. Rather than take an occasional plunge with the opportunistic hope of coming up with something good, Schatz has done nothing less than re-invent the studio. Or rather, he has invented something entirely new in photography: the liquid studio. He has taken what can only be called a hostile environment and, through painstaking methodology, has made it user-friendly. He and his camera are underwater not because his subjects are naturally there, like sharks off the Great Barrier Reef, or simply to prove that he can solve a new set of self-imposed problems, but to take advantage of the magic that happens when the law of gravity is rescinded. It is not simply being underwater that interests him, but rather what happens *because* he and his subjects are underwater. This means he must make the water transparent, not just to the eye but to the mind. He must take his extraordinary studio and make it the background for business as usual.

One should never dwell too long on how photographs were made, and any photographer who claims credit for simply being there should be viewed with suspicion. All that really matters is how pictures move the viewer, not the level of difficulty in obtaining them. You can go to the top of Everest or land on a beach with the marines, but if what you see and show when you get there are ordinary, you might as well have stayed home. Schatz understands this. Only the photographs count; that the photographer and his models are in the water is just a fact,

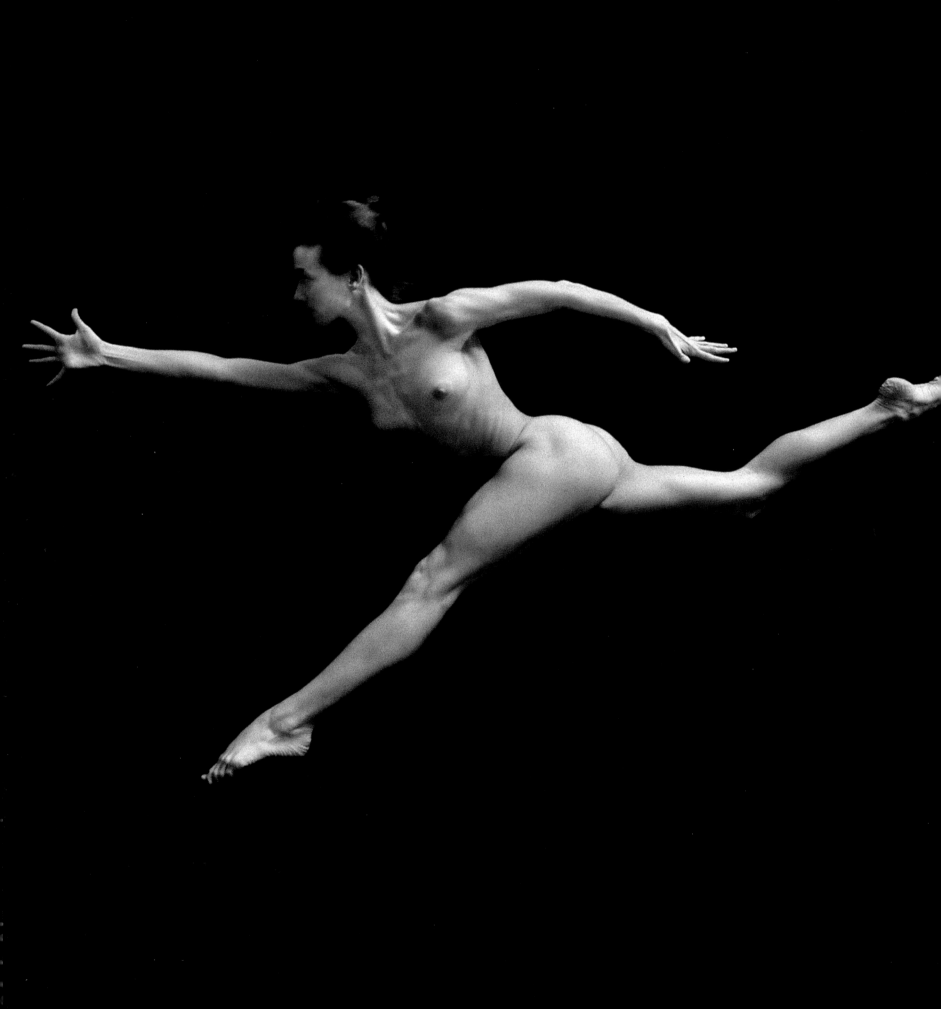

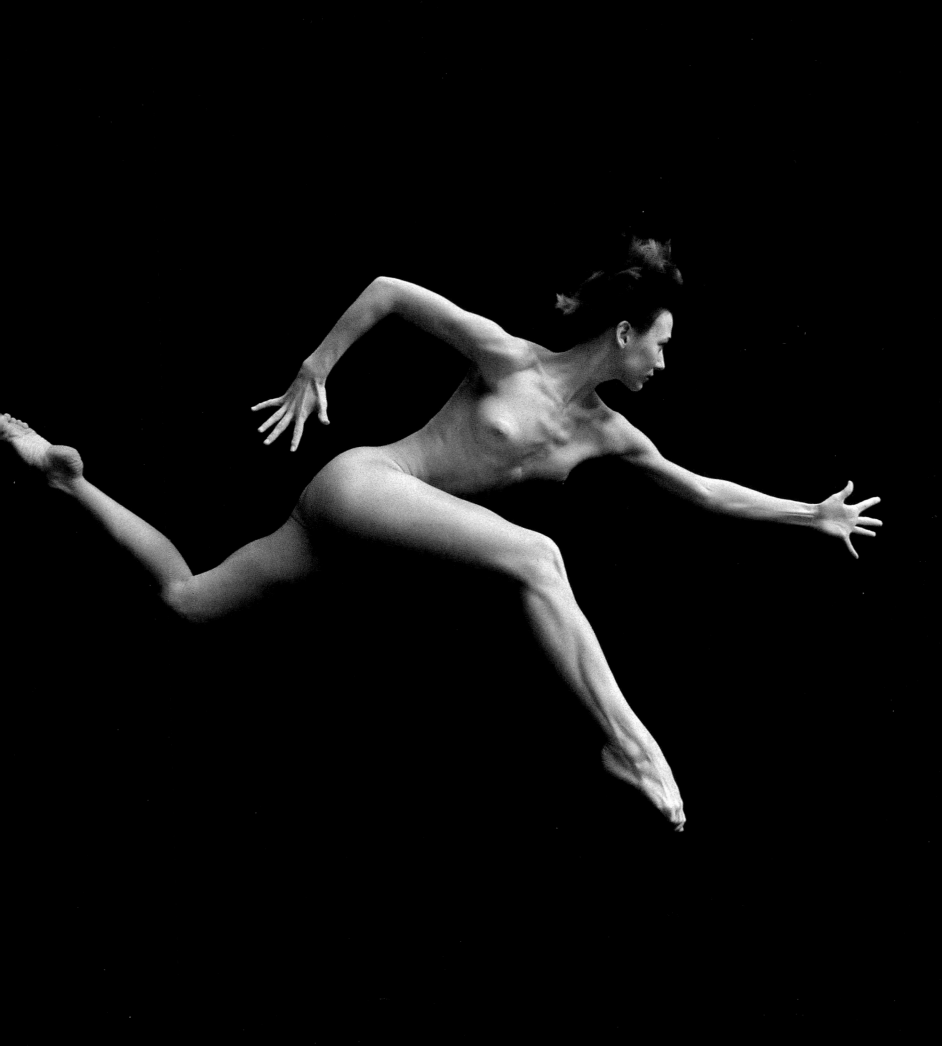

and one that we needn't dwell on. After all, when we see a picture of a woman modeling a dress on a runway, we don't say, "My God, she's on dry land!" If, when we look at the pictures in this book, we notice the beauty or joy or implausible poses first, and only then think about where and how they were made, then Schatz has succeeded in getting us to accept his unnatural conditions as natural.

What it takes to do this, however, is still worth a few admiring words. Like all the best photographers, Schatz is obsessed with control. Putting himself and his models under a highly unusual set of constraints doesn't change his determination to leave nothing to chance save that slender wisp of unpredictability that makes the difference between a merely good photograph and one that clings to the mind like a haunting melody—the sweet surprises of sight that can be prepared for but never predicted. The barriers to control in the liquid studio are higher by far than those above water. The time to make pictures is limited by each person's capacity to stay underwater. Each new pose, each set of instructions, requires another plunge, so Schatz has rewired the pool house to speed up the recycling of his strobe lights (which must, of course, be kept safely away from the water). Because his models must keep their eyes open underwater, he has improved the method of measuring pH balance to insure that the pH of the pool water exactly matches the pH of human tears. To clarify the water to a point of operating room perfection, he taught the pool man a more thorough method for cleaning. ("That dust is killing me!" he wailed, making the man look at slides that fell short of his exacting standards.) In order to have another artistic element to work with, Schatz even learned how to control the ripples in the pool.

After all this was done, he was simply at square one. These are, after all, portraits of exquisite creatures. Perhaps the biggest challenge in creating an underwater studio was finding models who could work below the surface and make it look easy. The process was unique, and daunting. First, Schatz would tell prospective models to swim one length of the 44-foot pool underwater in one breath. If they couldn't do that—and many couldn't—they didn't make the cut. Then he tested each one in the shallow end to see if she could relax, open her eyes underwater, and control the muscles in her face so that she could easily smile, laugh, or maintain a neutral expression as the pose required. This eliminated a surprisingly large number. For those who remained, the next step was to exhale, sink to the bottom at the deep end, and stay there a while. All these were basic prerequisites, to which were added the requirements of beauty, grace, athleticism, and an ability to respond to direction. The men and women on the following pages, dancers, models and competitive swimmers, represent a tiny minority of the 400 or so Schatz auditioned. They became a uniquely talented repertory company, genetically adapted to the liquid studio. Some, like Sarah Sessions, an exquisite young star of the San Francisco Ballet, and Shawnee Free Jones, a model who grew up in Fiji and seems at least half naiad, ended up spending weeks working with Schatz, becoming in the process bona fide subaqueous super-models.

No theater or dance troupe has ever been directed with more determination. Schatz has no advantage over the models, except for a pair of swimming goggles. He doesn't wear scuba

gear, so when his model rises to breathe, so does he. Instructions are given—sometimes they are very specific, sometimes only suggestive of a feeling. "That was terrific," Schatz says, treading water. "Now, let's try making it seem more dangerous. There's a door...you know you shouldn't walk through that door, but you can't help yourself." Deep breaths. Down they go. Movement below, then stillness, then the strobes pop, pop, pop, again and again, and up to the surface come photographer and model. "Every time you hear the camera click," he tells her, "imagine it's the sound of applause. So, next time, do more. Go over the top. Let's hear that applause." And down they go again. And again.

What Schatz and his amphibians have produced by their unlikely labors is a series of visions as rhapsodic as anything seen since Blake, the pre-Raphaelites, or the nude gods and goddesses of the Photo Secession. These visions, set free of earthly constraints, are unequivocally, unambivalently beautiful. This is no small act of artistic courage. Beauty has not been in demand in art and photography during recent years. Like melody and tonality in music, it is suspect; since the world is imperfect, how can photographed perfection be anything other than dishonest? In fashion, the taint of irony (the $2000 dress that fails to bring a smile to the wan model's face, the sullen slouch) self-consciously tells the viewer that certain pictures are above the need to please. Portraits set out not to ennoble but to unmask, and end up presenting ugliness, anger, confusion or fear that draw attention to the portraitist's skill at ambush. Photographs are sliced up, badly printed, sabotaged in a hundred ways, lest, God forbid, they should actually delight the eye. The reigning question most photographers seem intent on asking as we rush up on the millennium is, Who needs beauty?

To which Howard Schatz resoundingly answers, "I do!" In what he calls his "slow motion heaven," he rejoices in beauty, and, having overcome the countless difficulties of his revolutionary liquid studio, wonderfully reminds us of the power of the camera to capture forever exquisite moments our own eyes and memories would have missed. Can the beauty of Schatz's hard-won pictures actually exist? Of course; here it is! Should we be suspicions, skeptical, resistant? Oh, please...

In Schatz' first underwater book, *WaterDance*, he brought his remarkable skill and determination to bear on the problem of energizing the human body in an essentially languid environment. In *Pool Light*, he plumbs the depths not only of water, but of emotion, feeling, and eroticism. Though out of fashion, these are hardly new fascinations for a visual artist. But by changing the rules and the venue for his timeless quest, Howard Schatz—in the greatest tradition of photography—gives us a new way of seeing and a dazzling reminder of how god-like we humans can sometimes be.

Made by a thoroughly modern technology, arranged in an entirely unprecedented way, these are nevertheless pictures in an ancient tradition: they depict miracles. And because they respond to ancient needs within us, they reach deep within our sea-borne souls. Schatz is as engaged in the enchantment as we are in being enchanted. "I'm not freezing action'" he says. "I'm finding moments in a dream."

To which we can only respond "Dream on." *Owen Edwards*

16

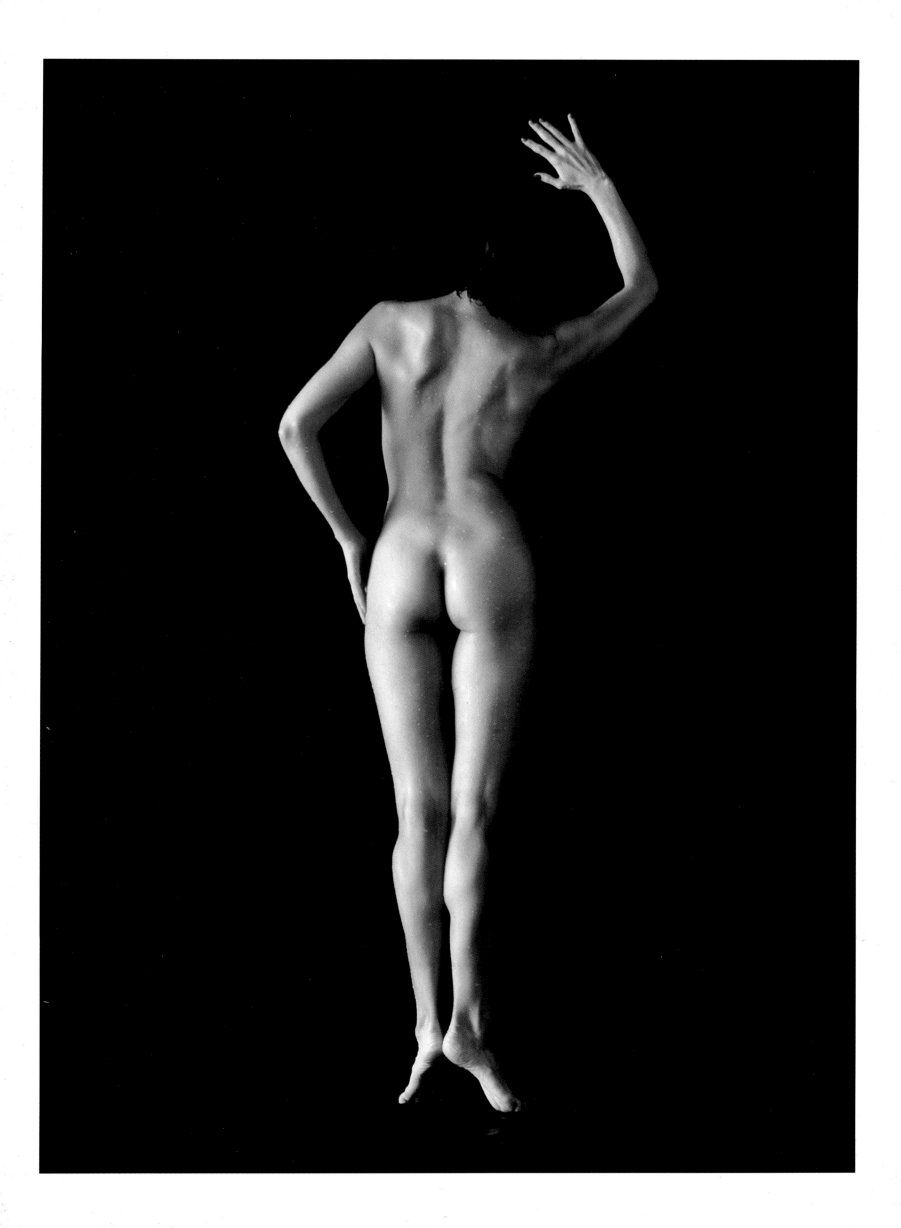

18

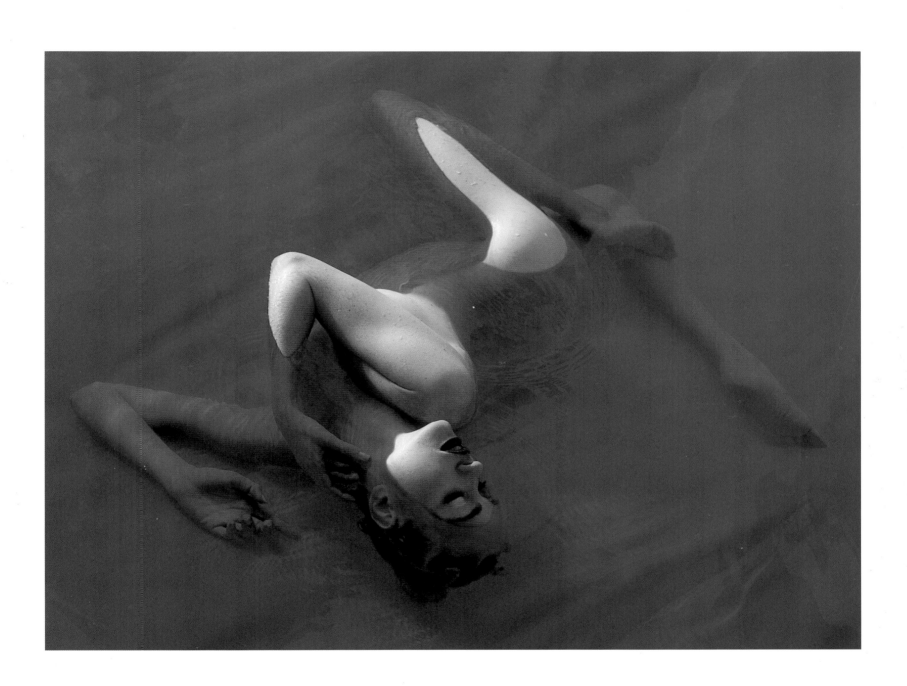

20

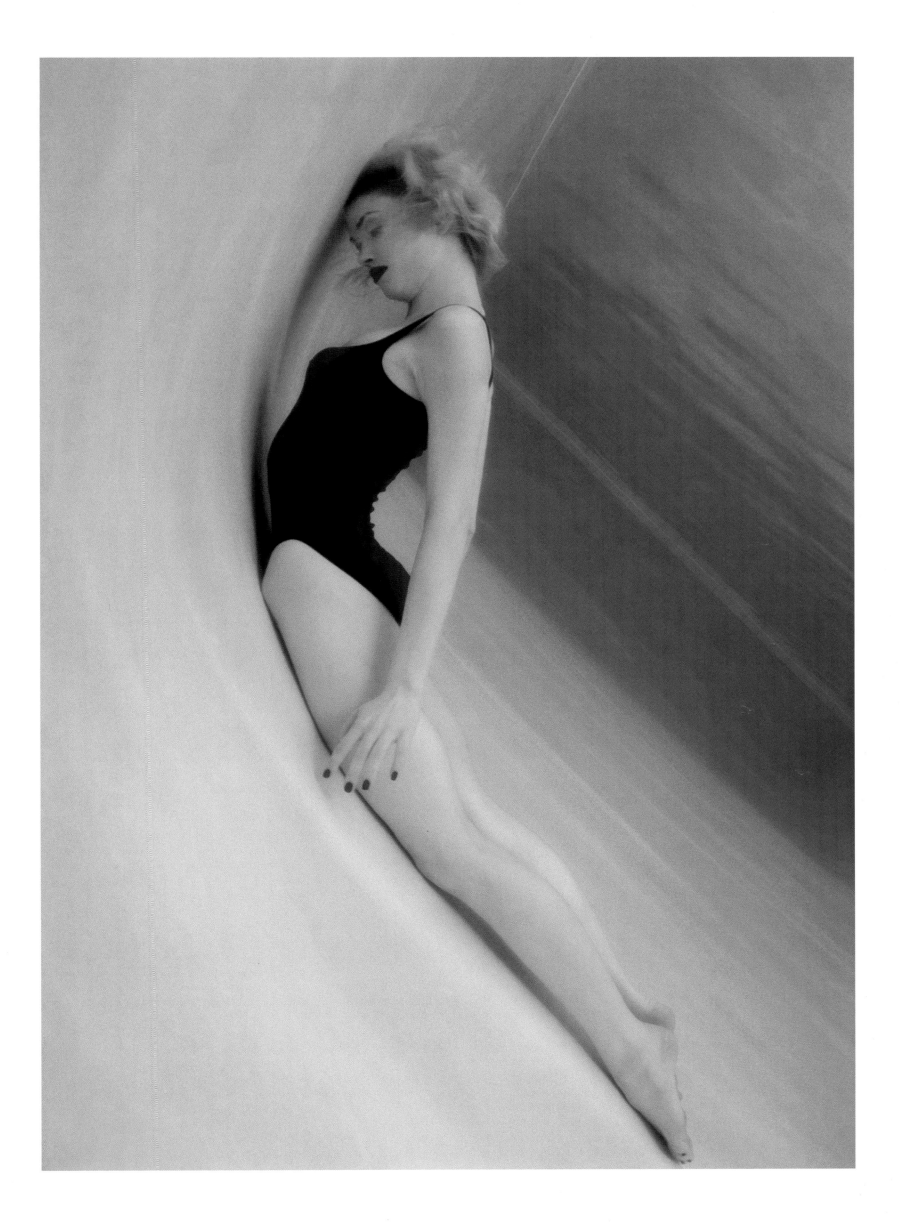

22

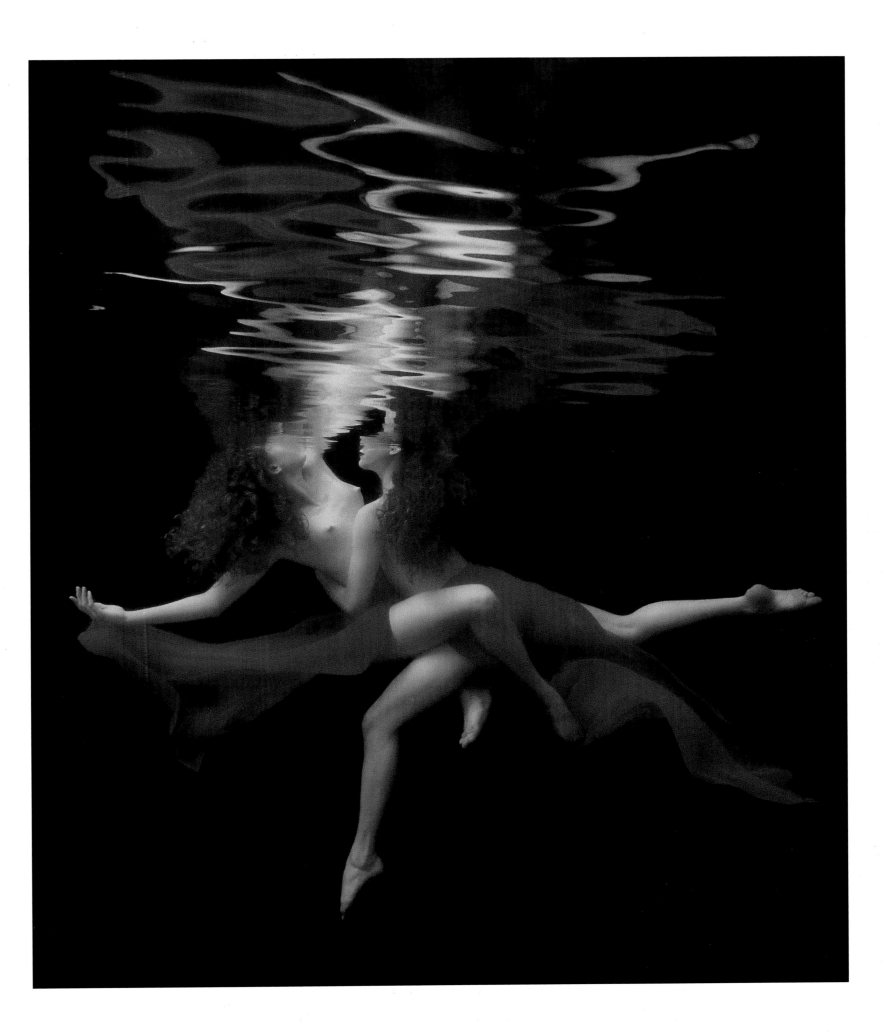

24

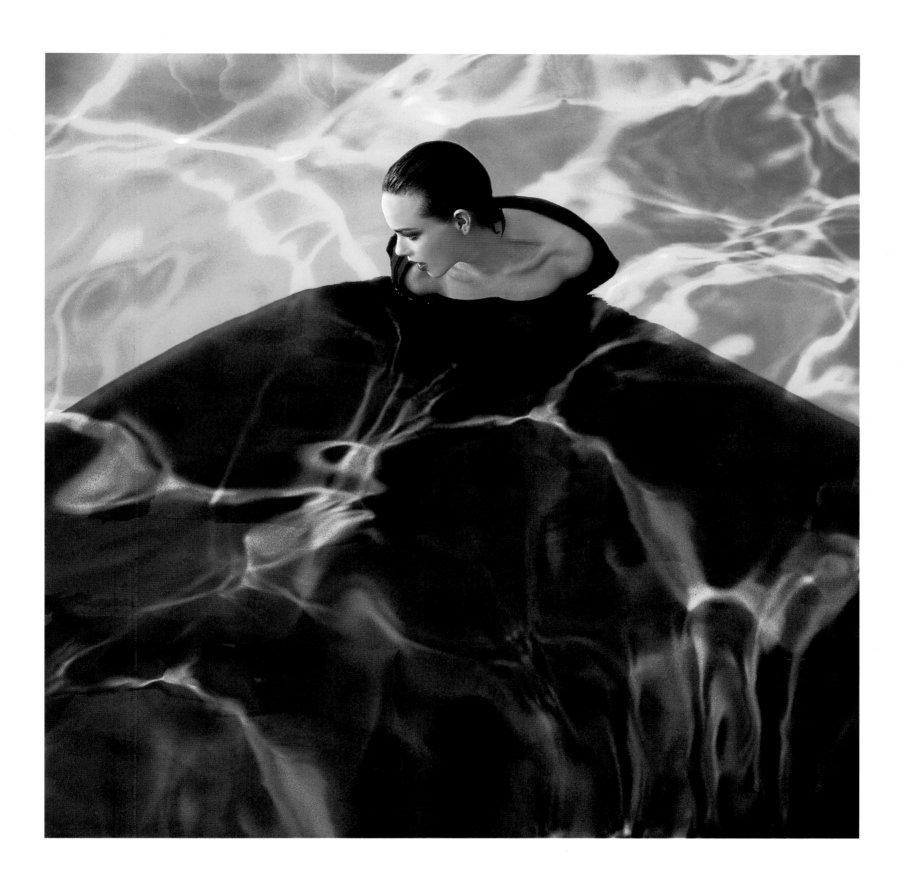

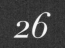

26

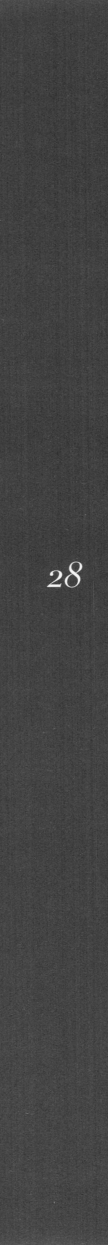

28

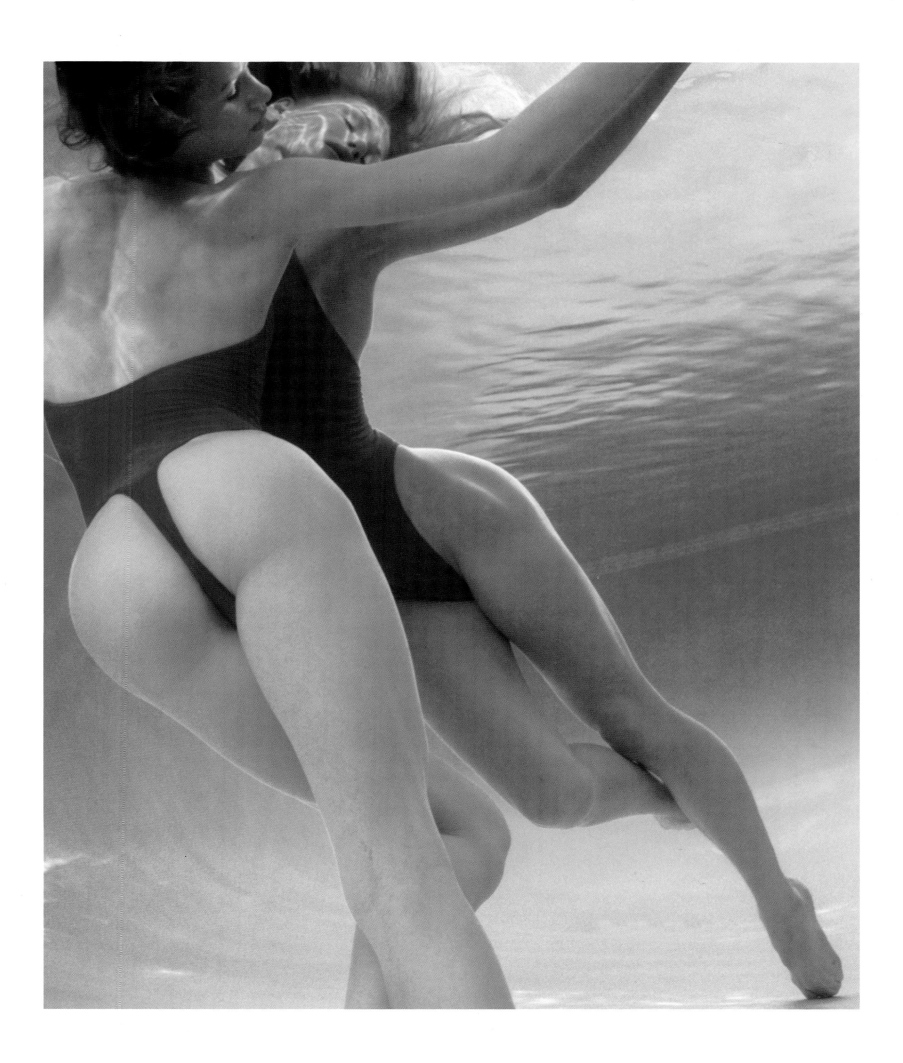

3o

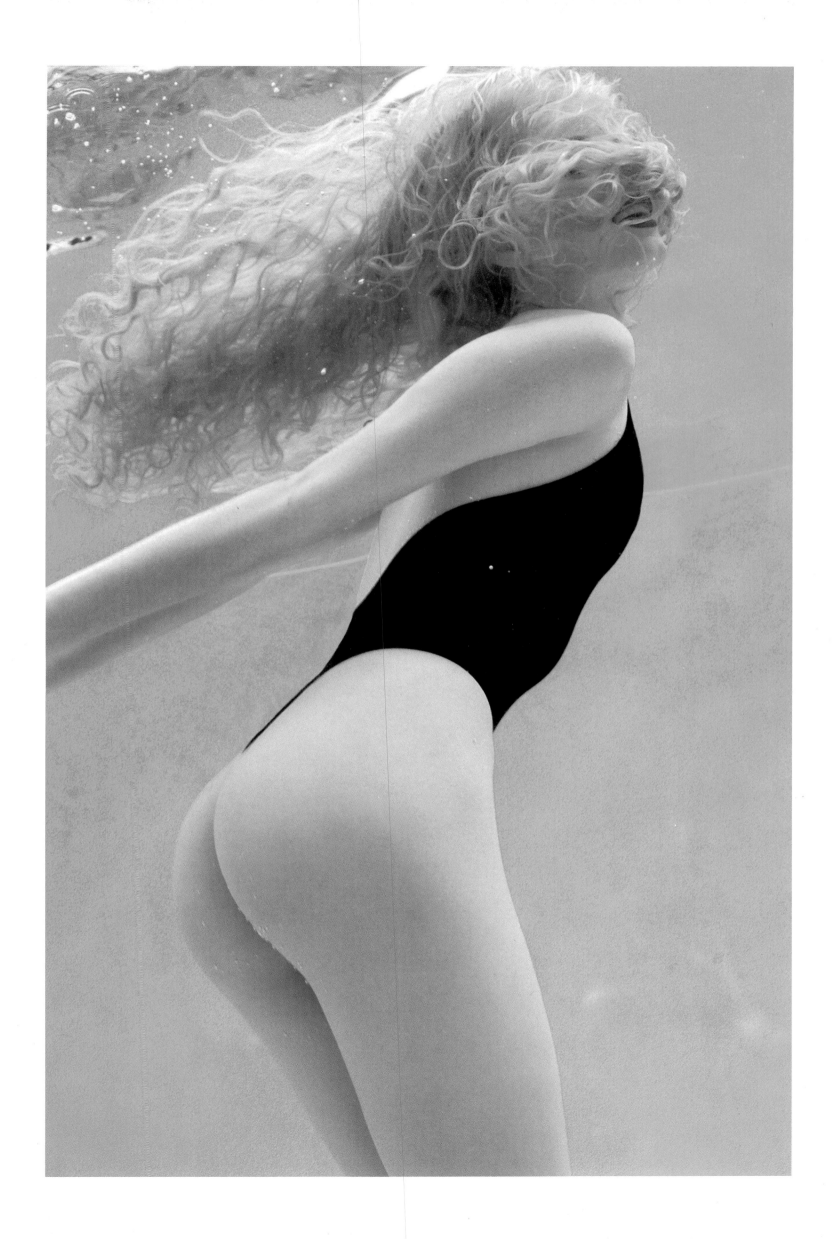

32

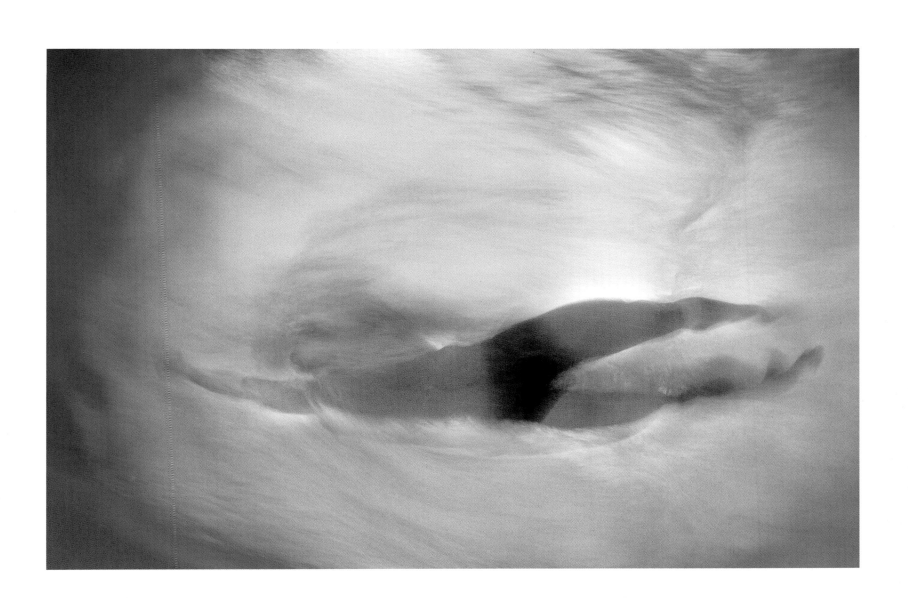

34

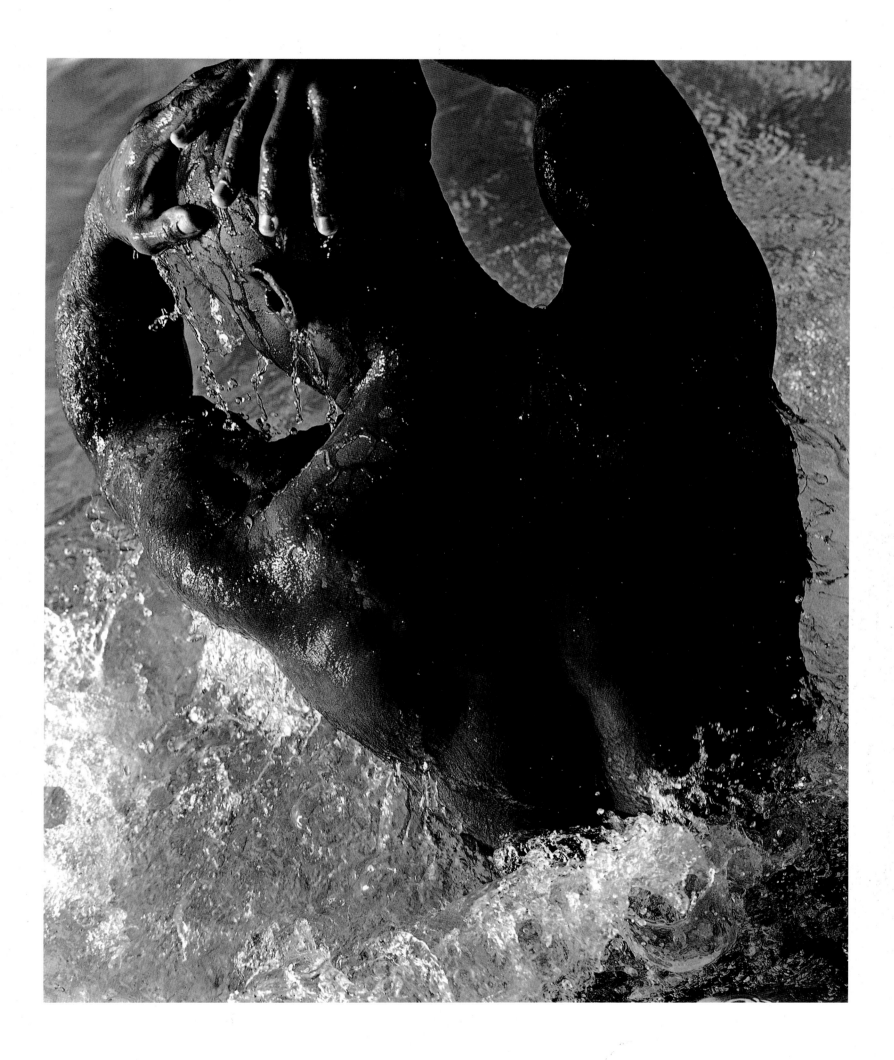

36

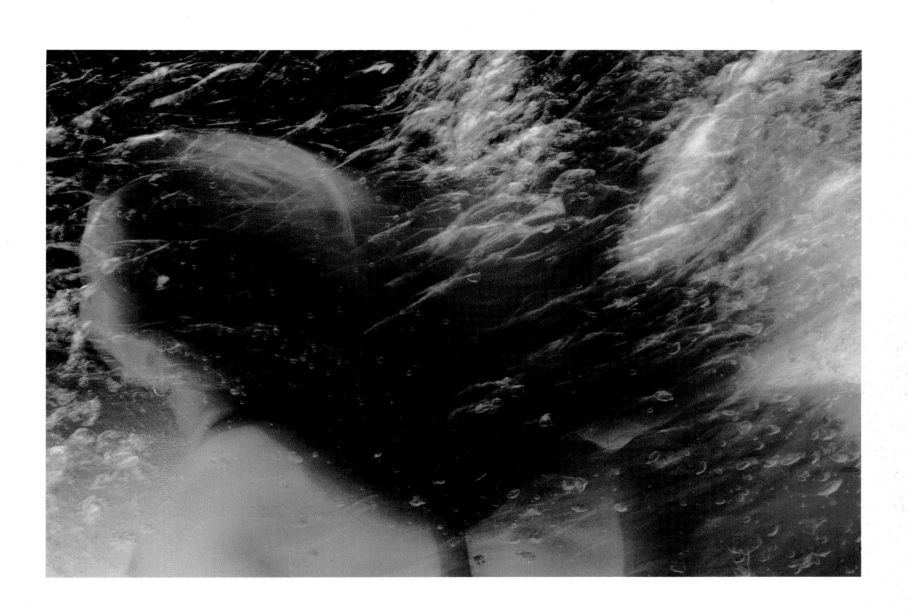

38

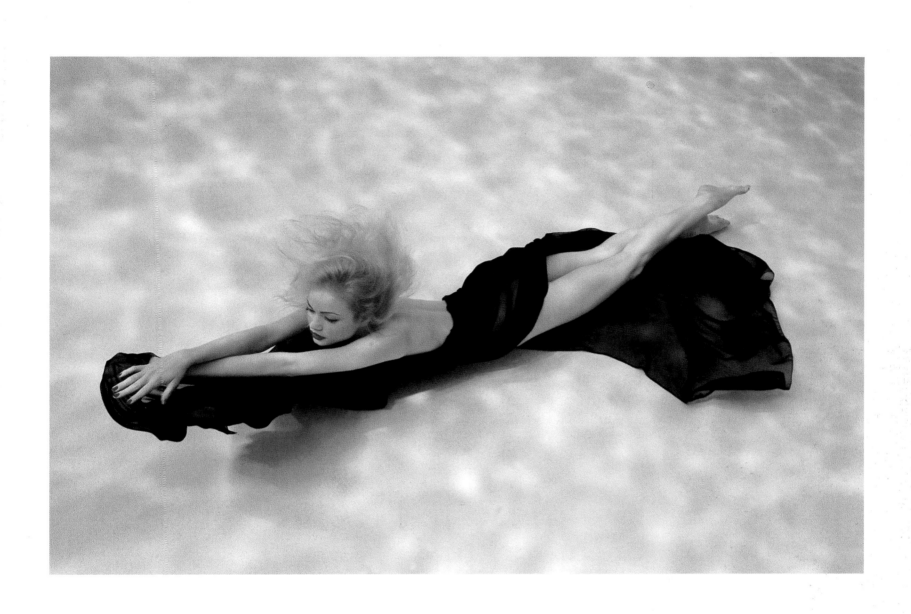

40

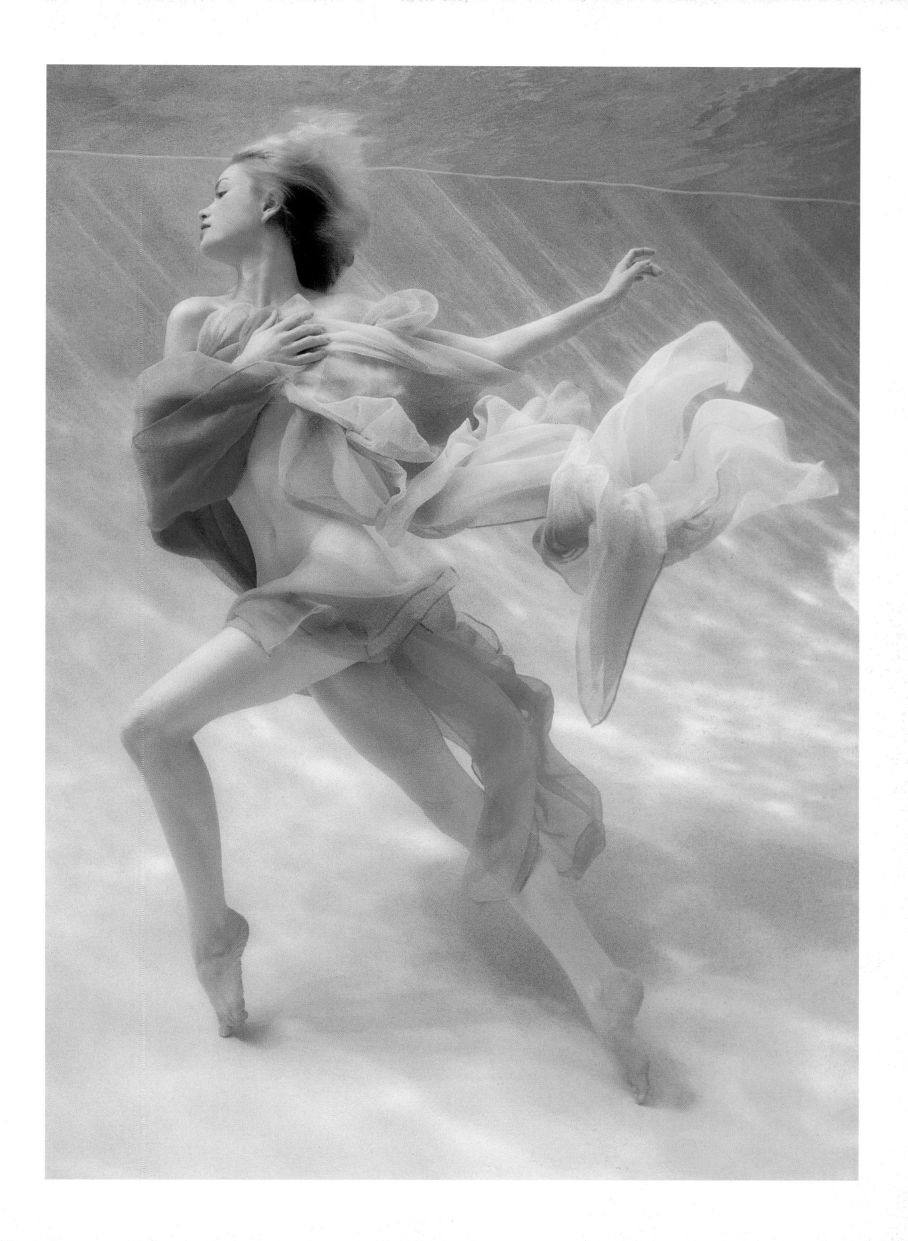

42

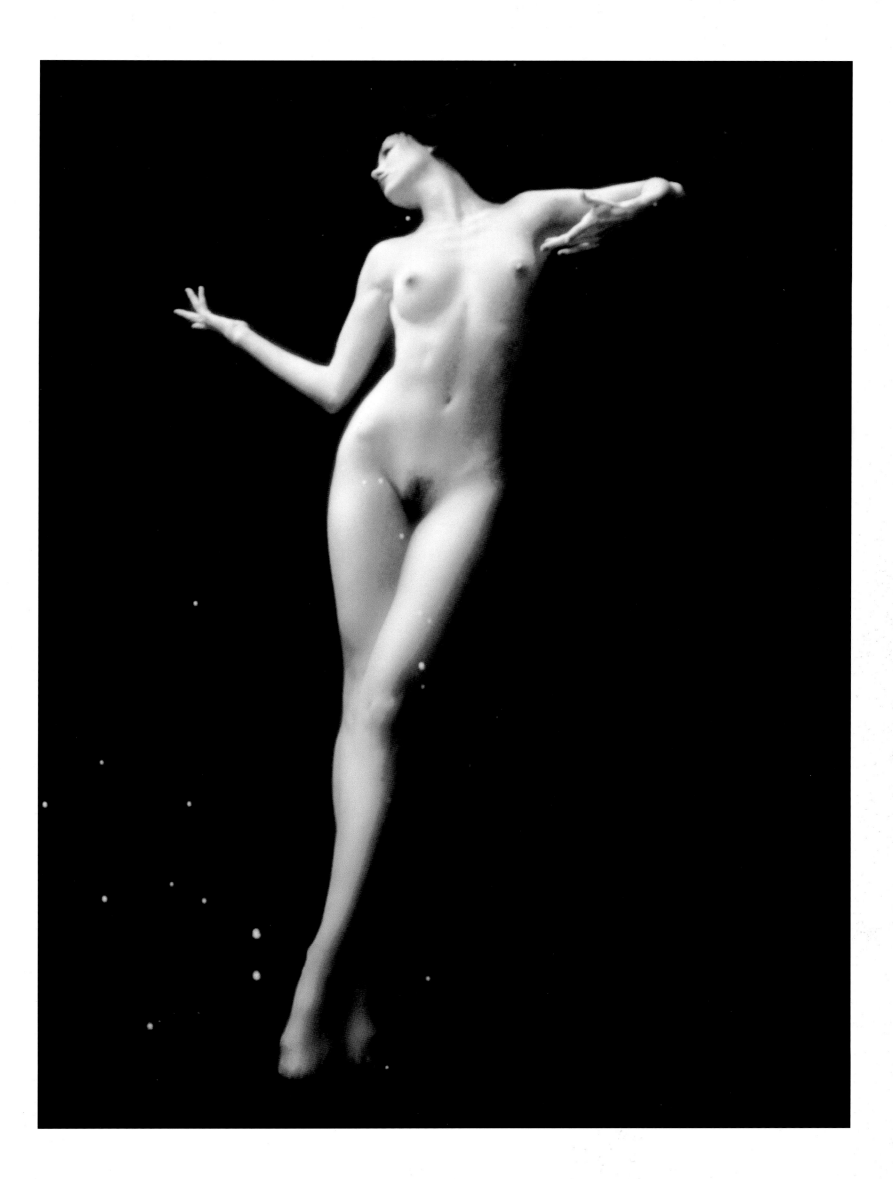

44

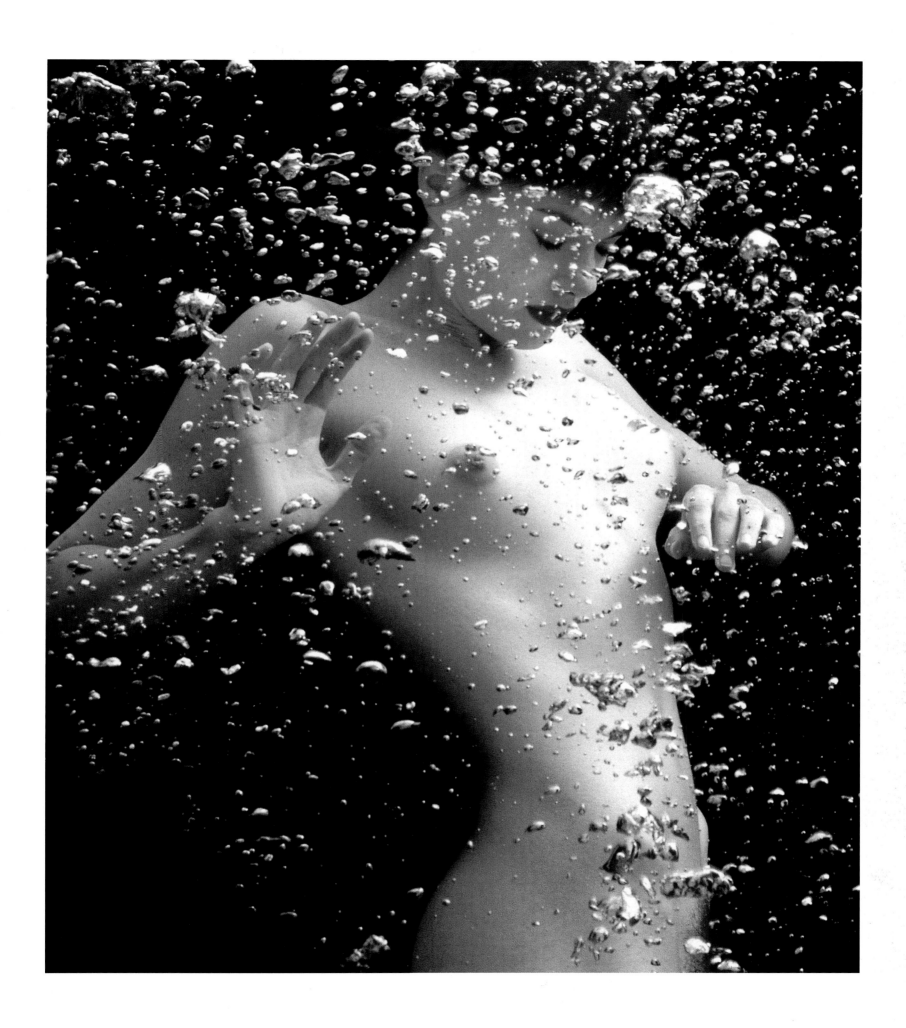

46

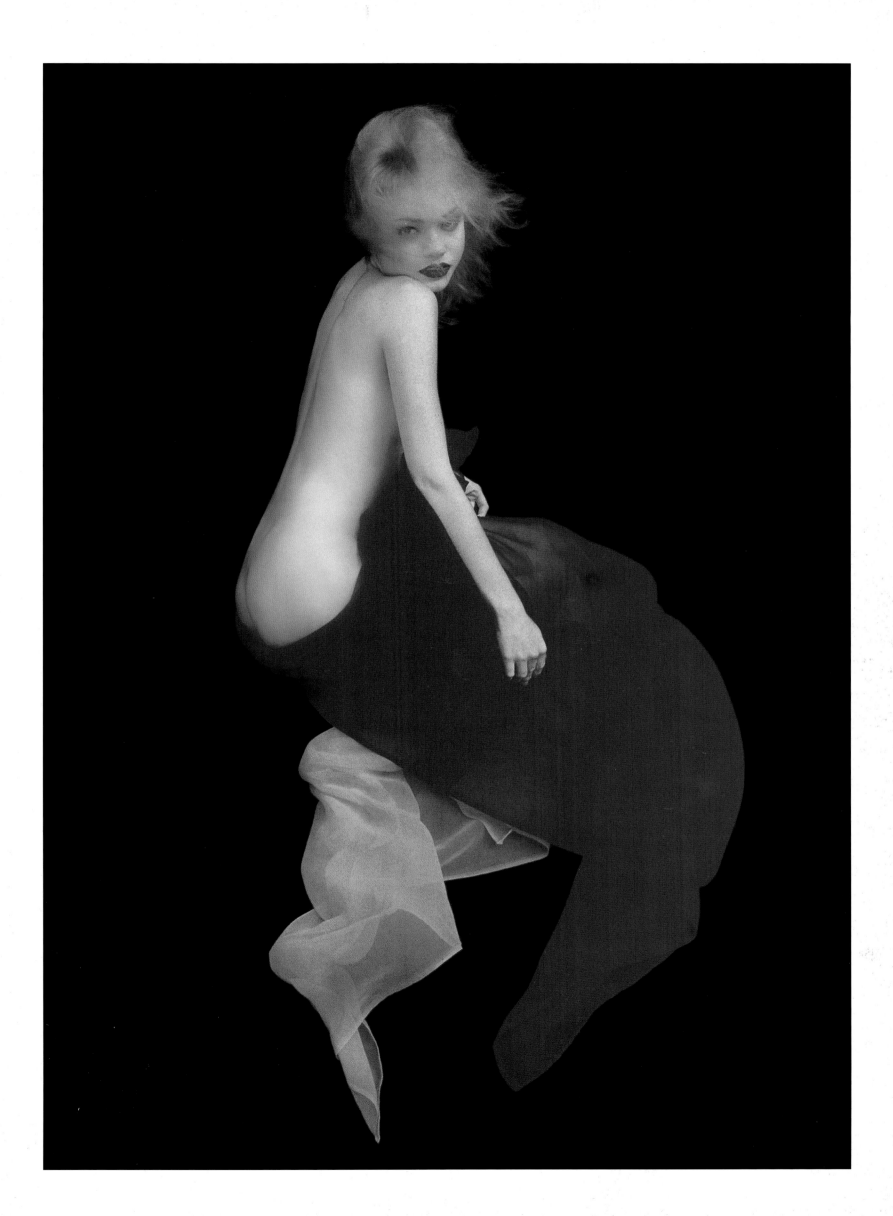

48

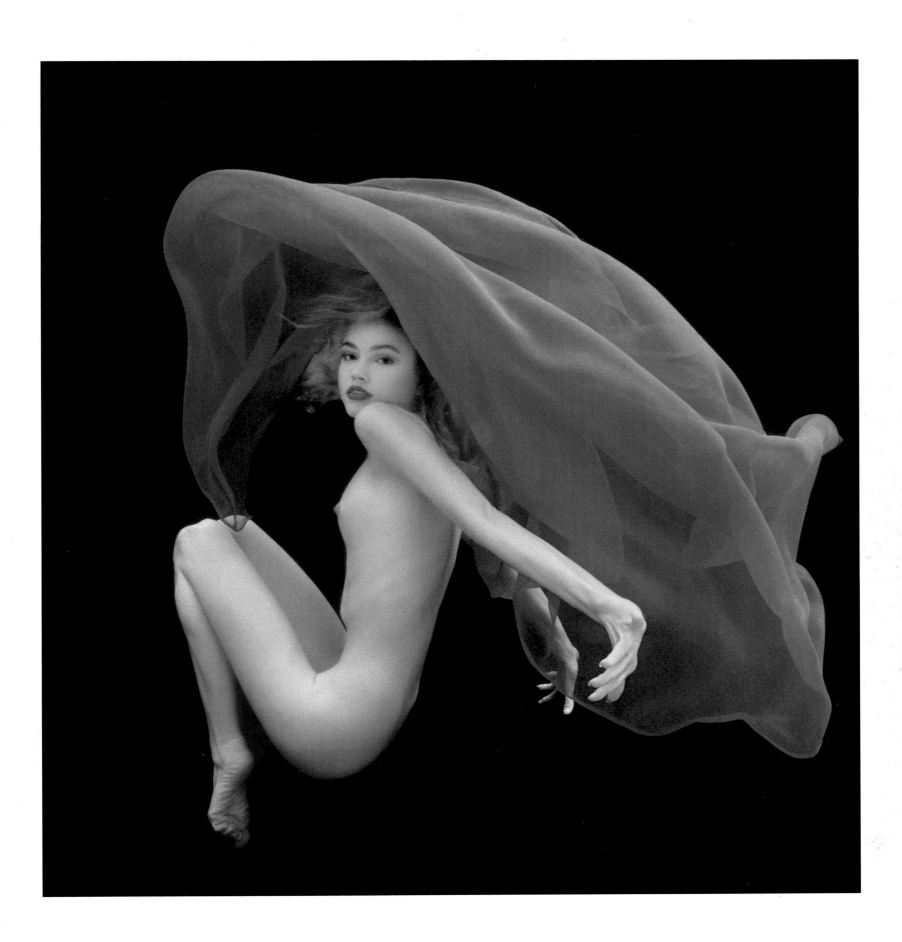

5o

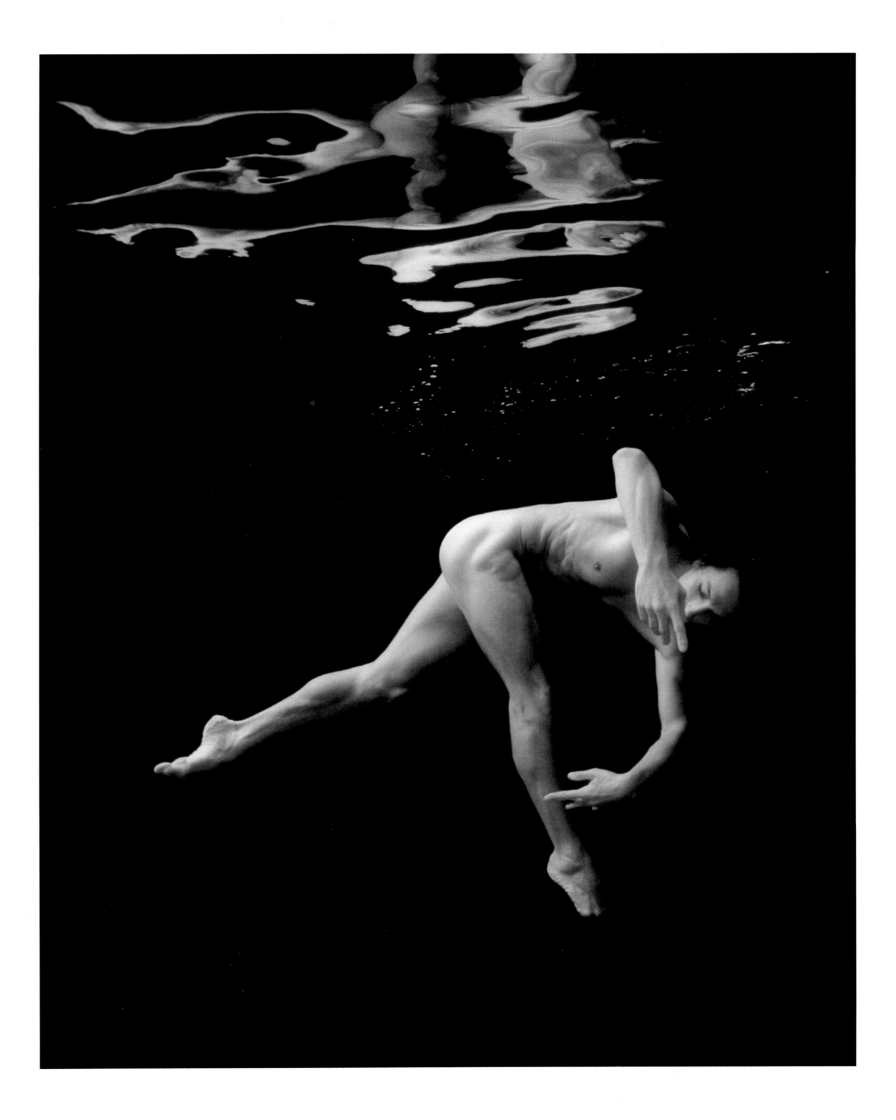

52

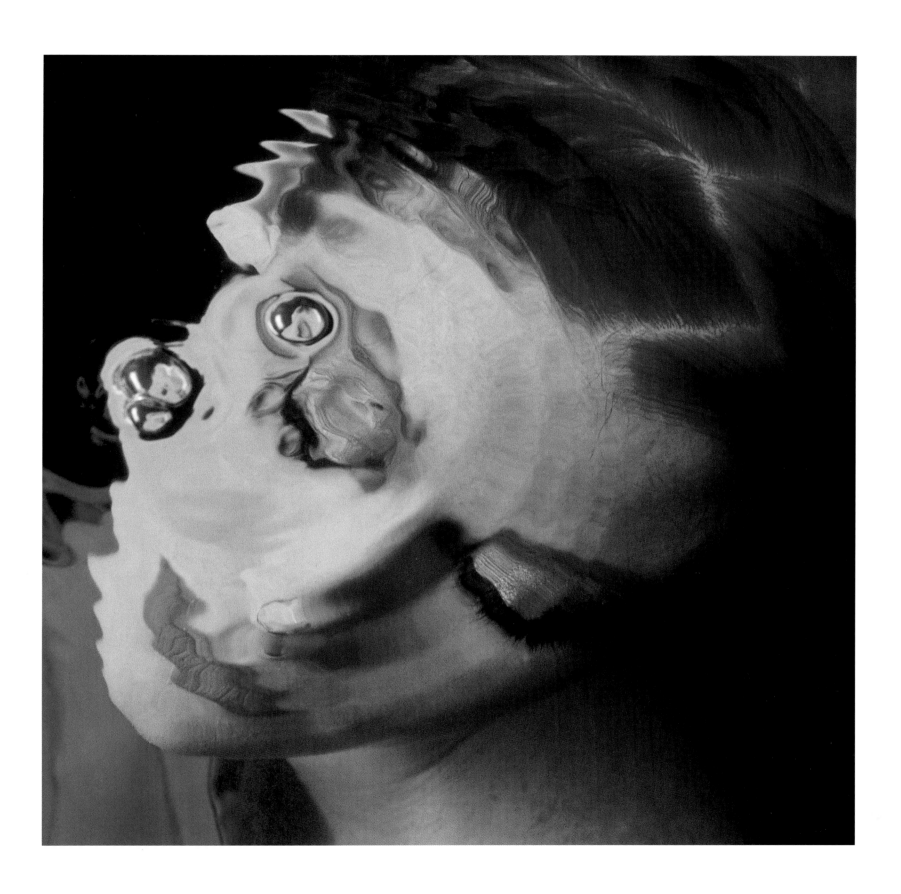

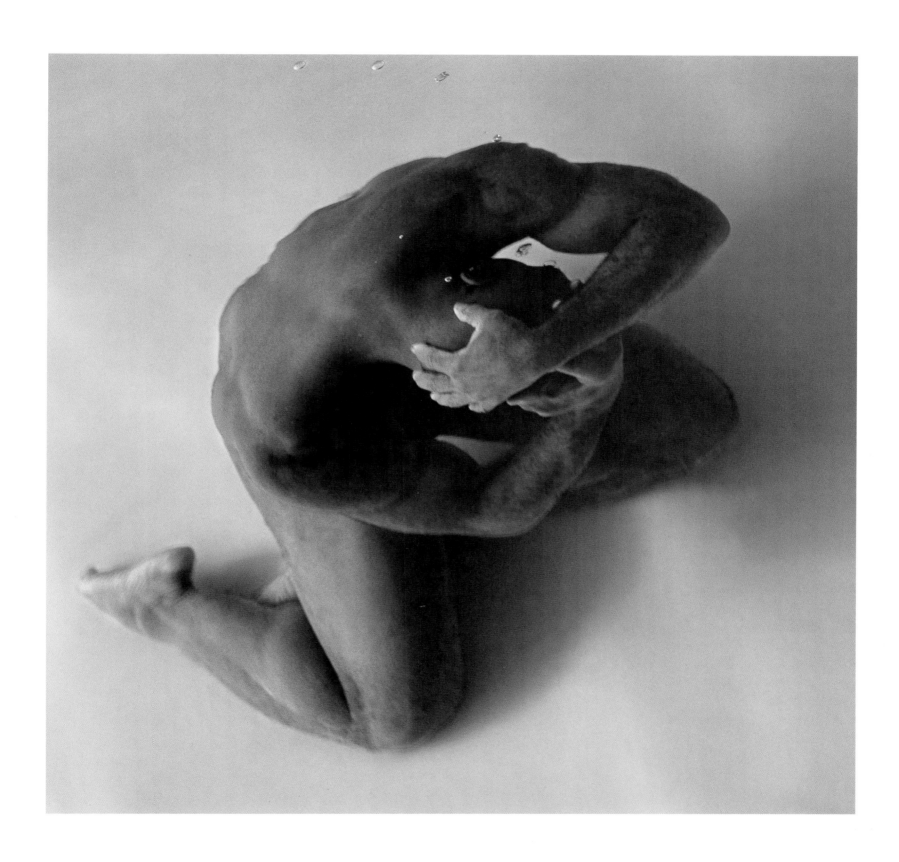

56

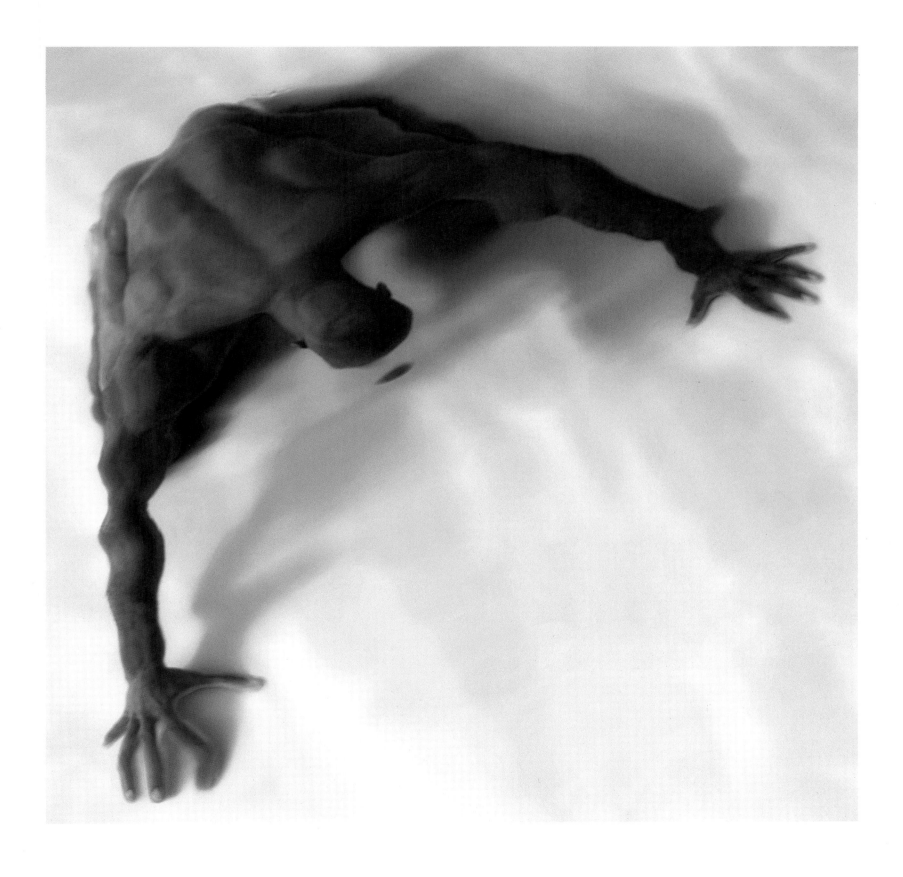

58

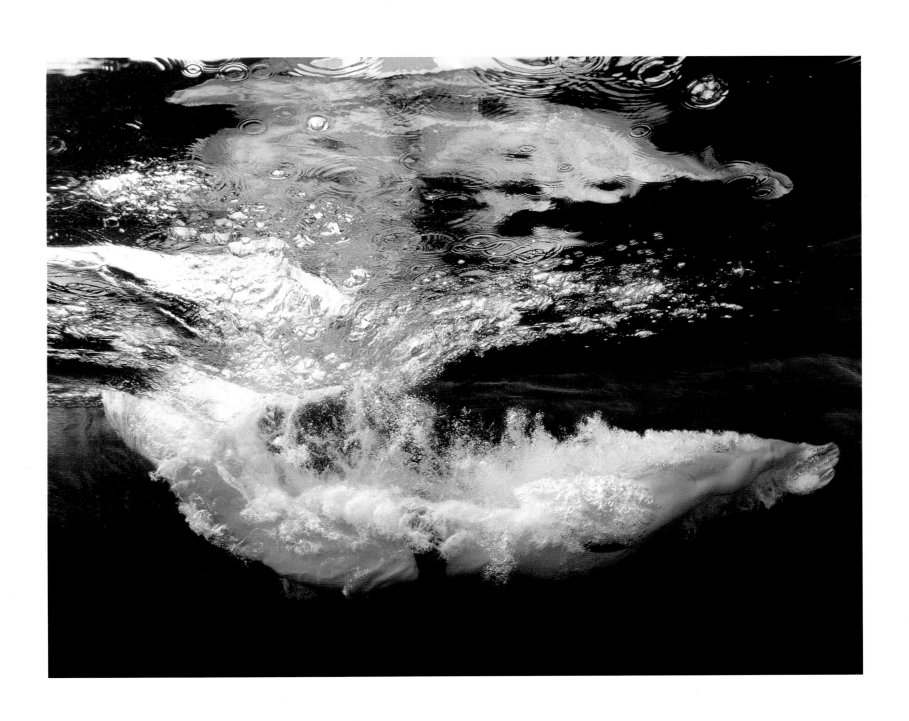

60

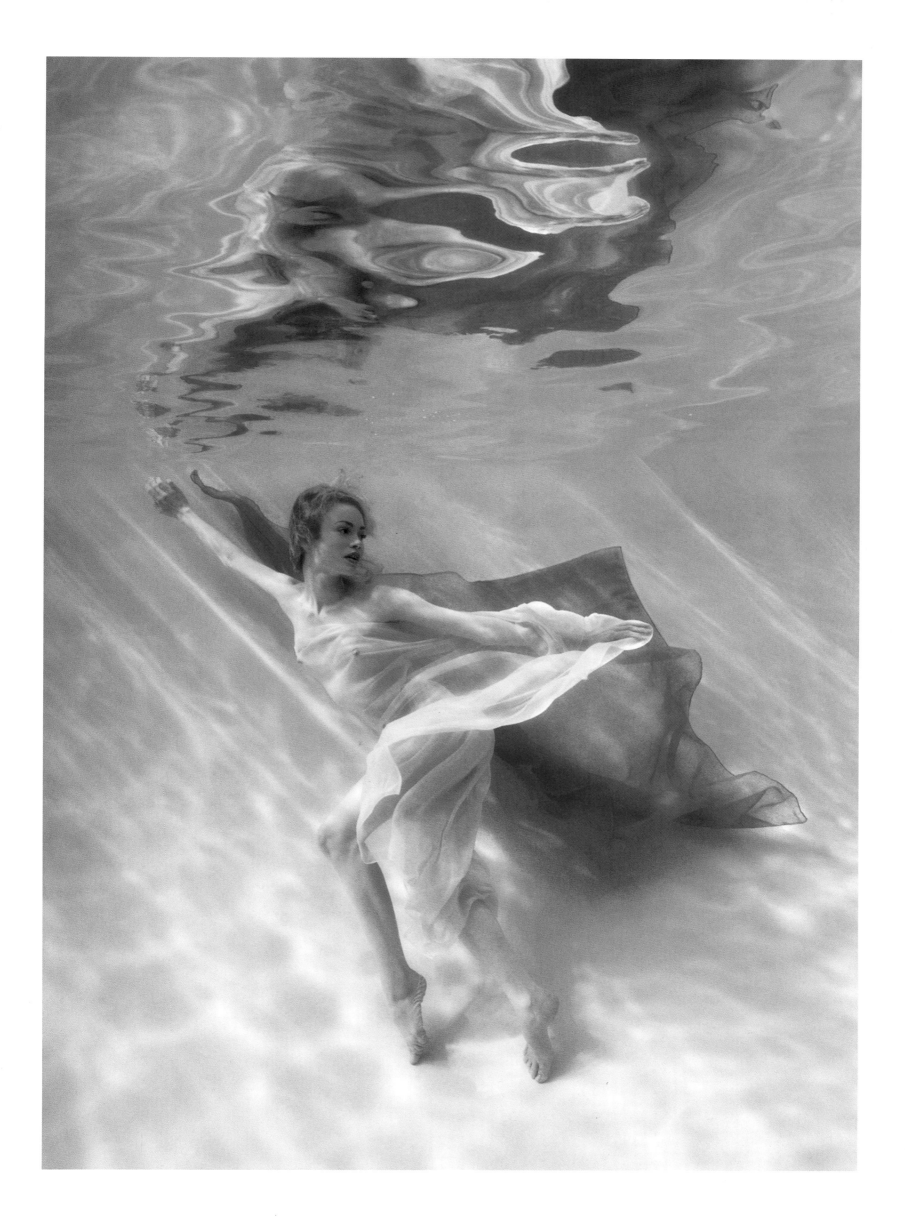

62

64

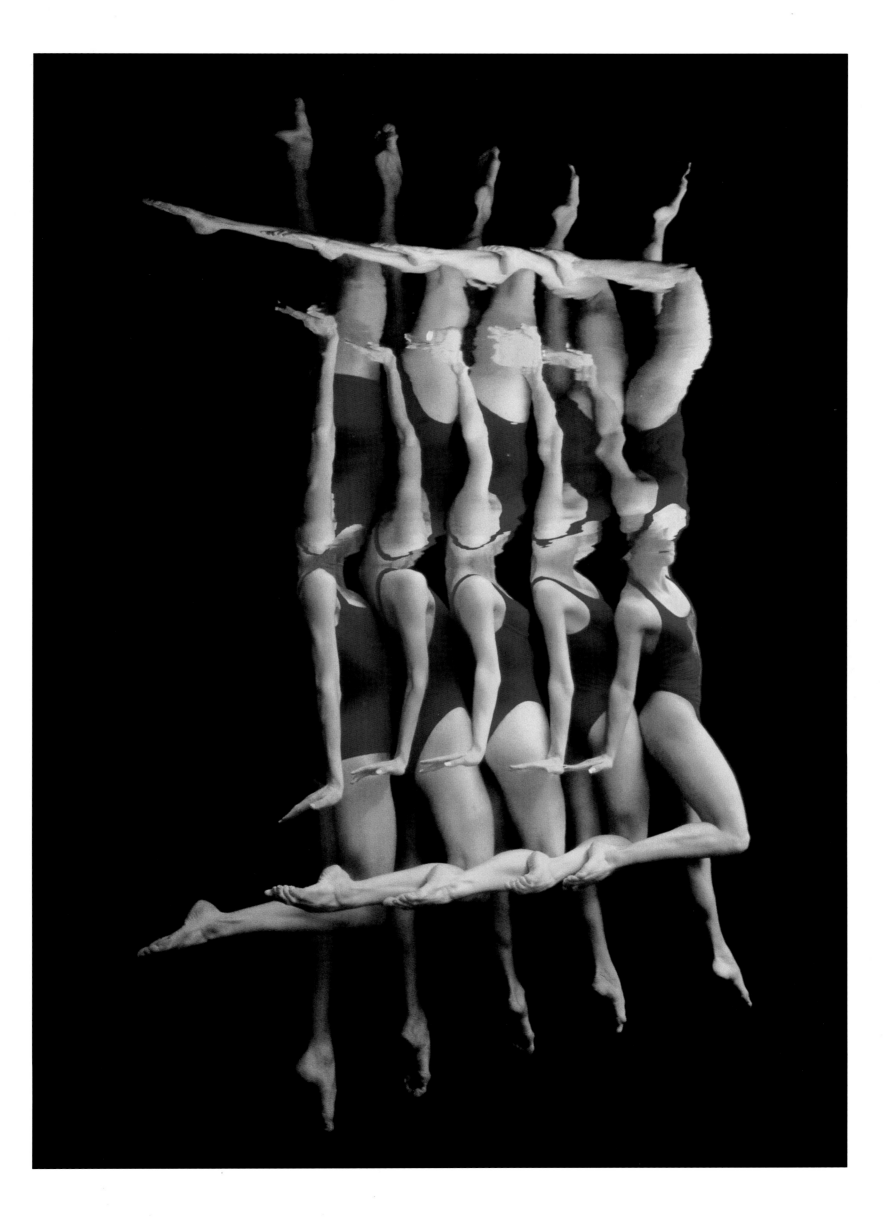

66

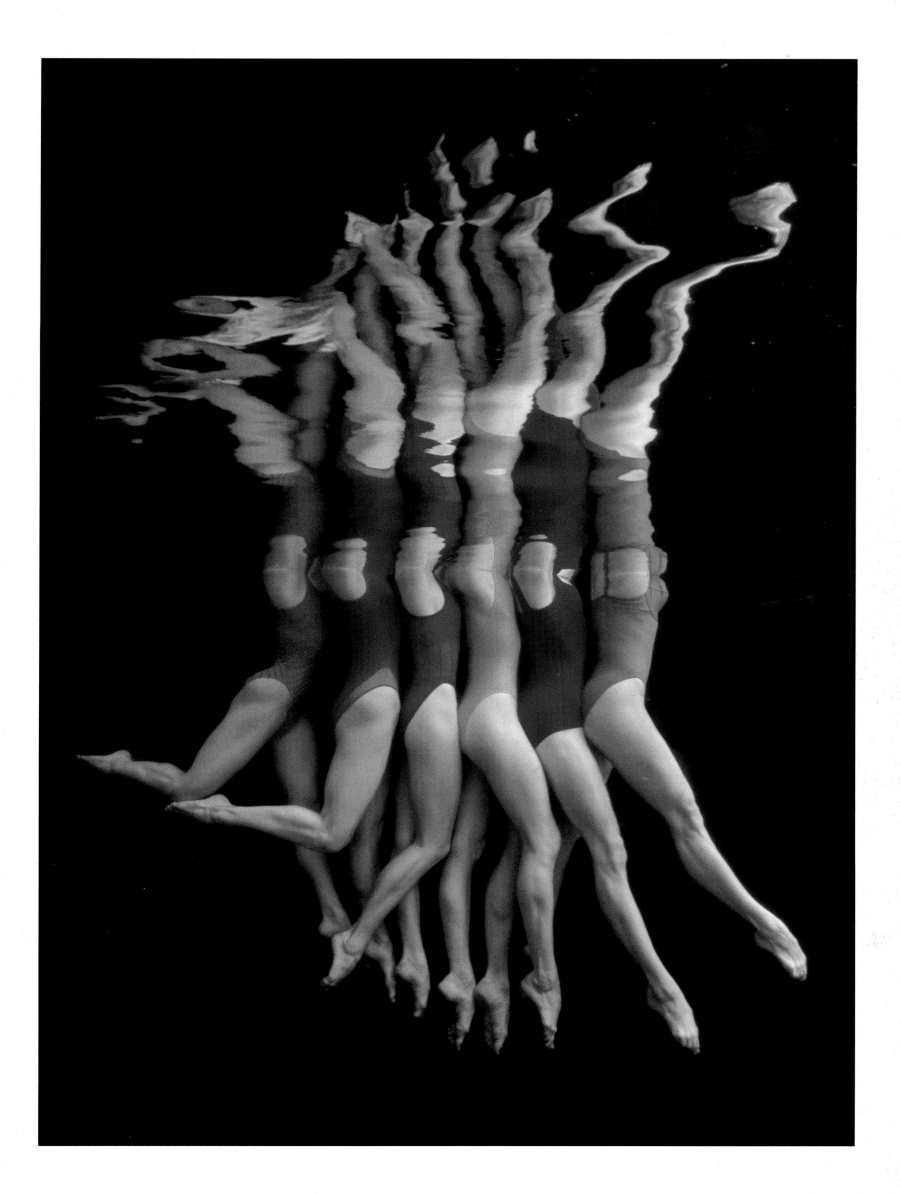

68

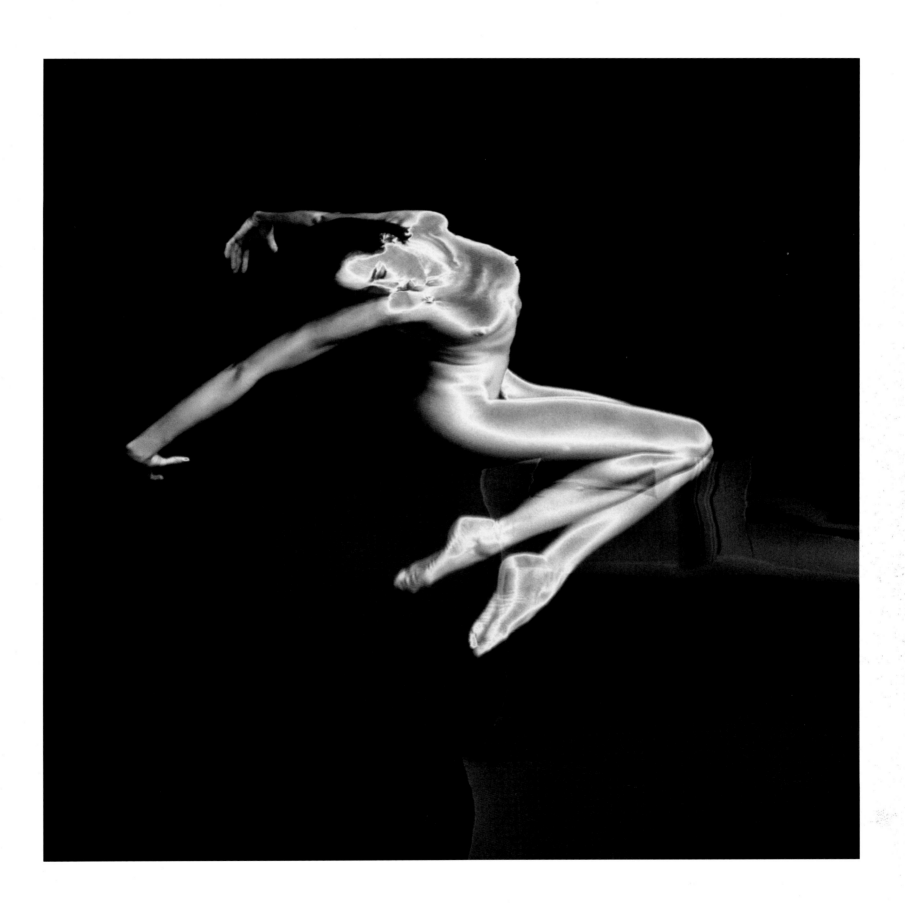

70

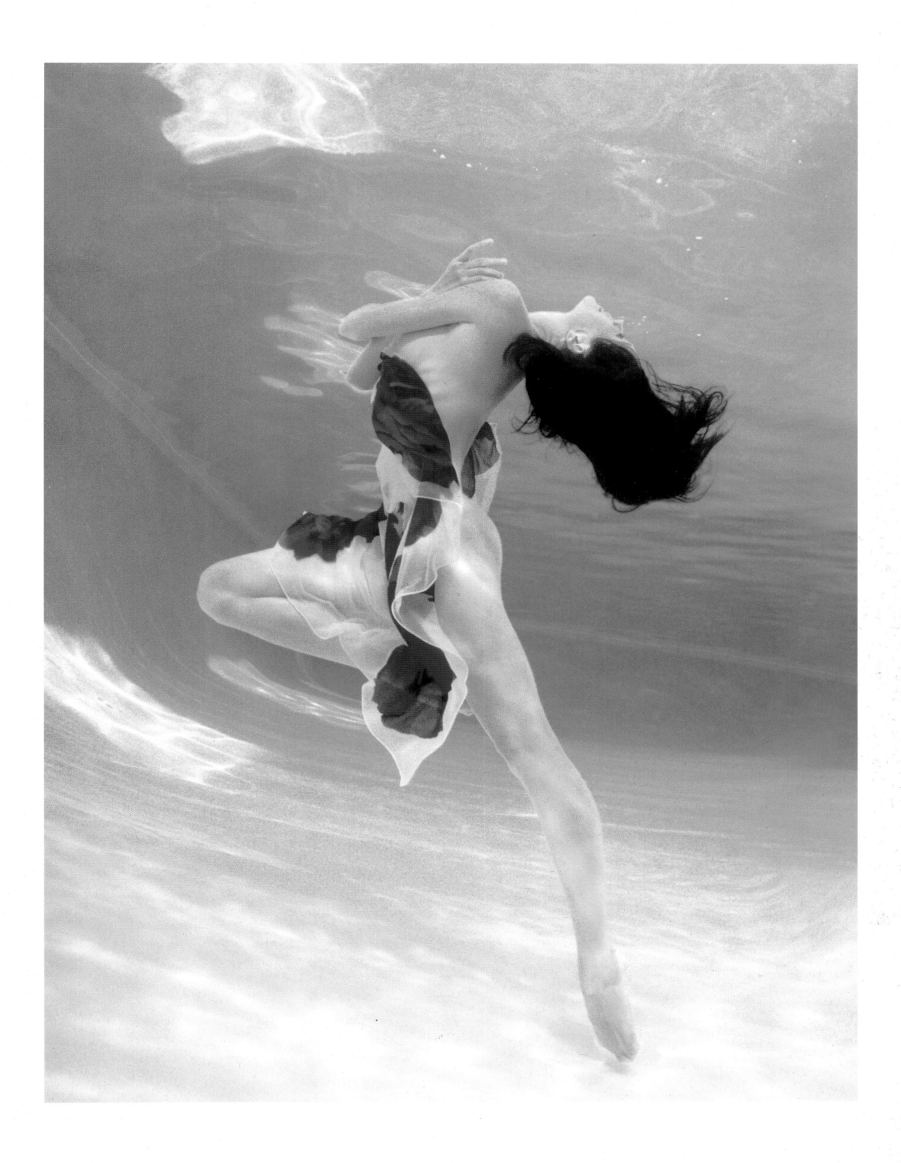

7^2

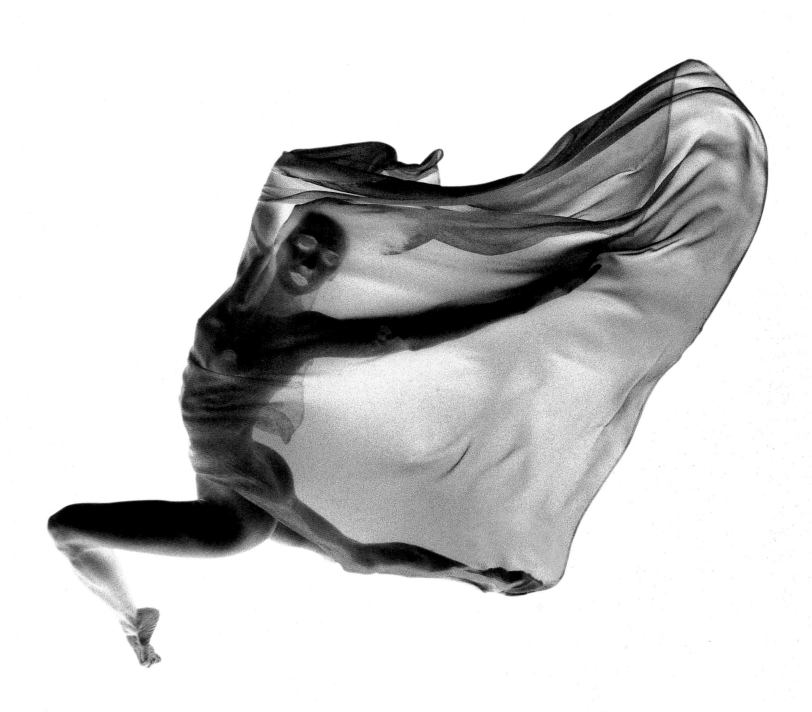

74

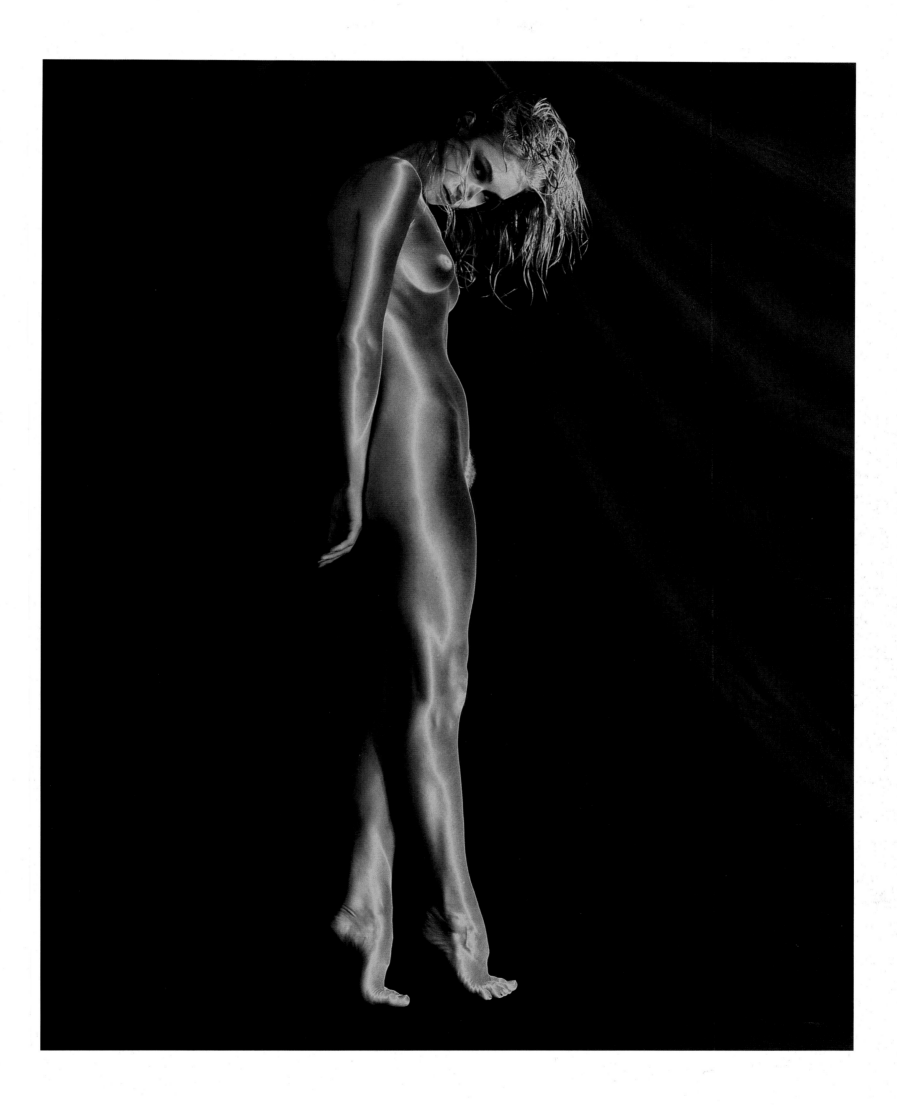

76

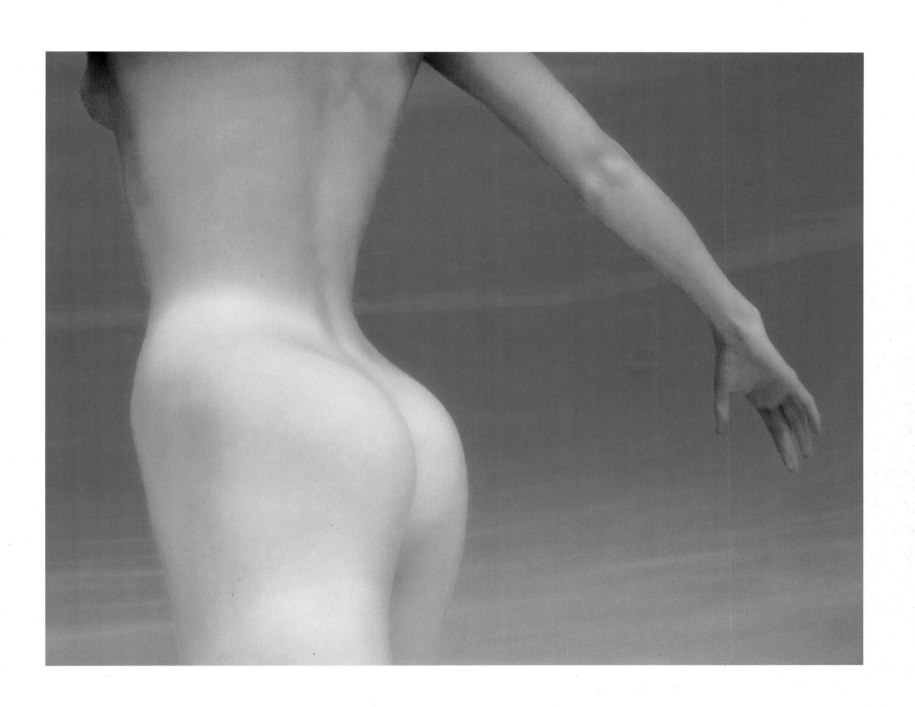

78

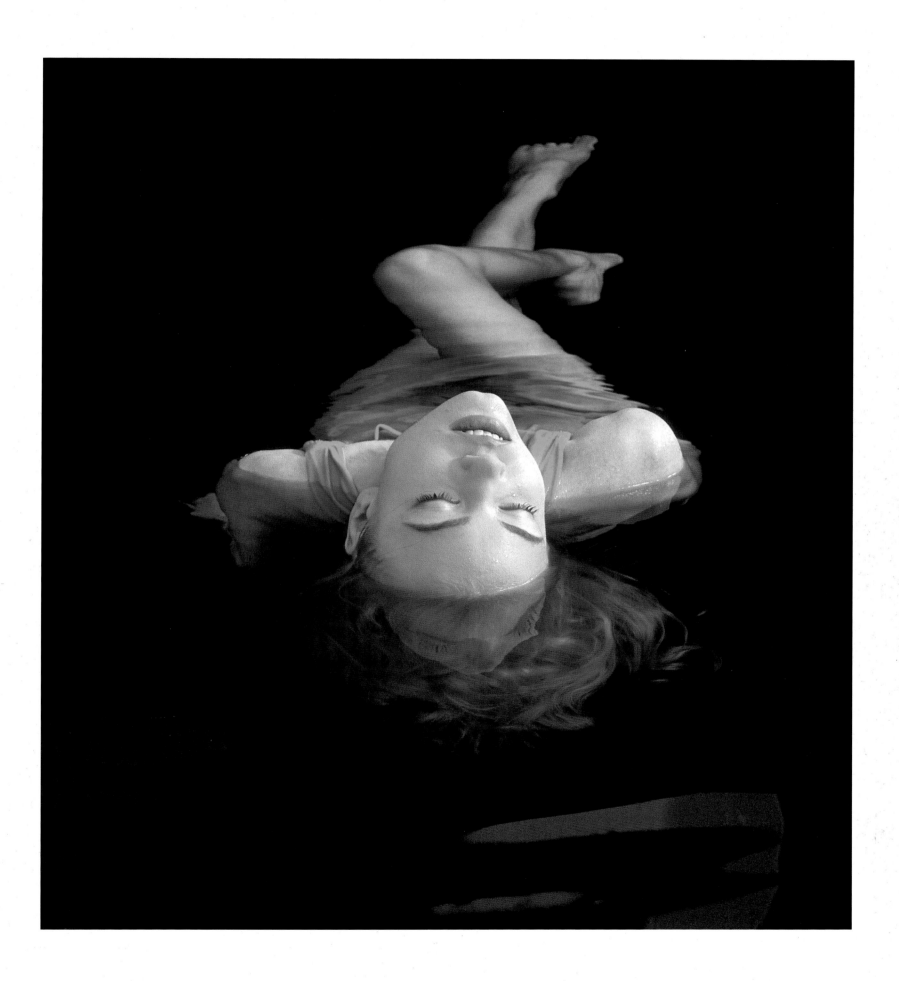

80

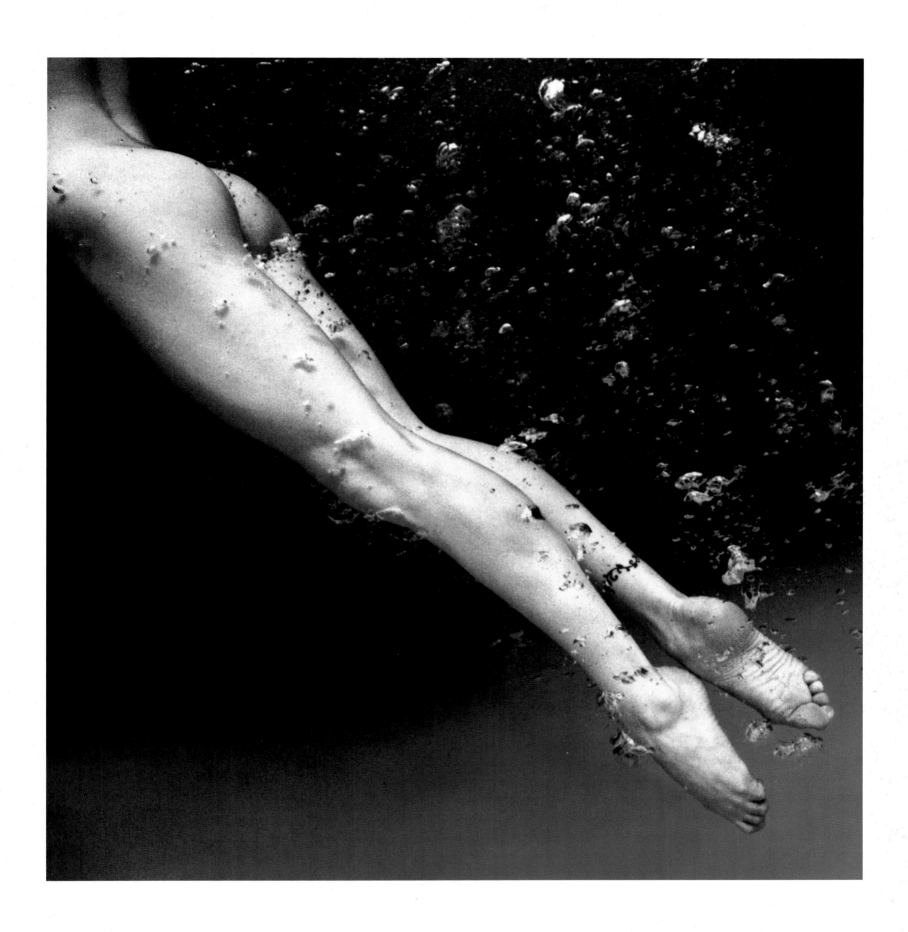

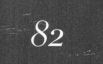

82

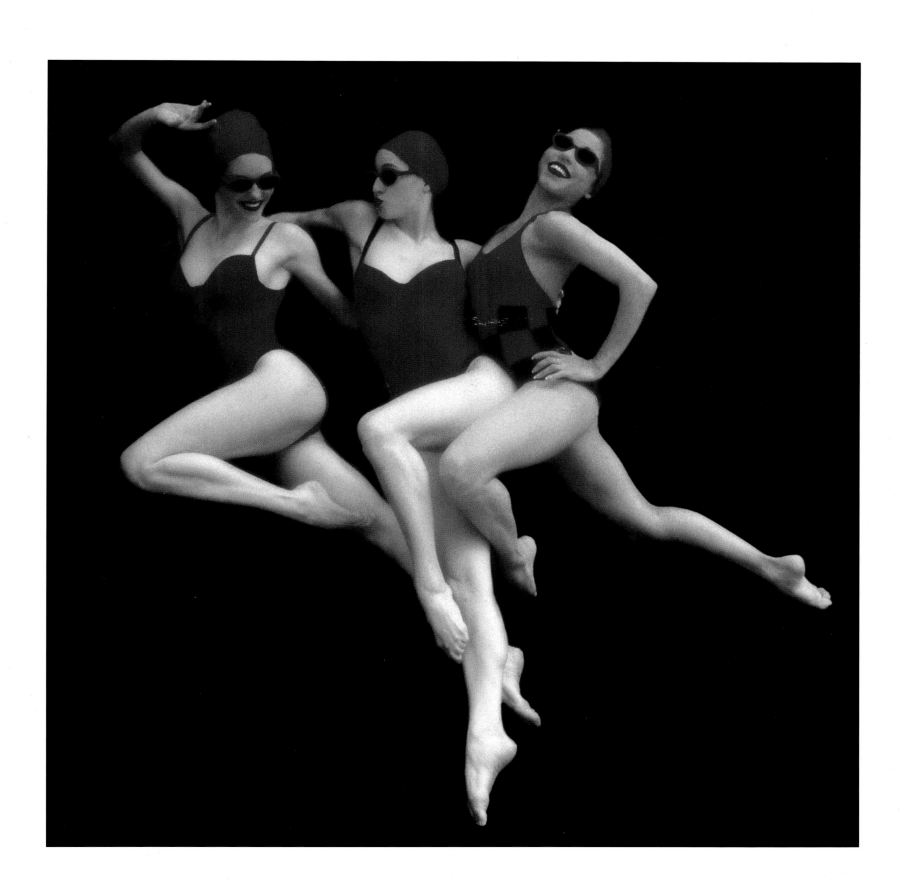

84

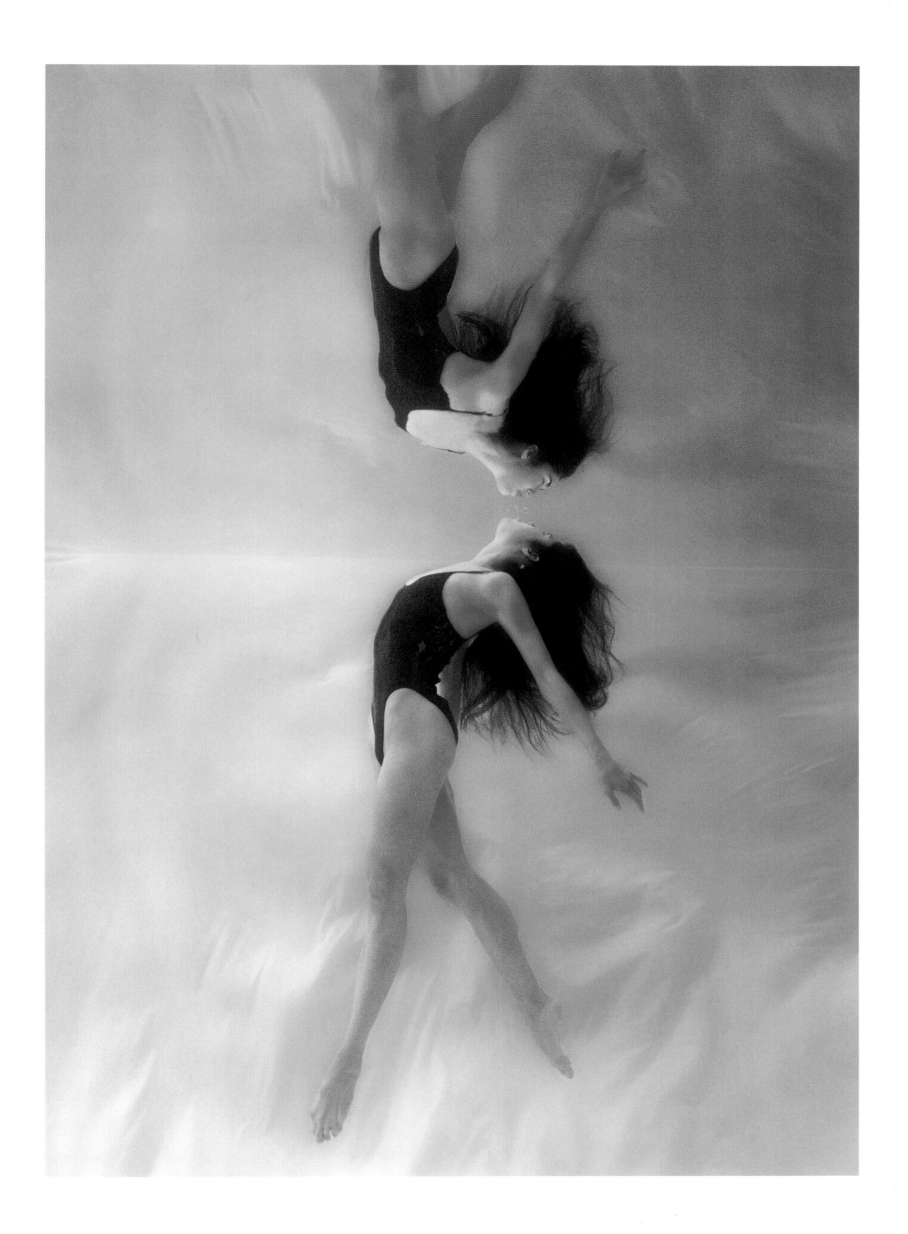

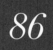

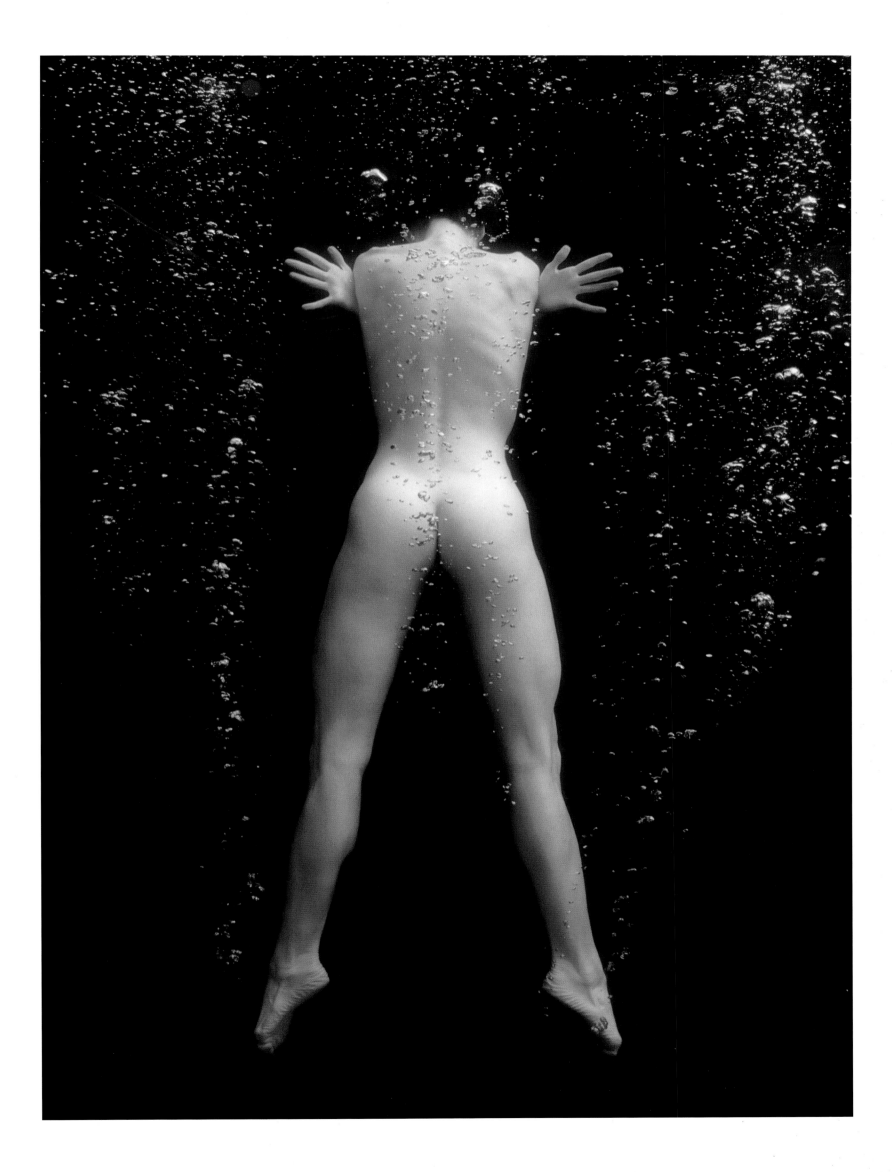

88

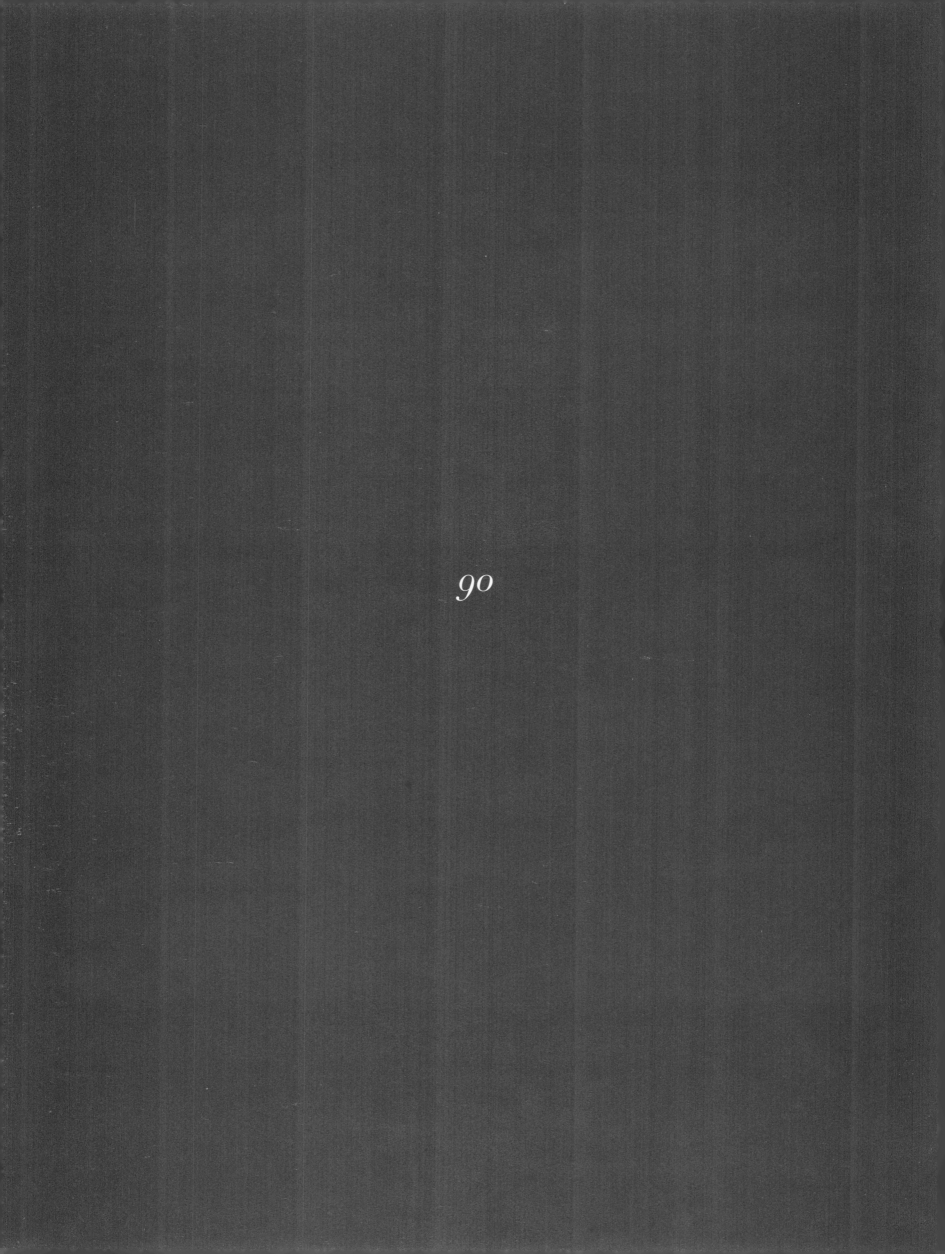

90

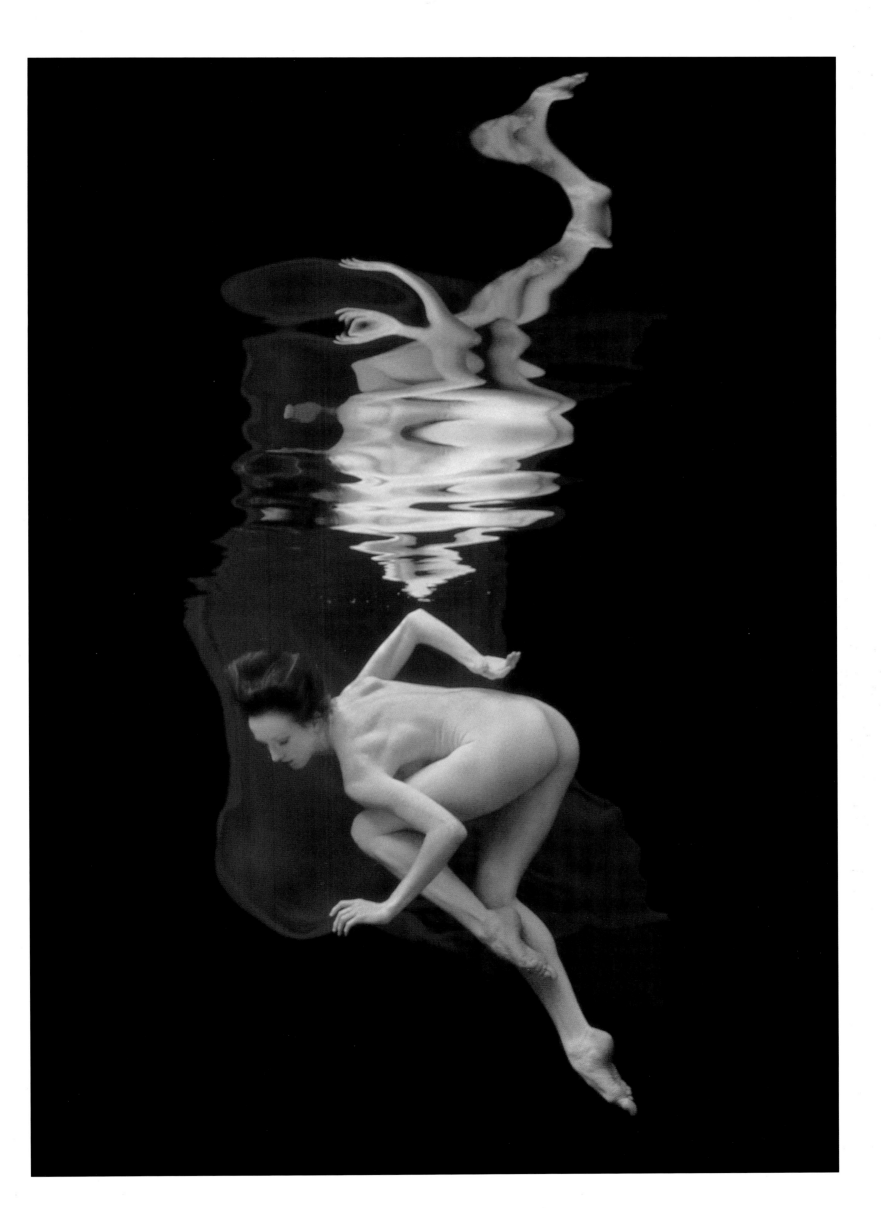

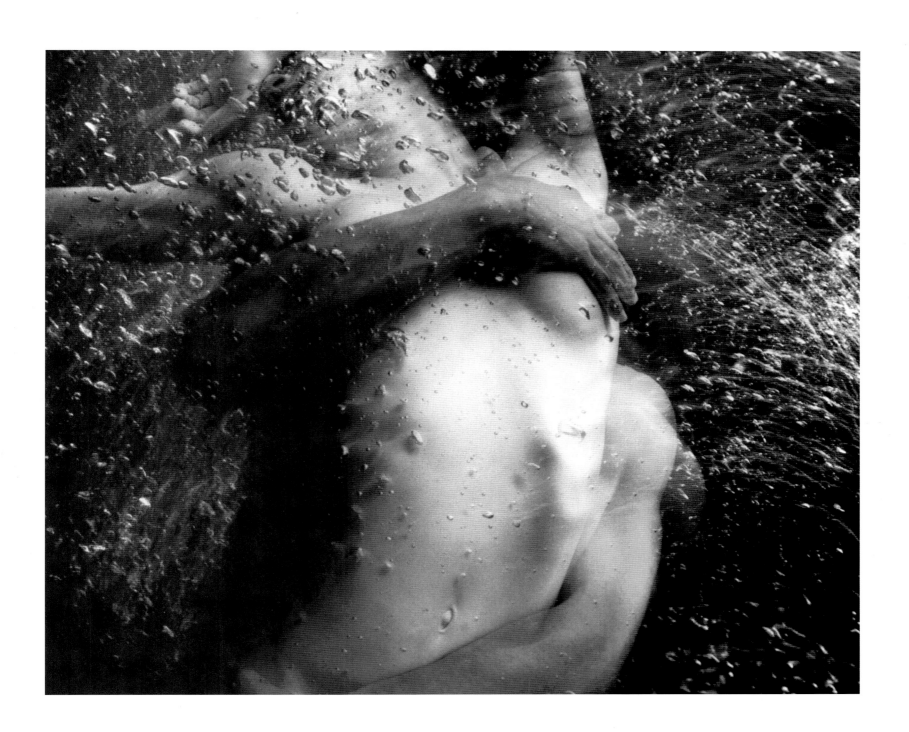

94

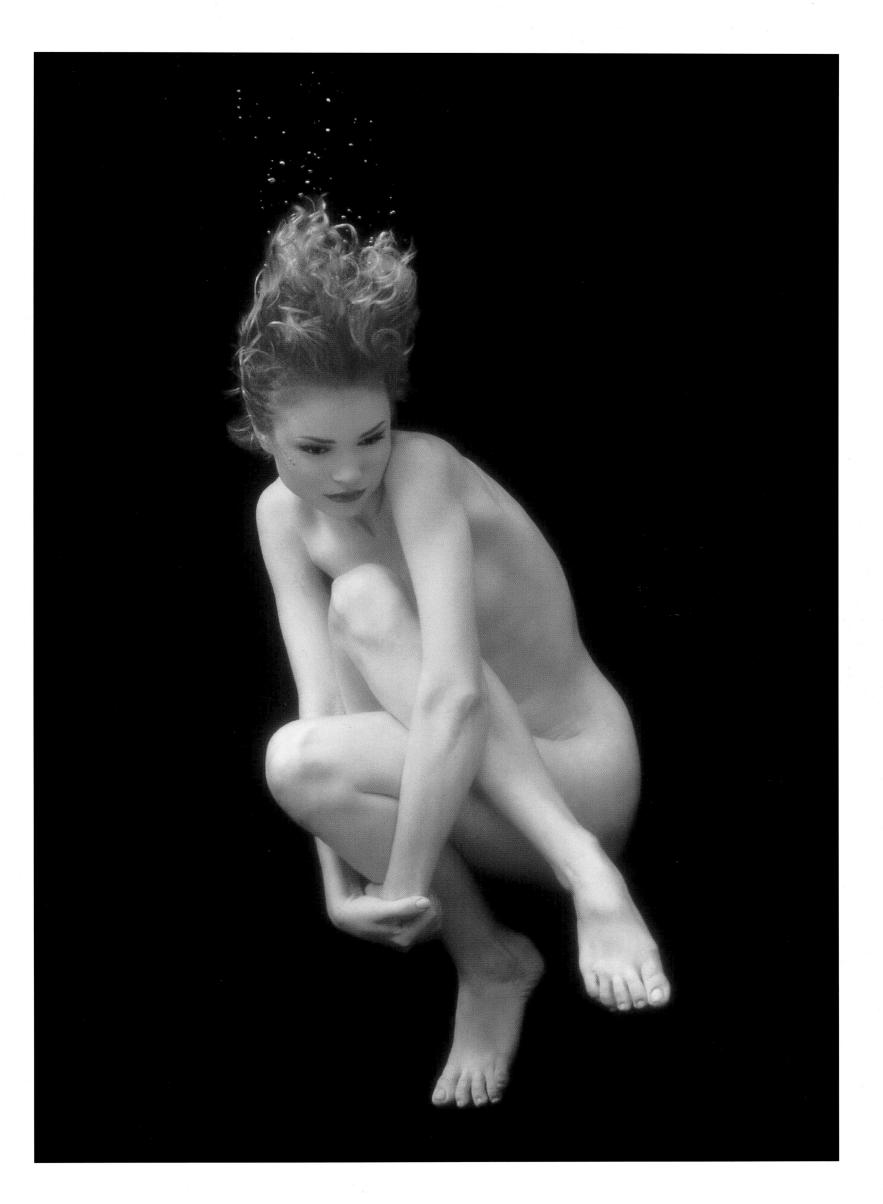

96

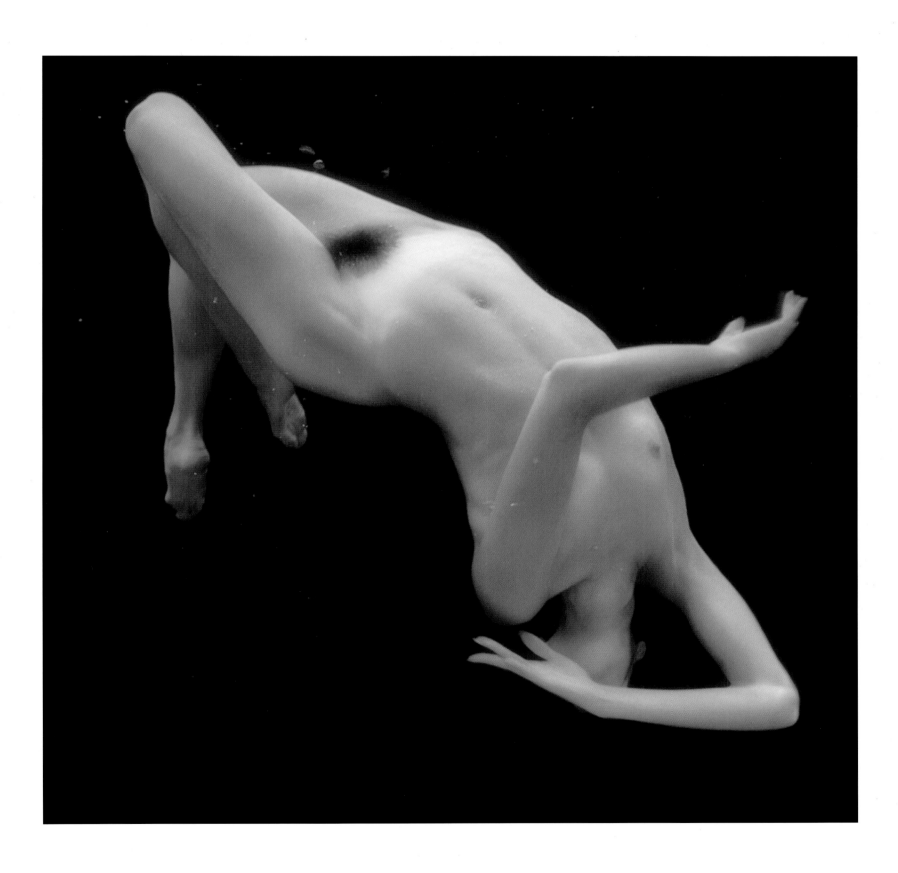

98

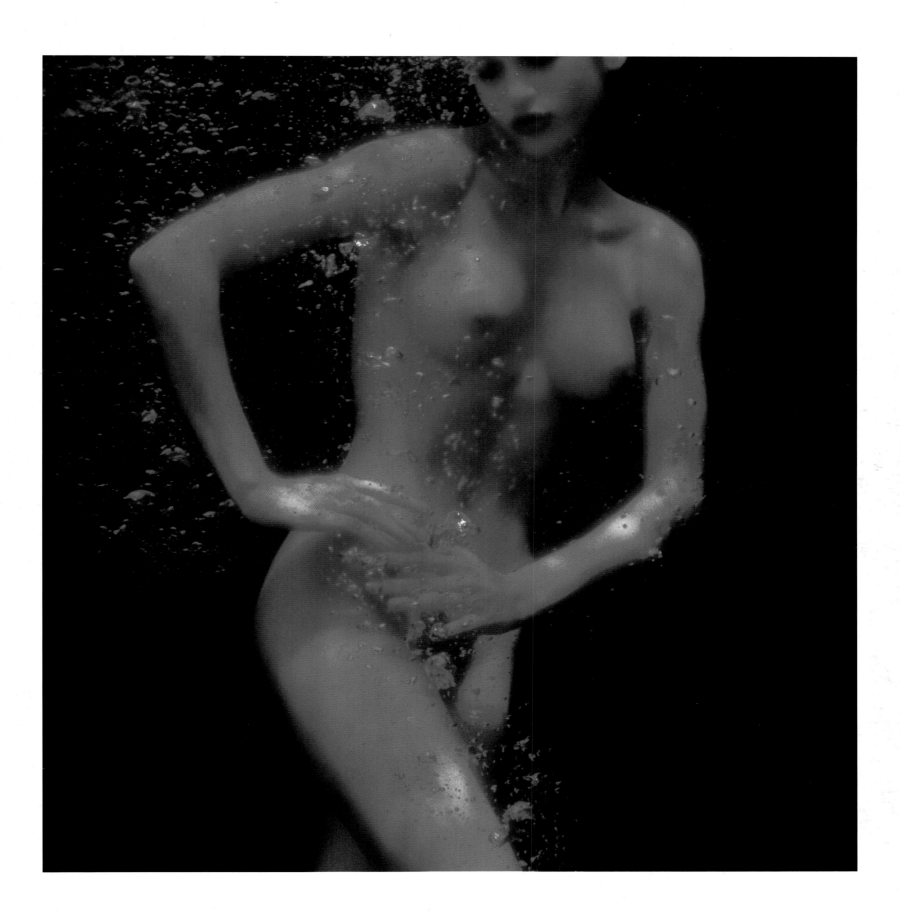

100

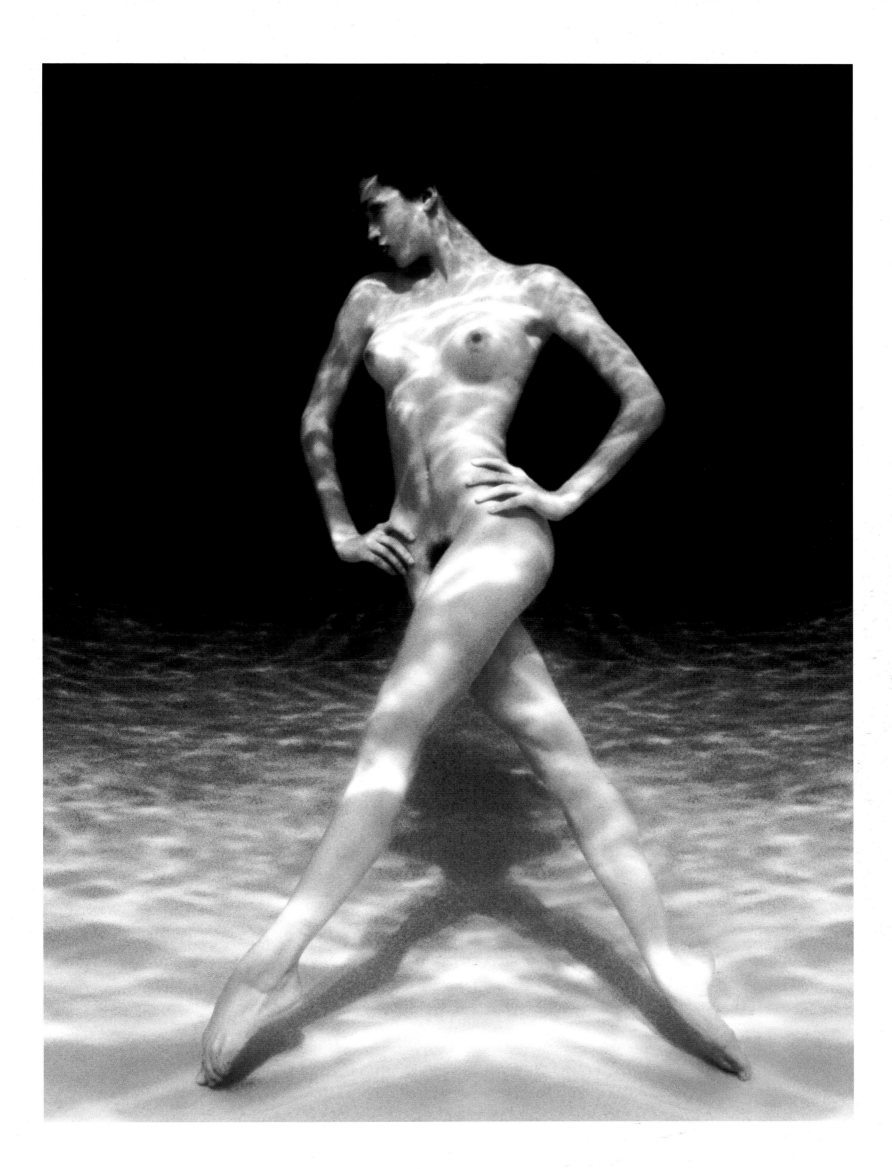

102

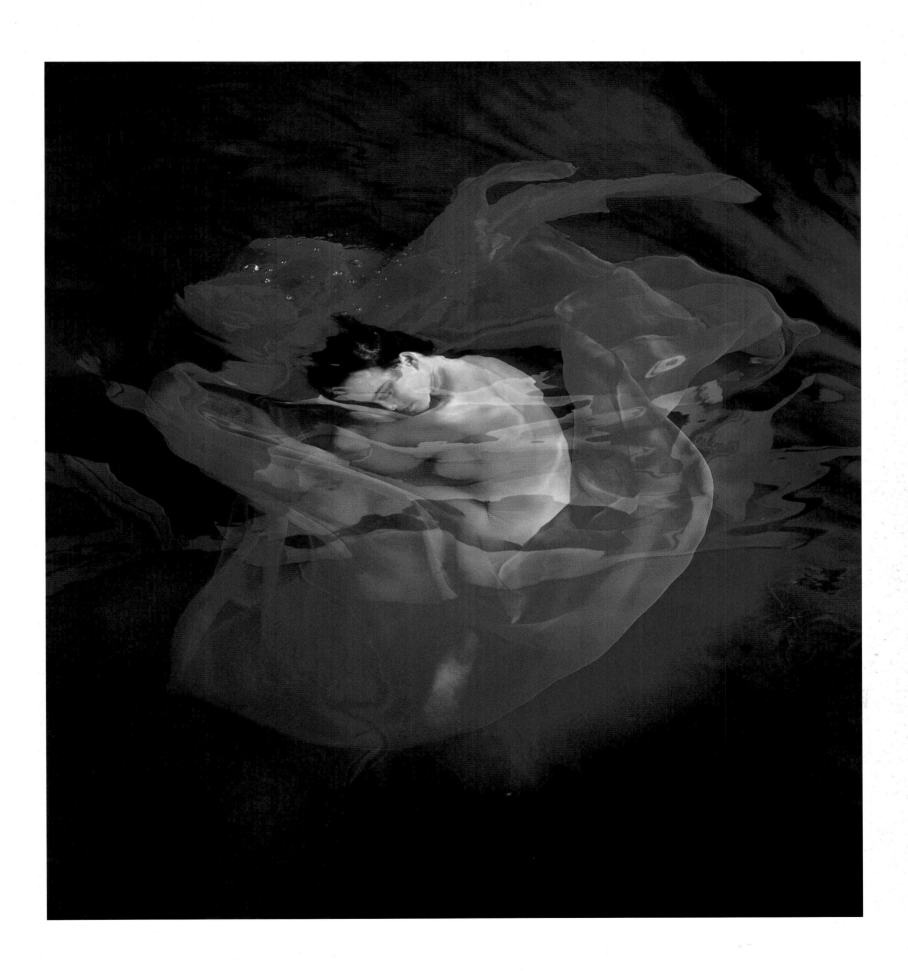

104

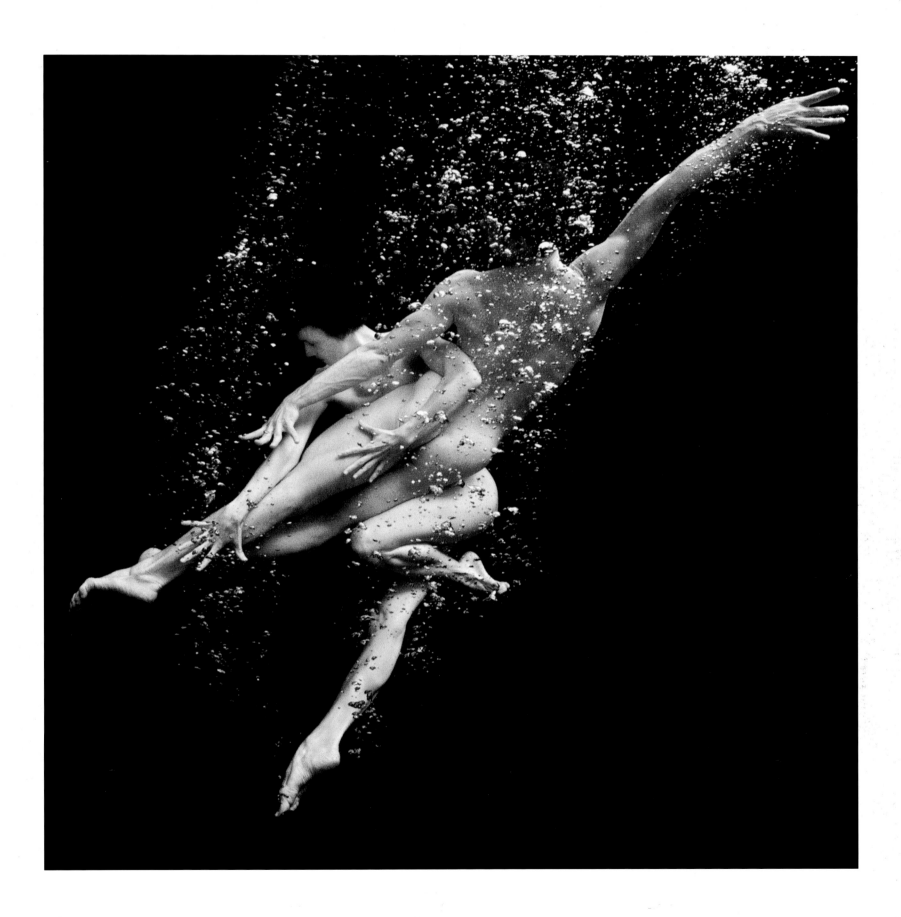

106

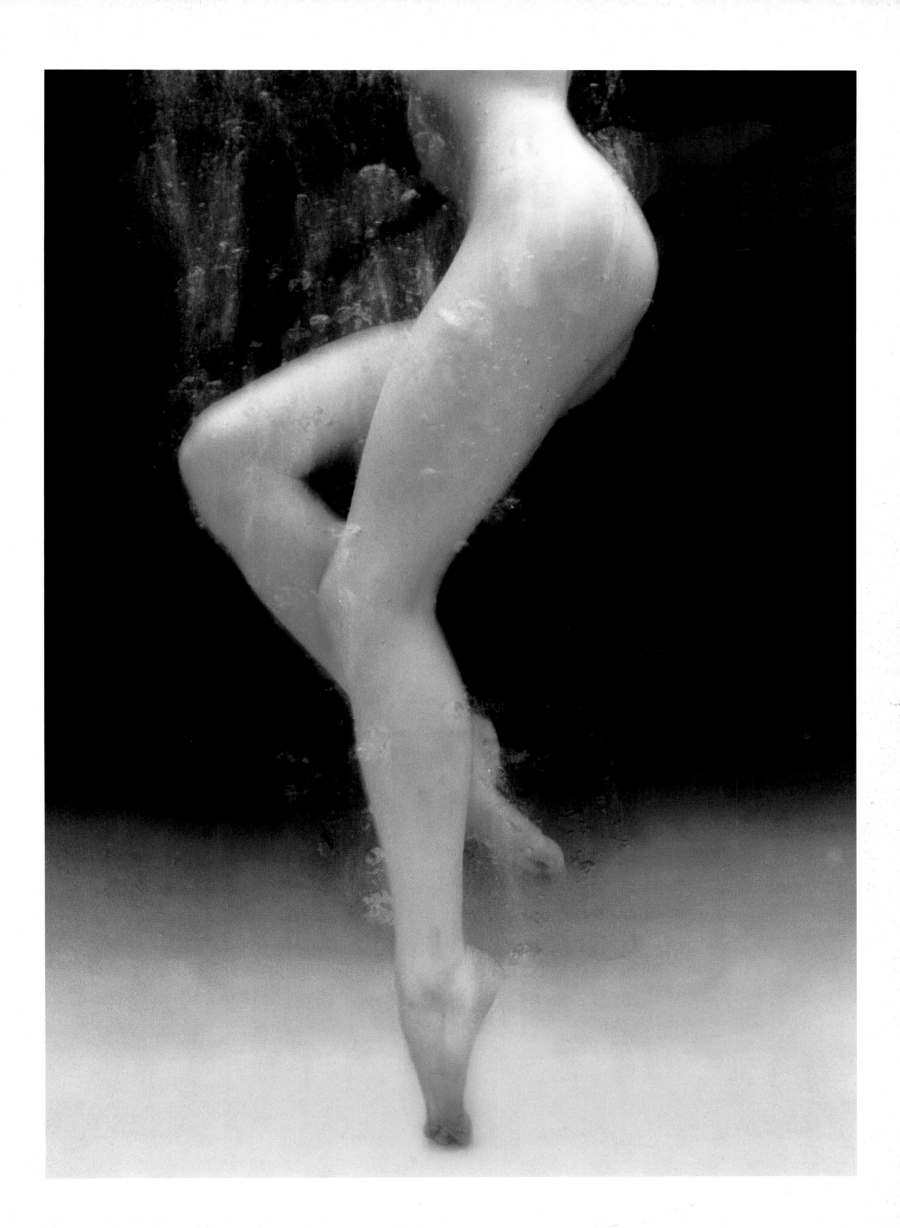

108

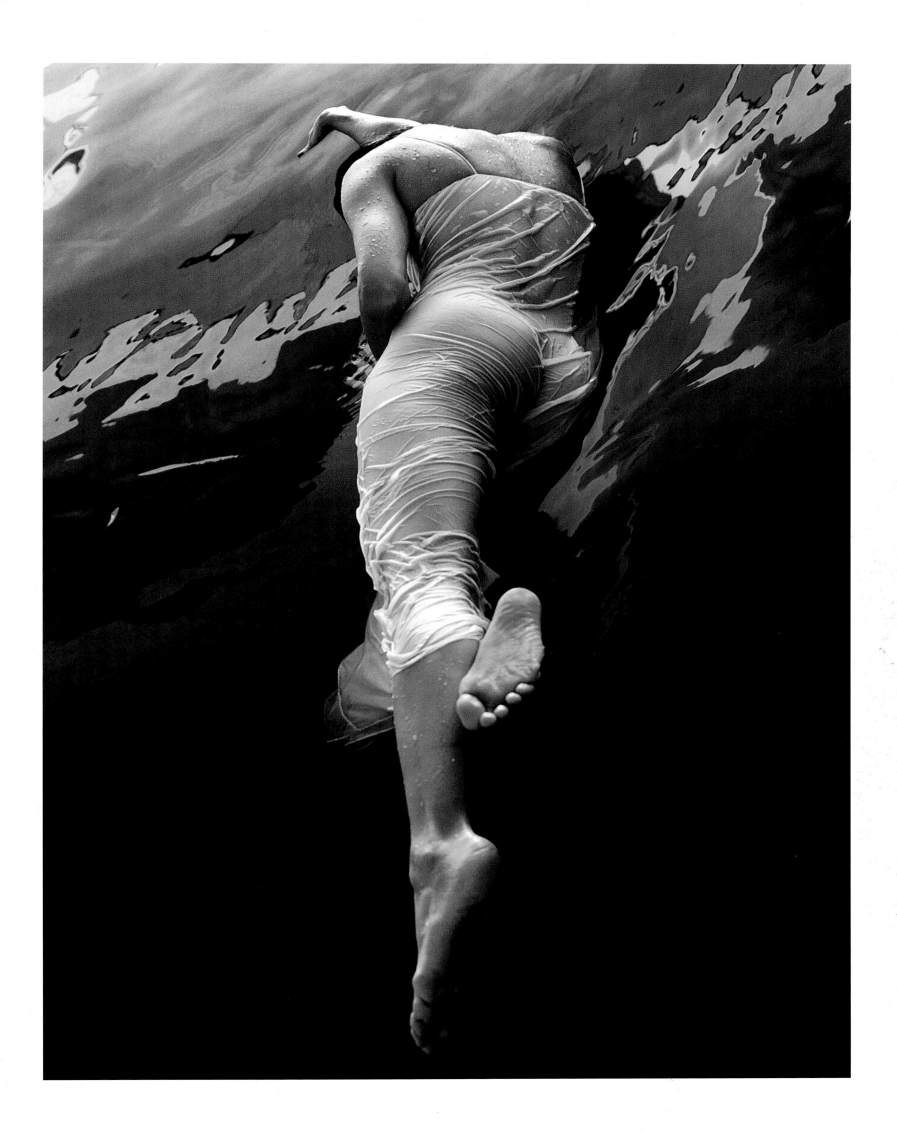

110

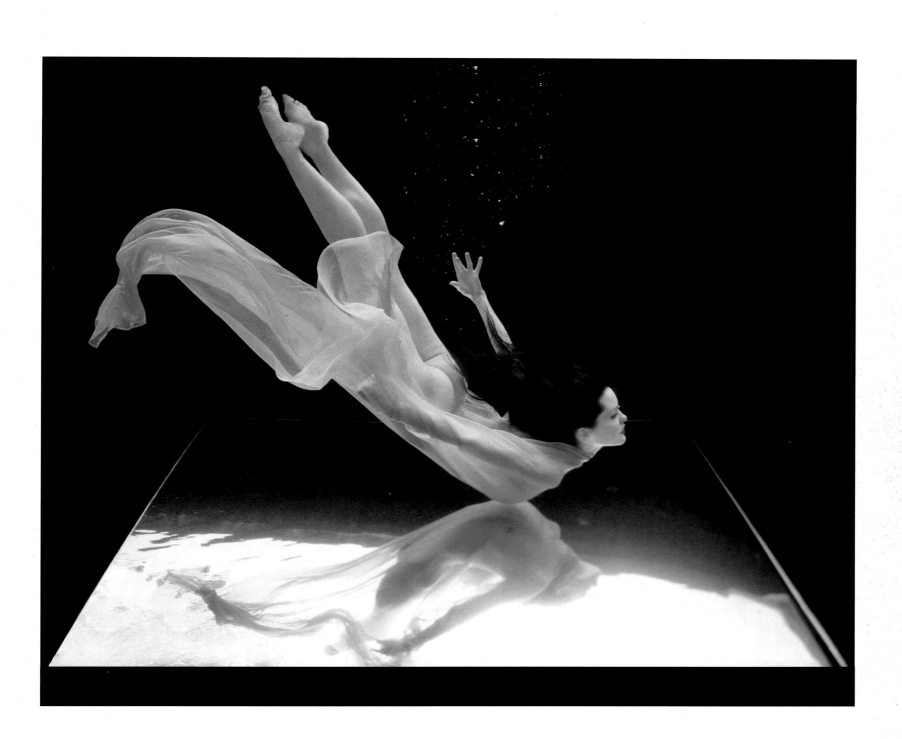

112

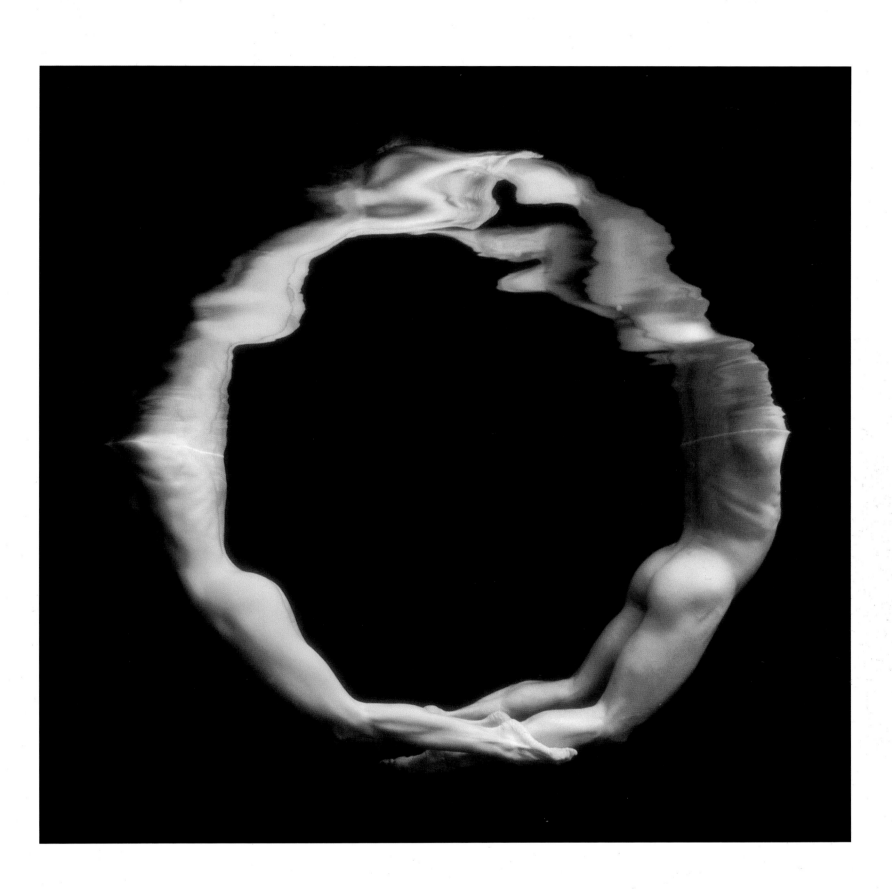

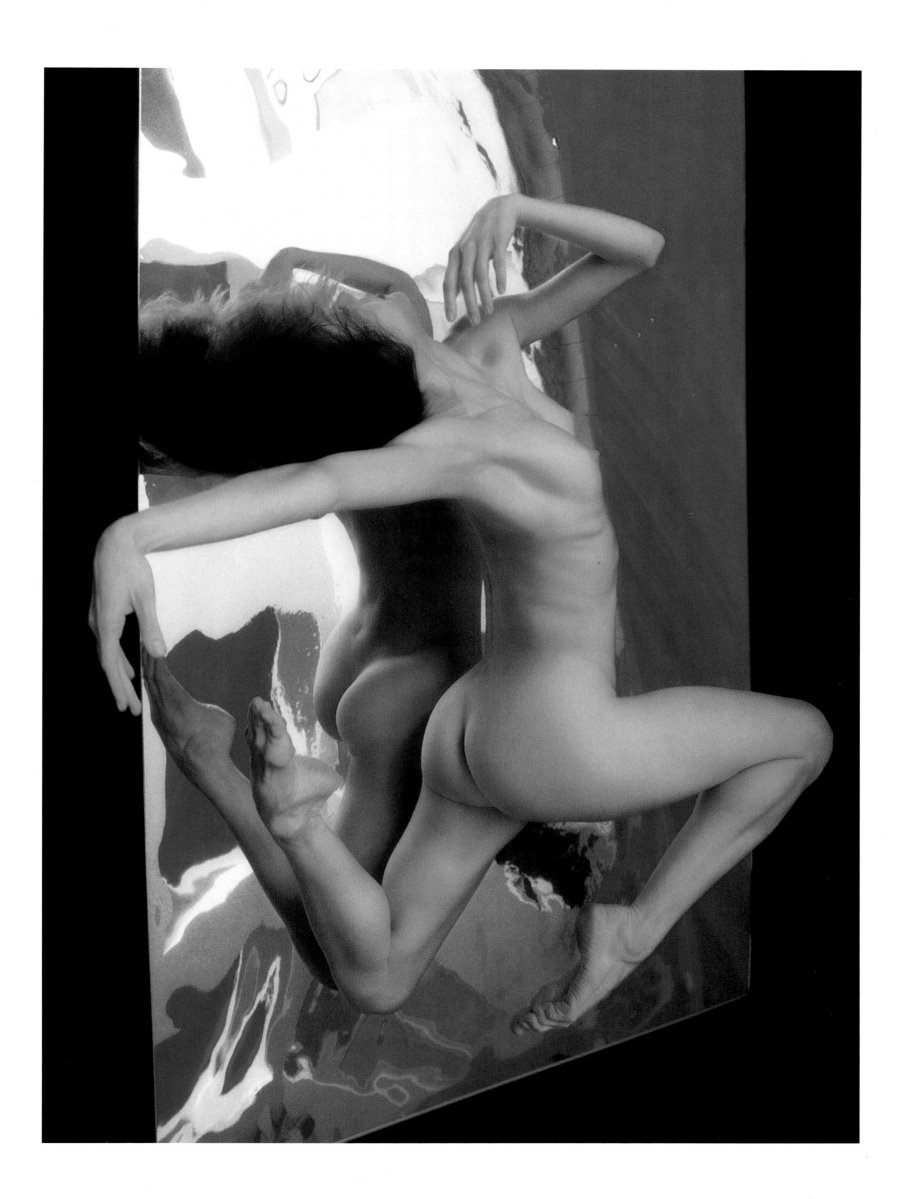

116

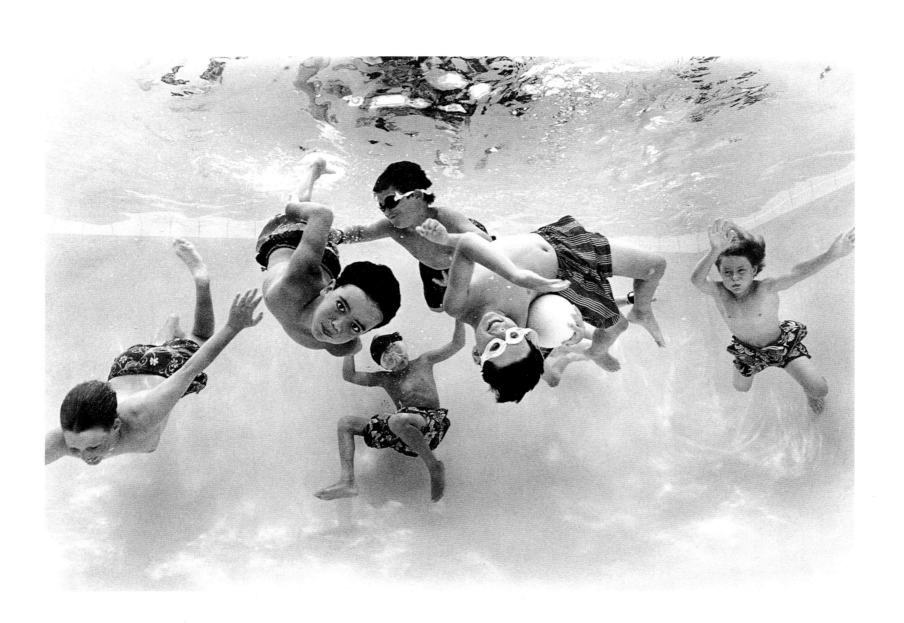

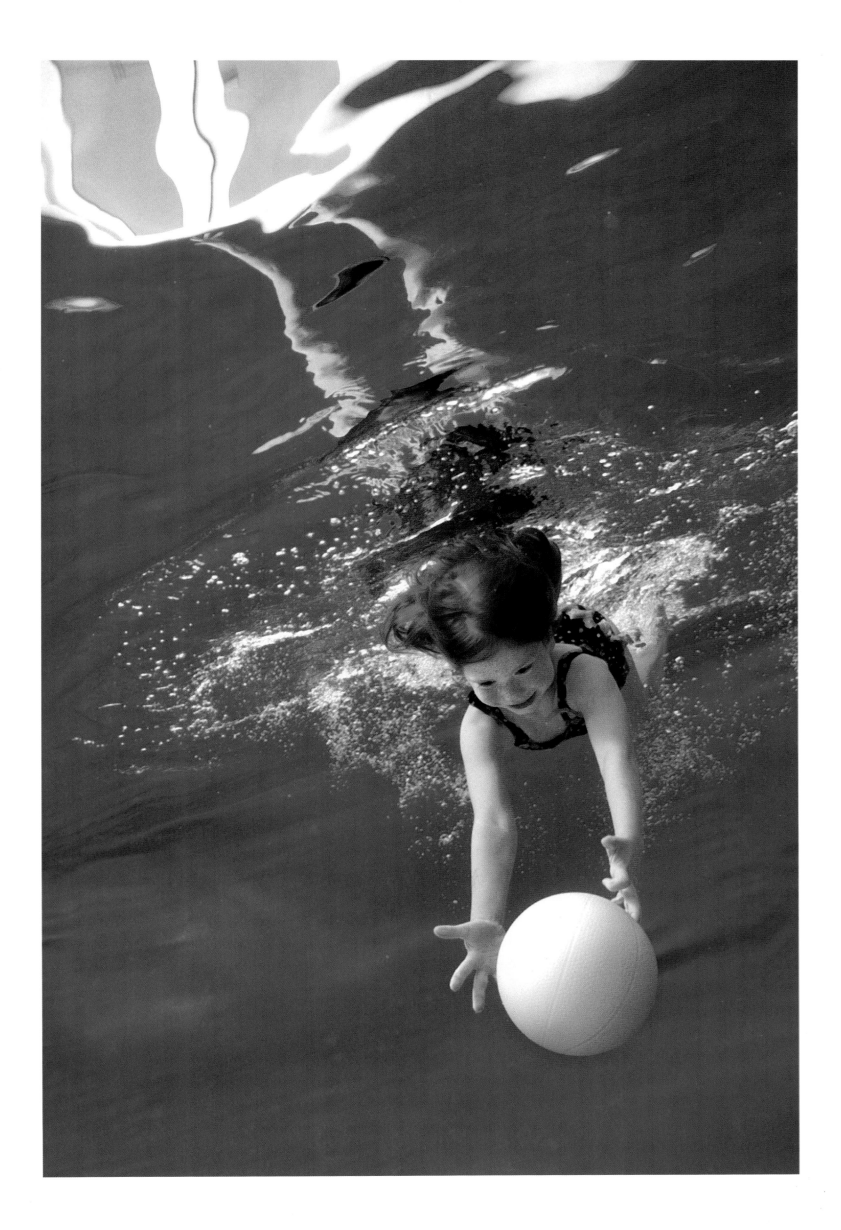

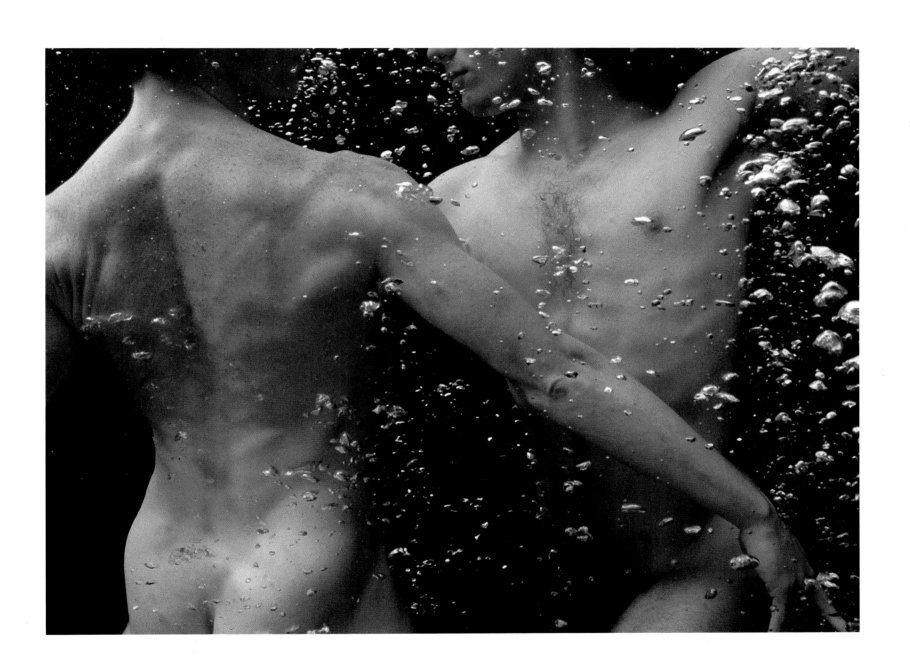

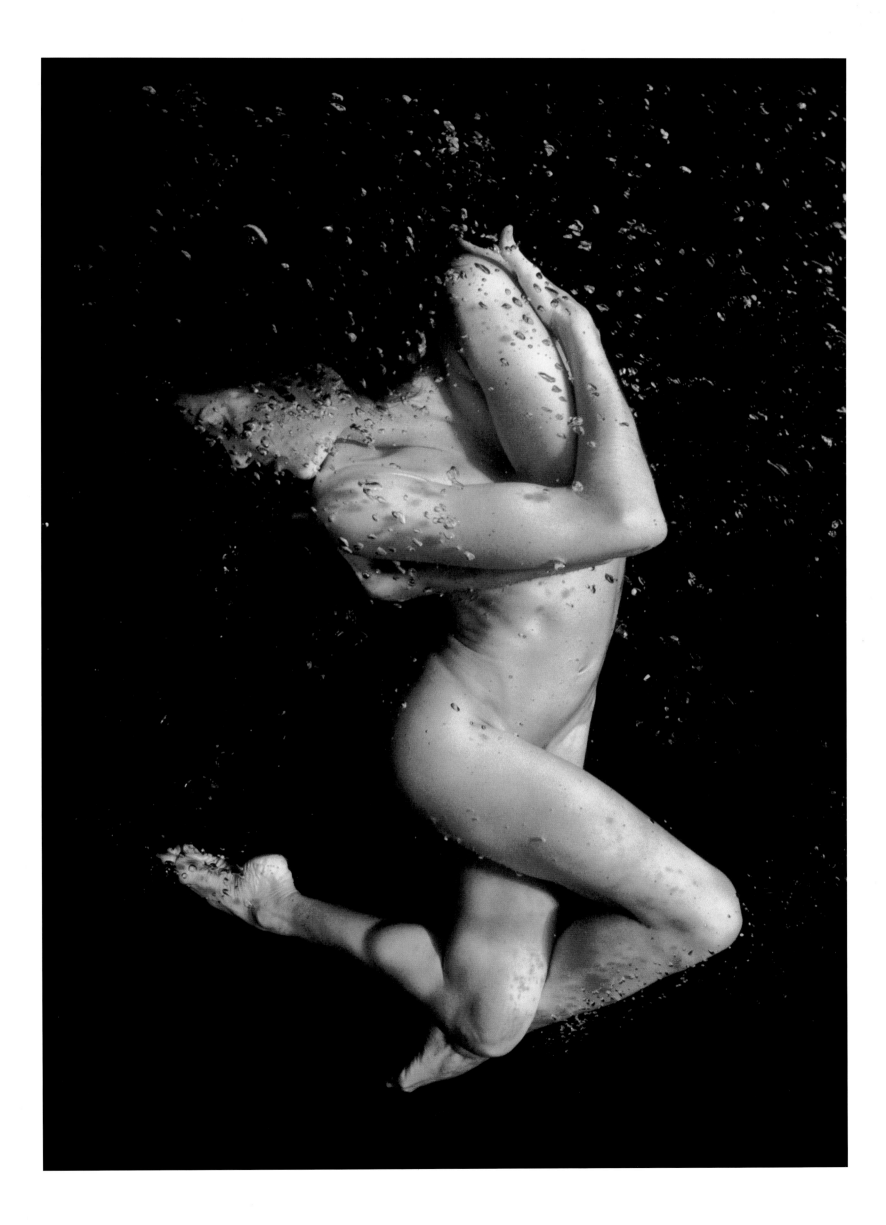

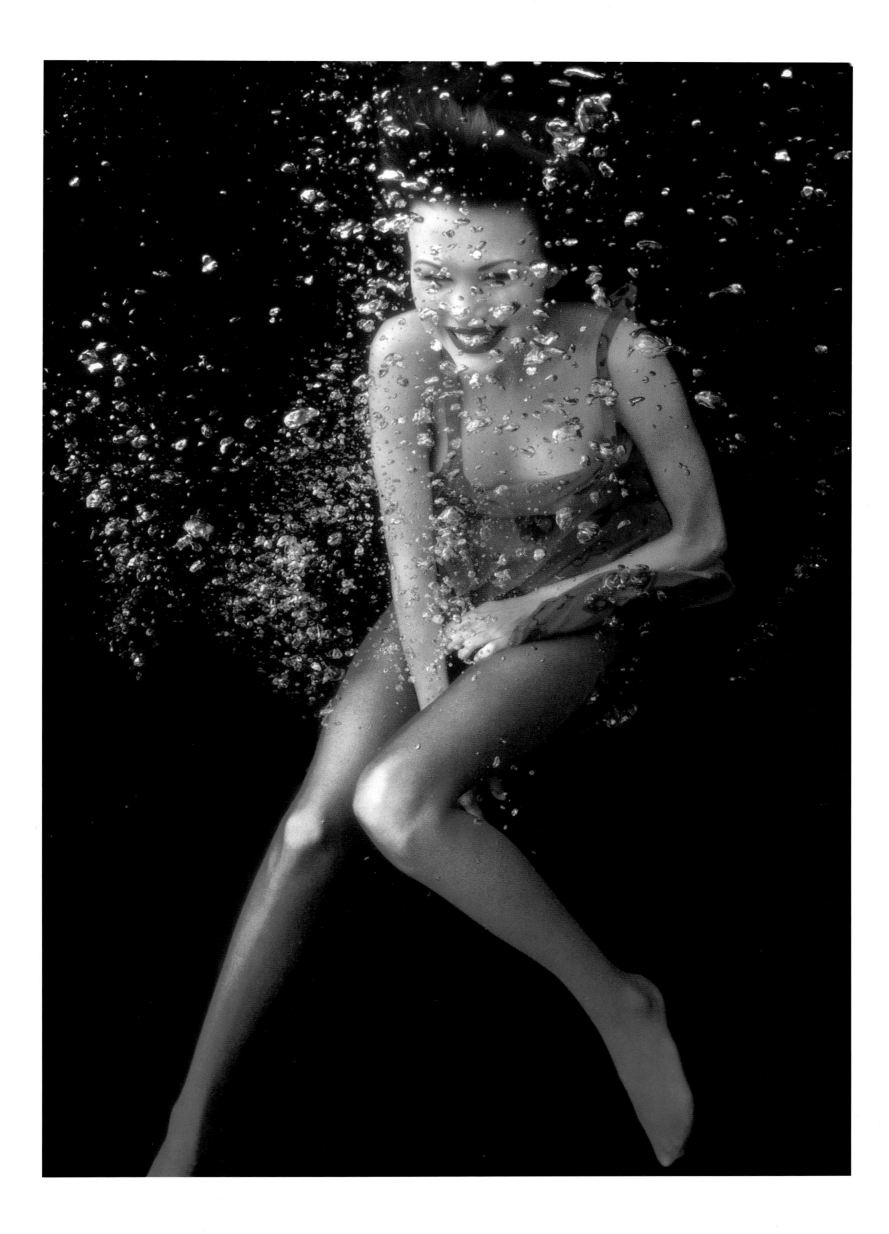

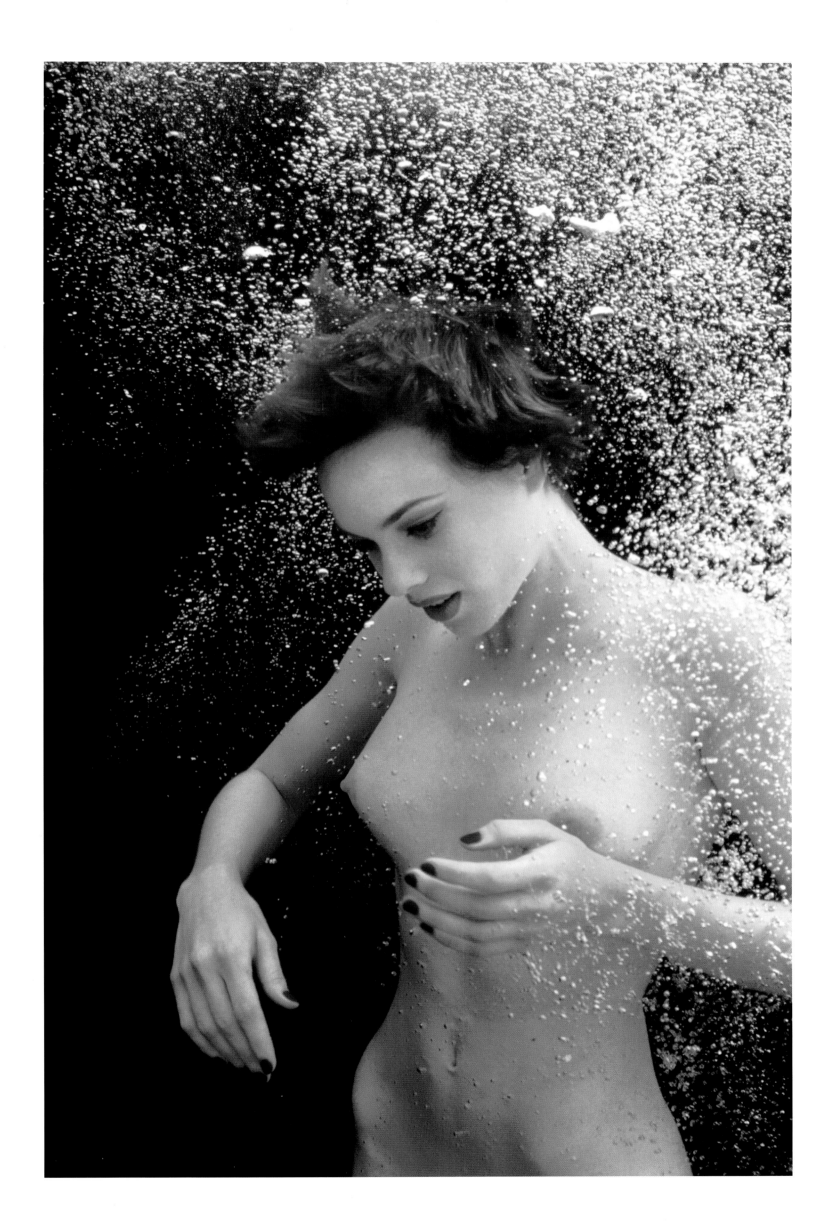

128

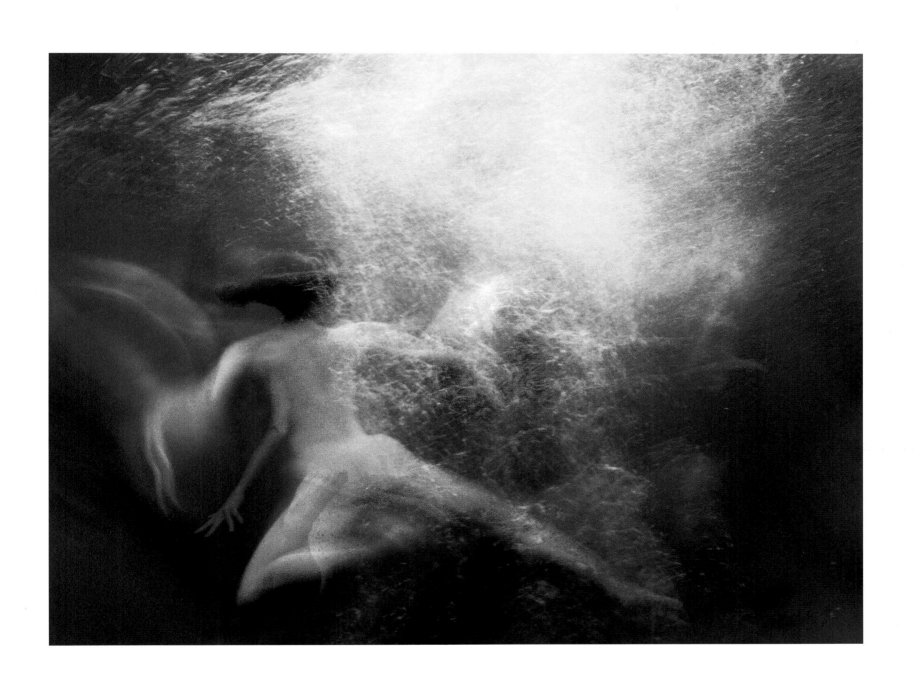

130

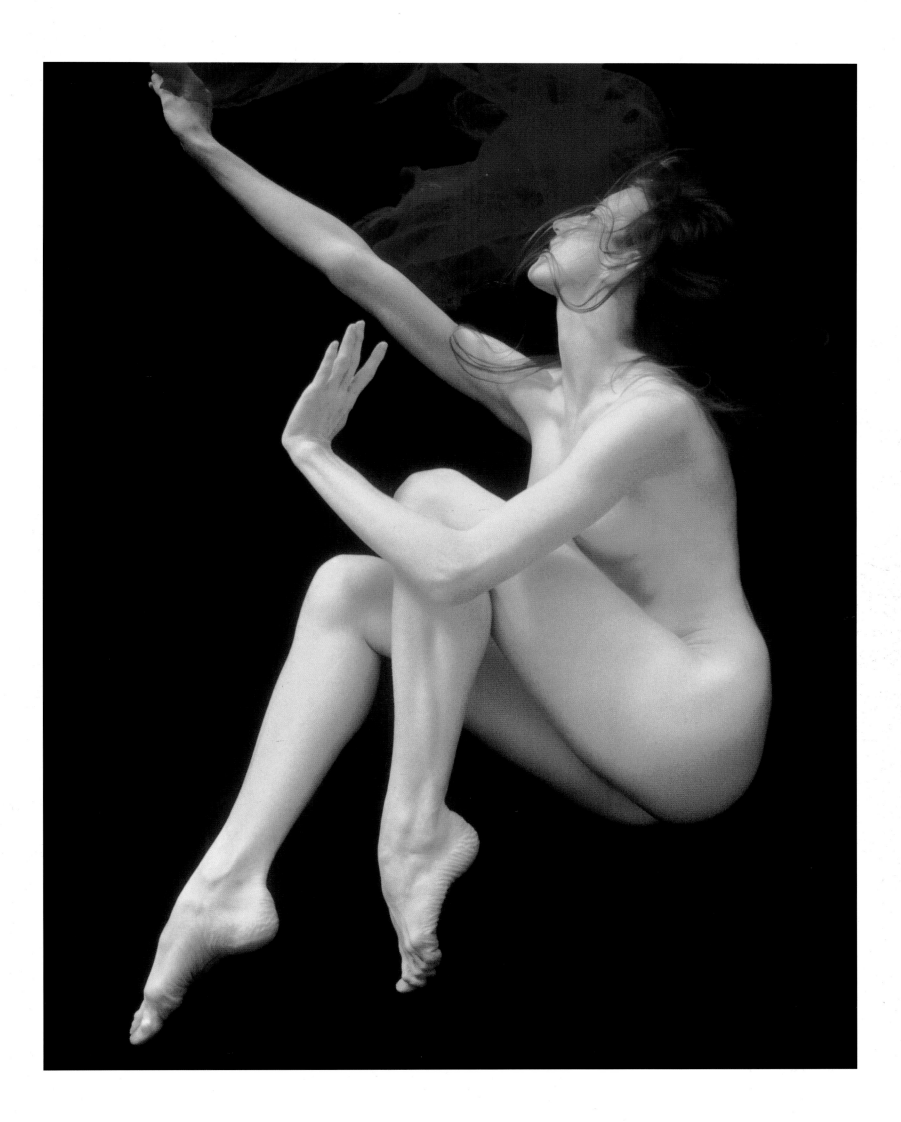

132

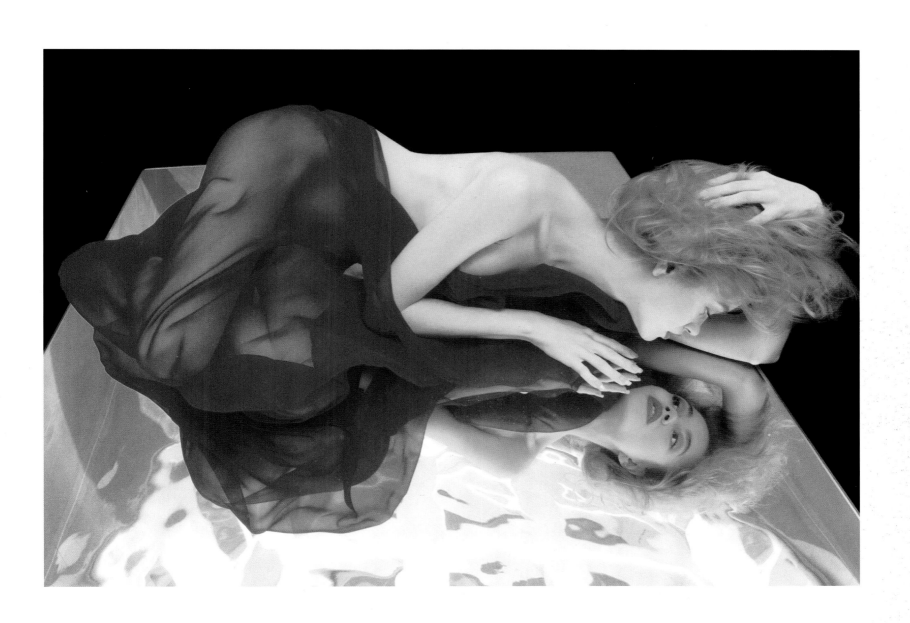

134

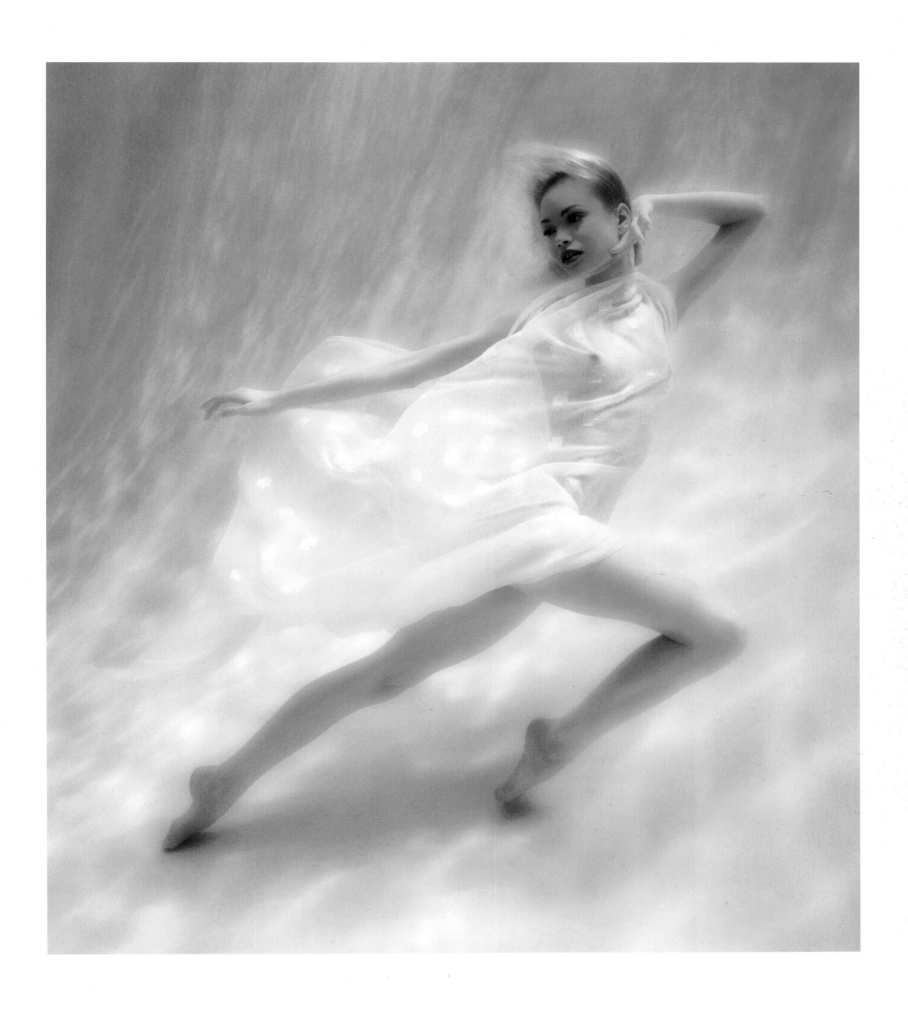

136

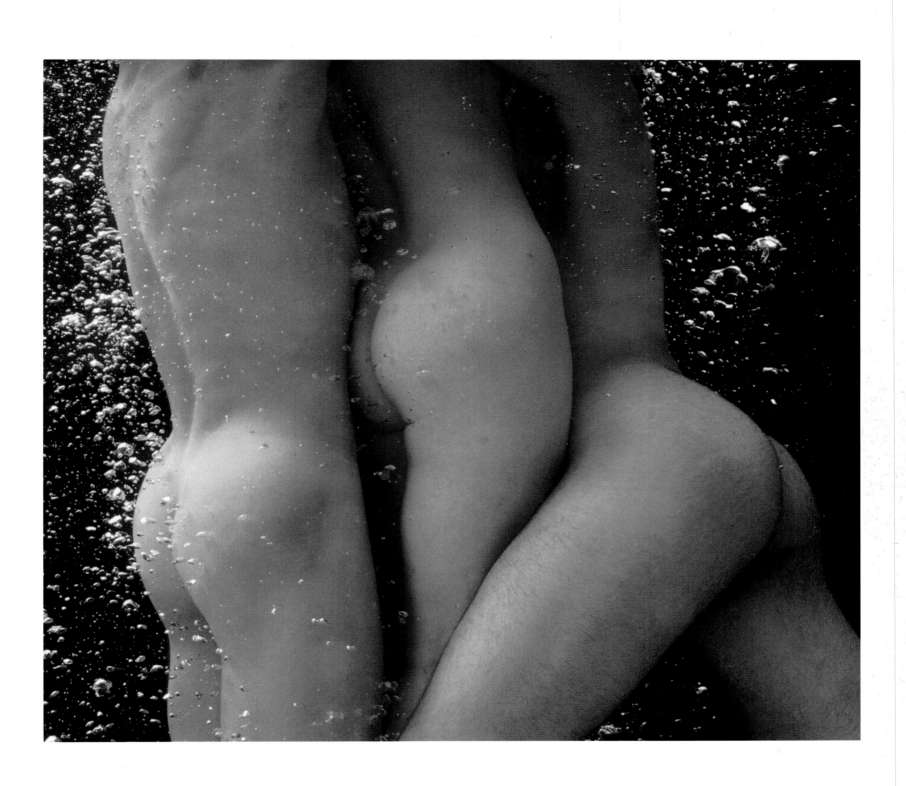

138

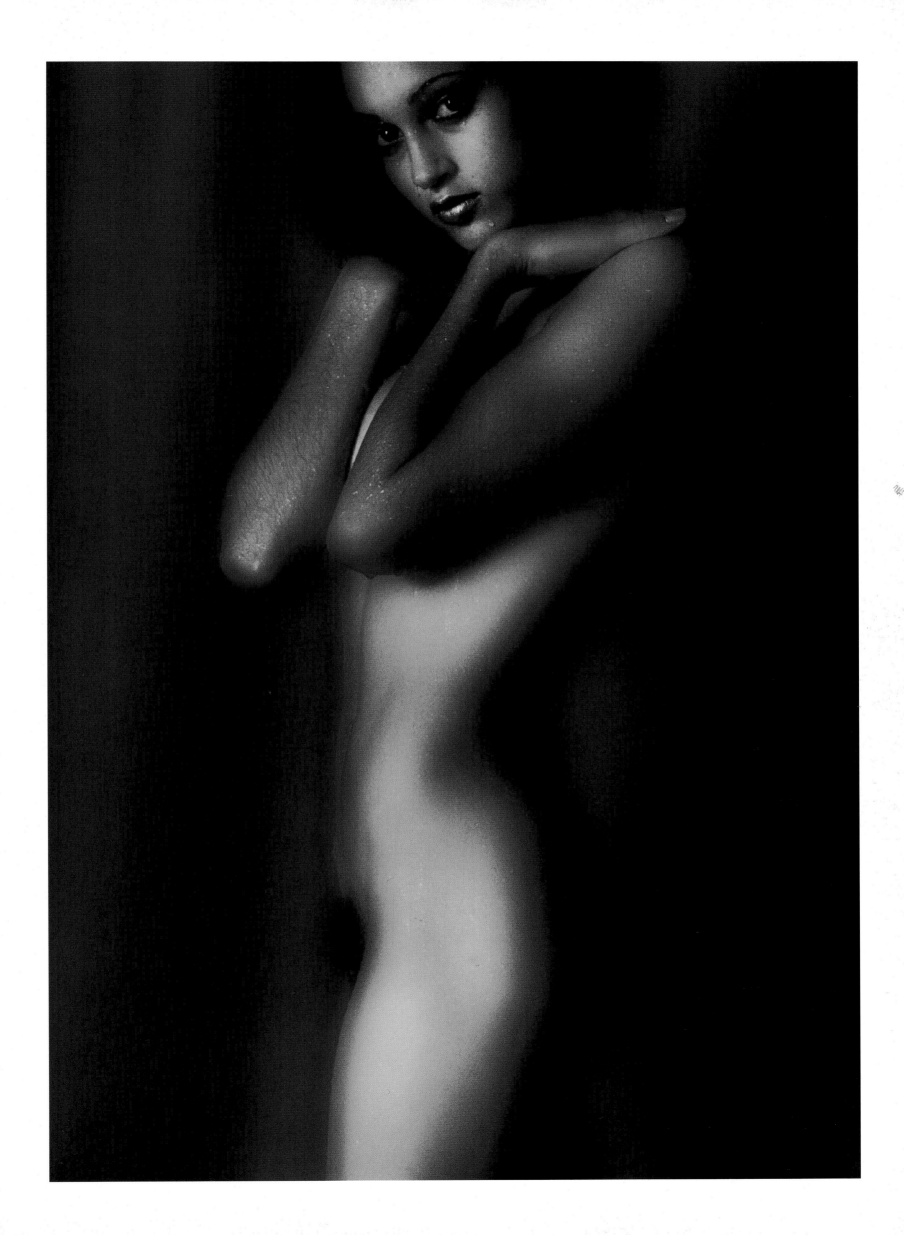

140

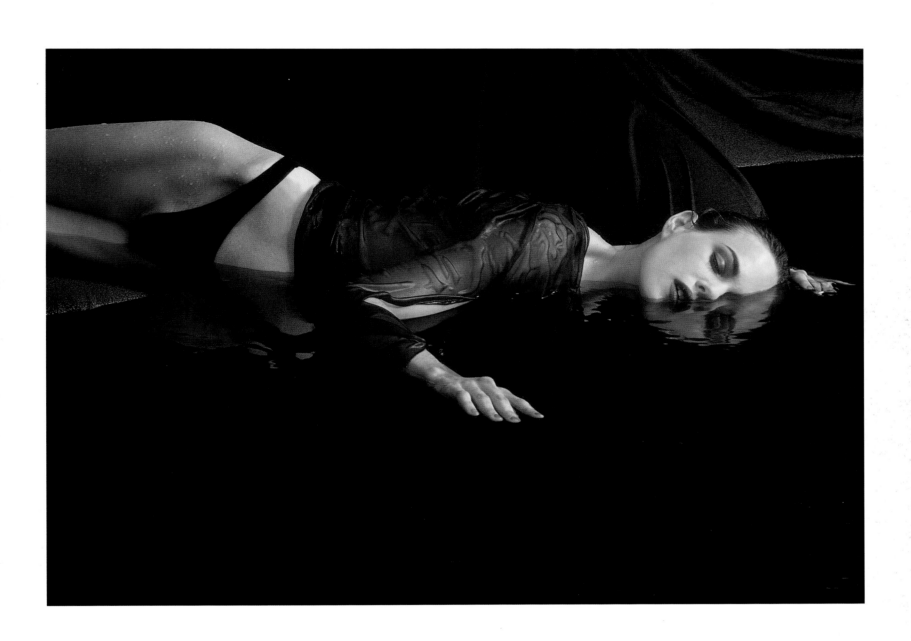

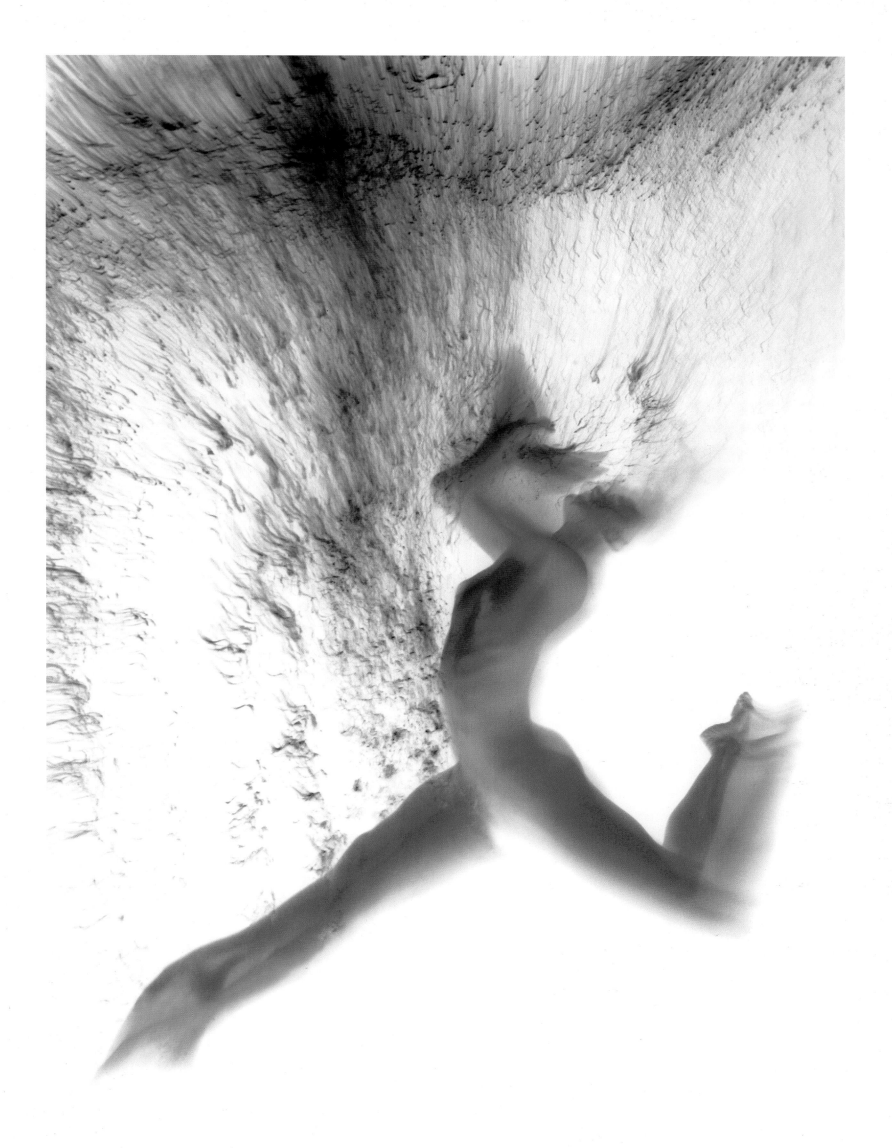

144

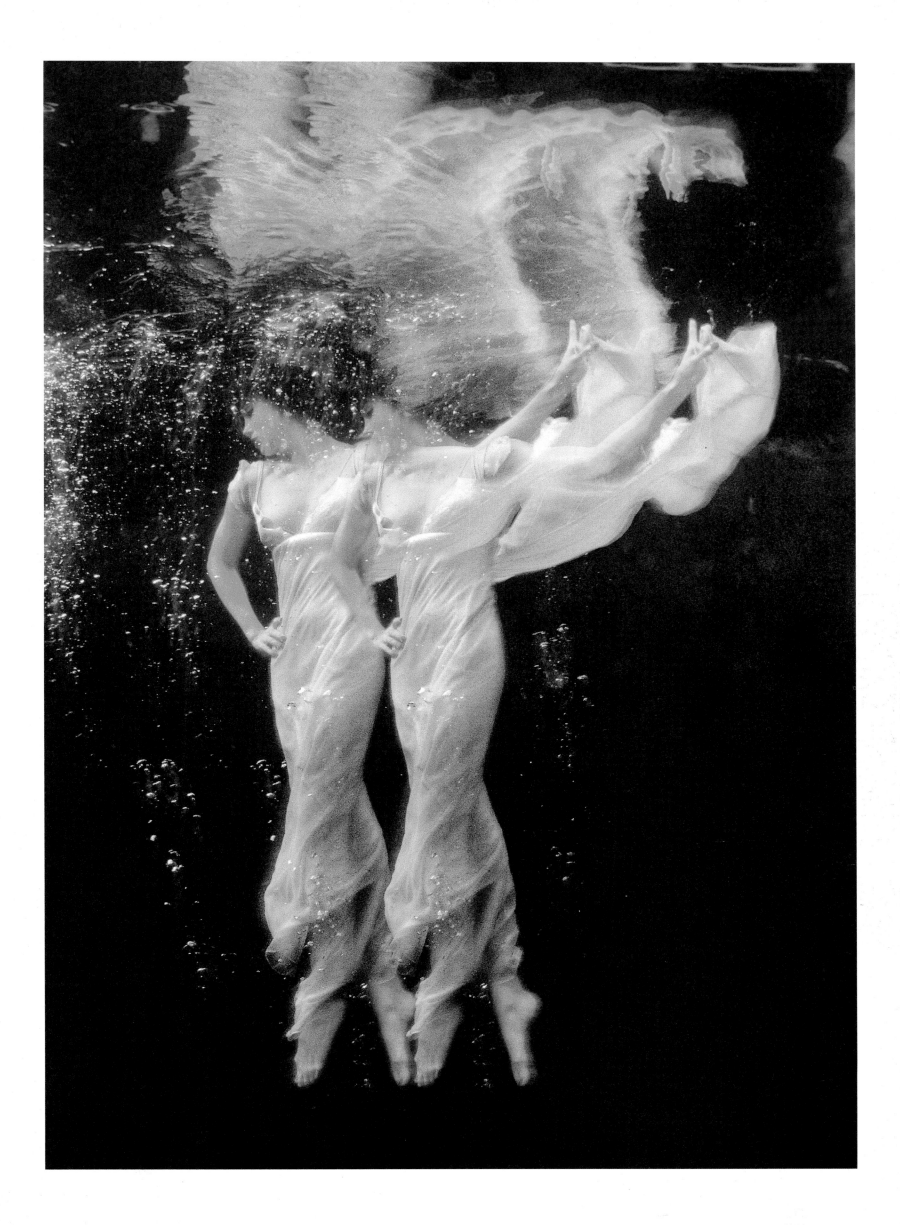

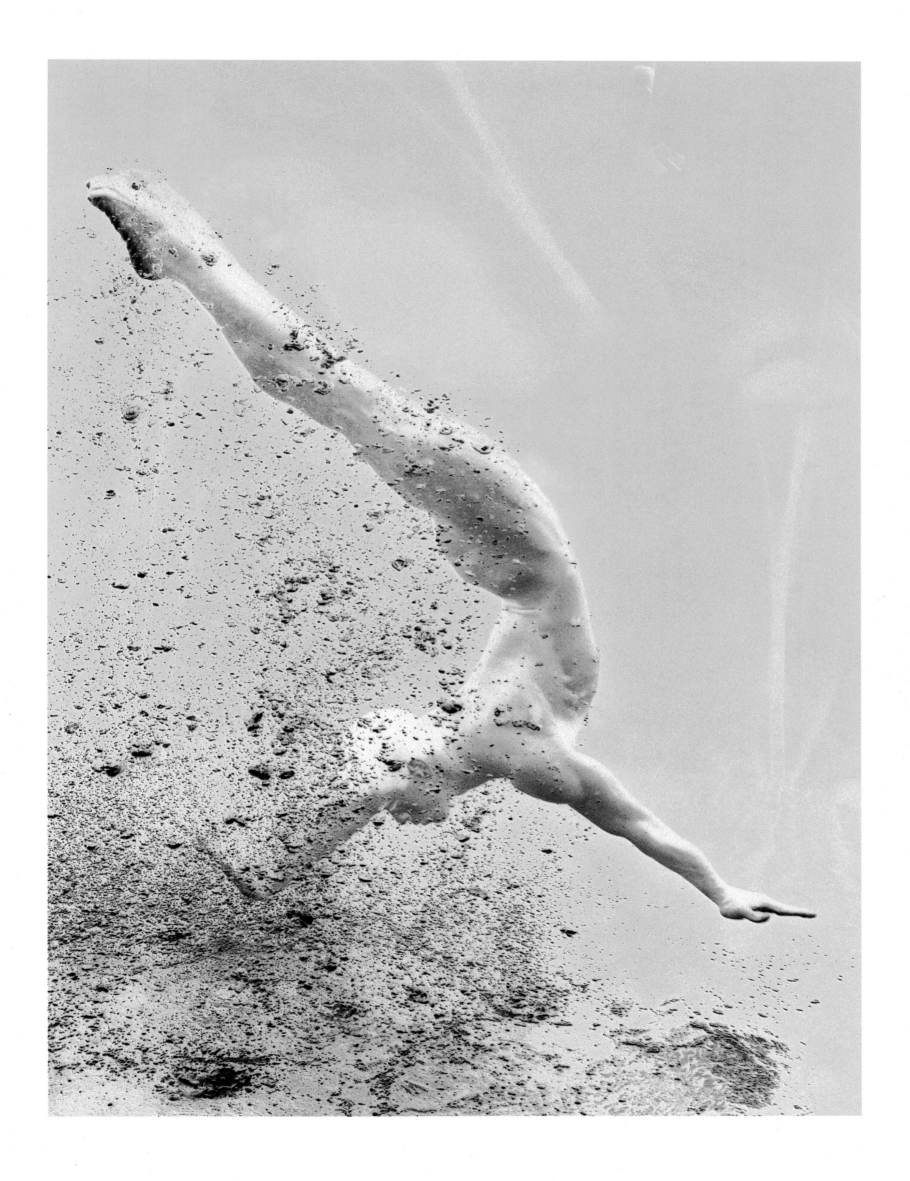

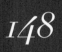

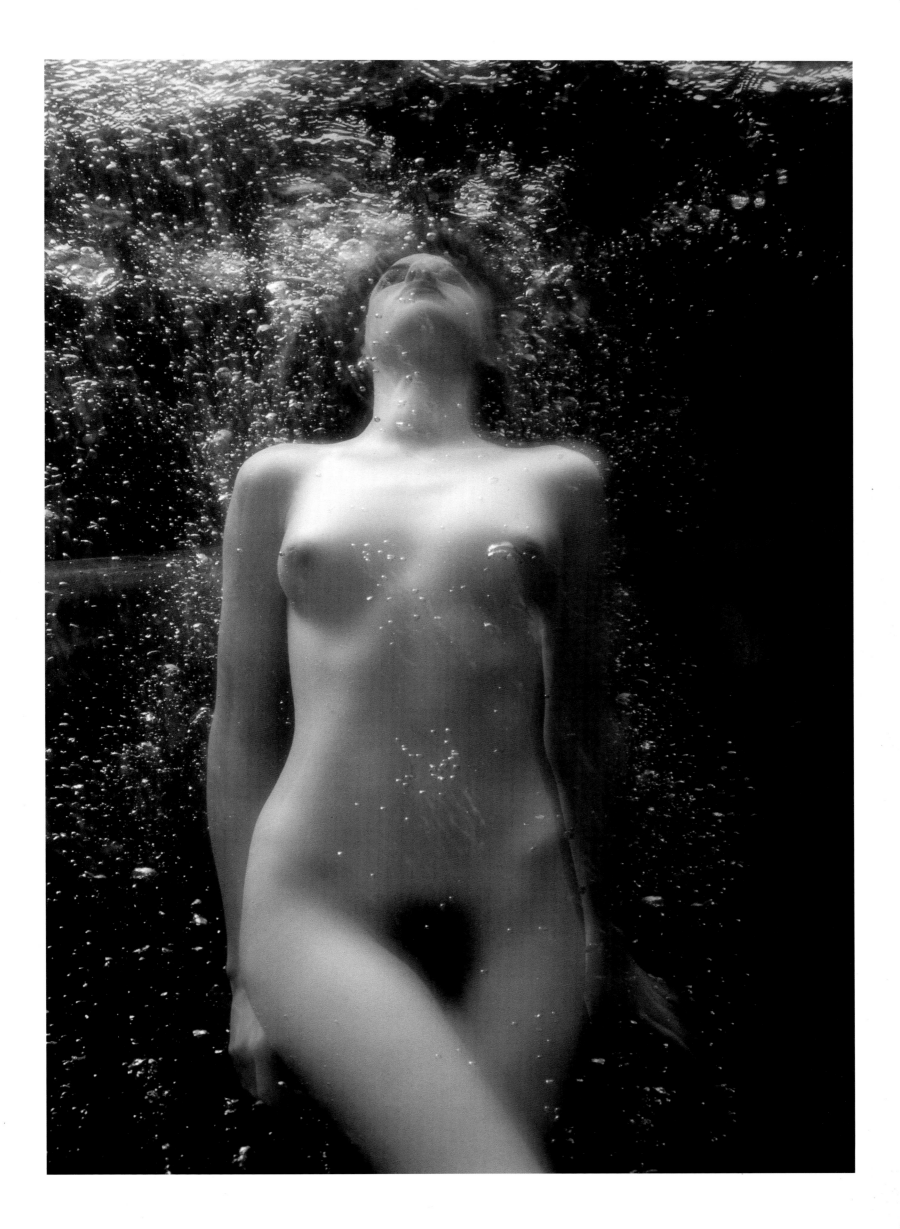

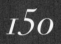

15o

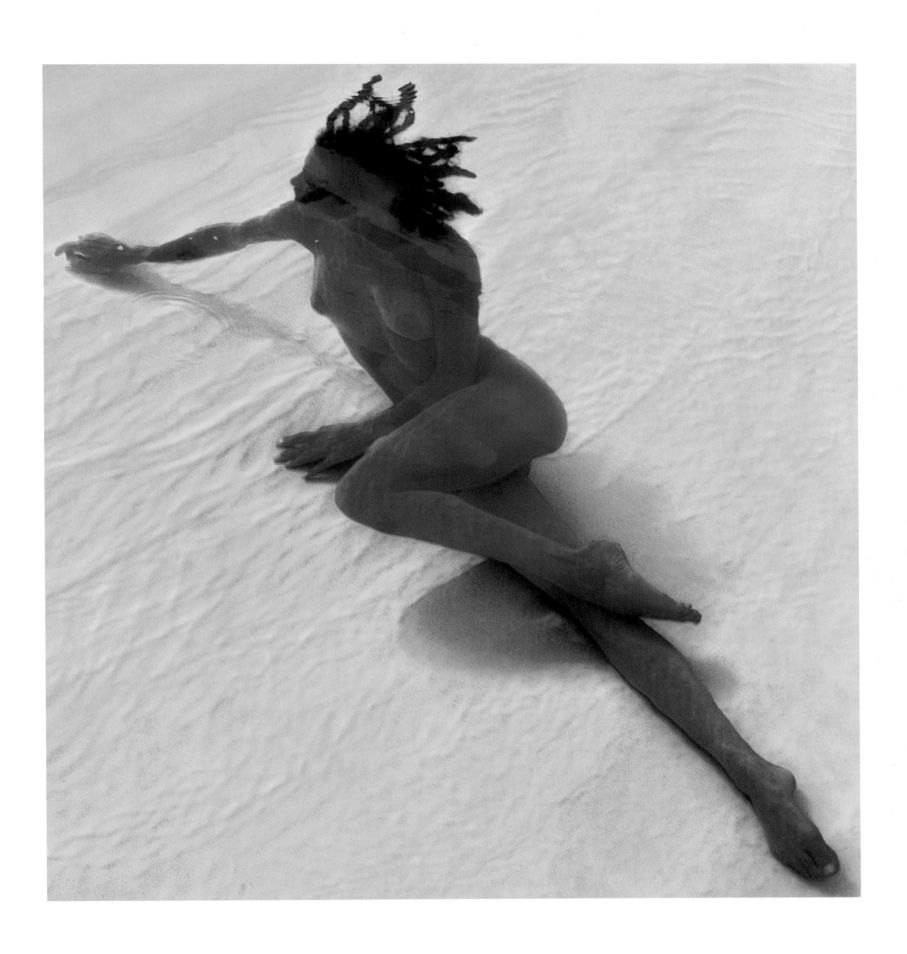

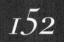

152

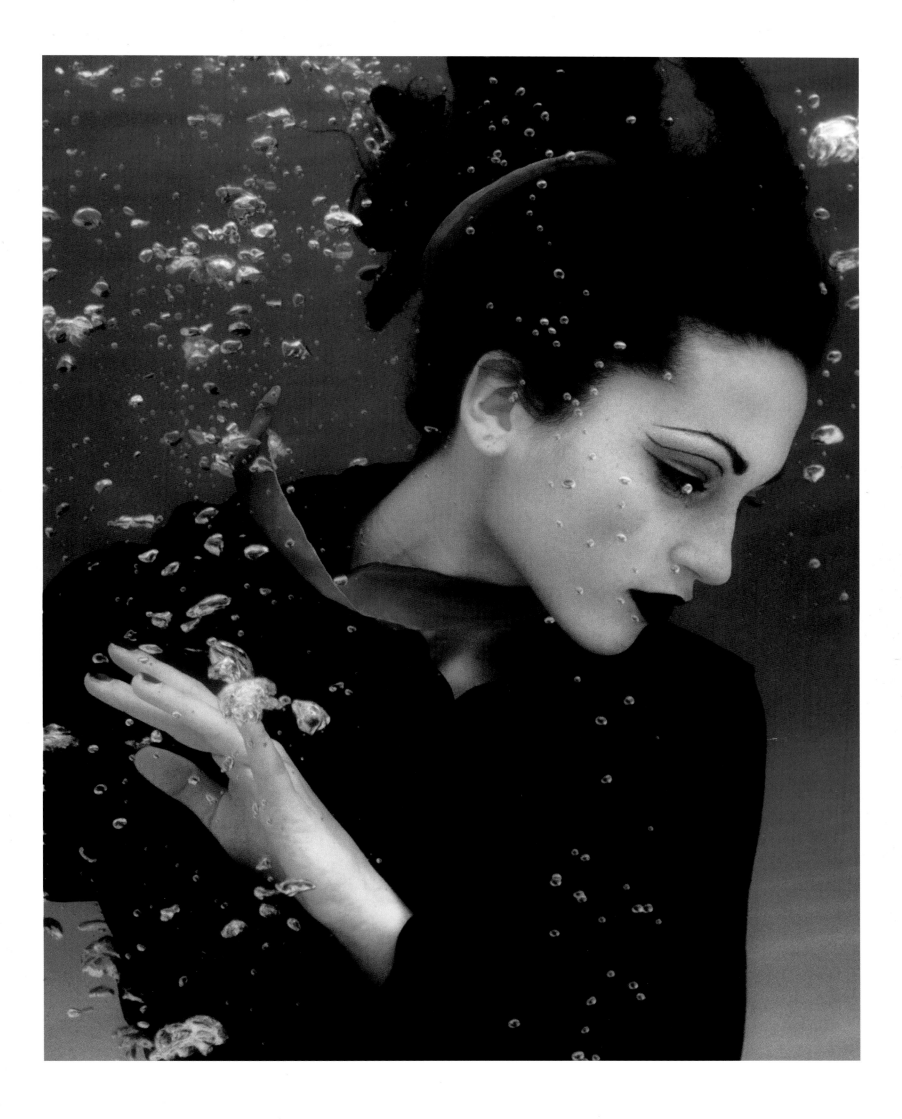

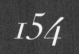

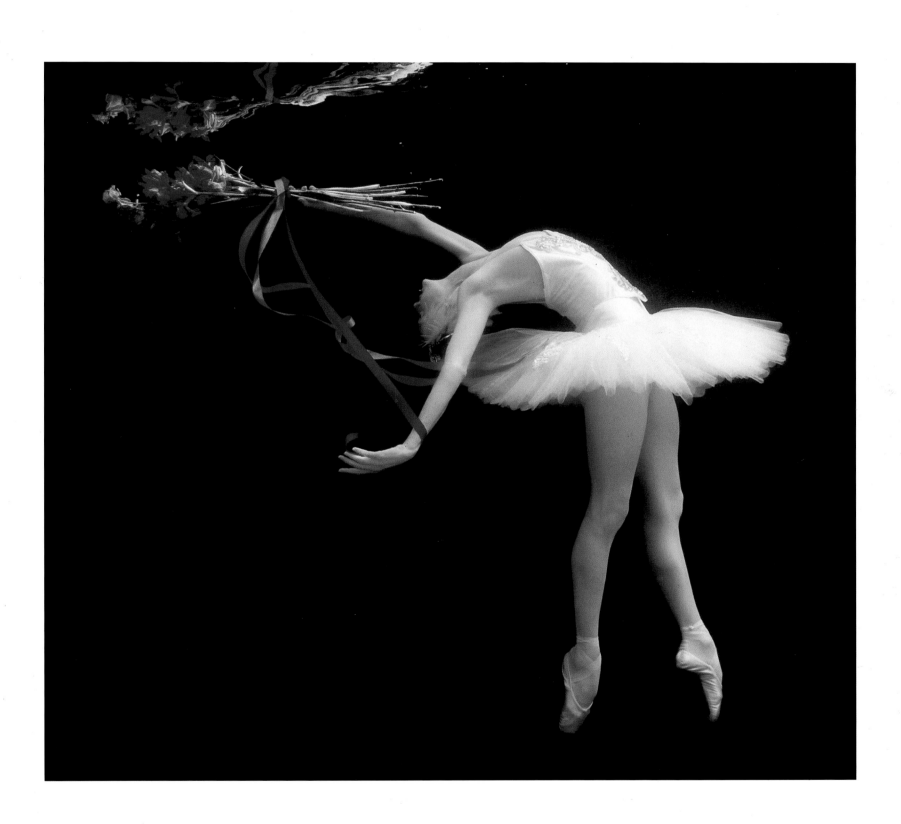

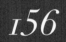

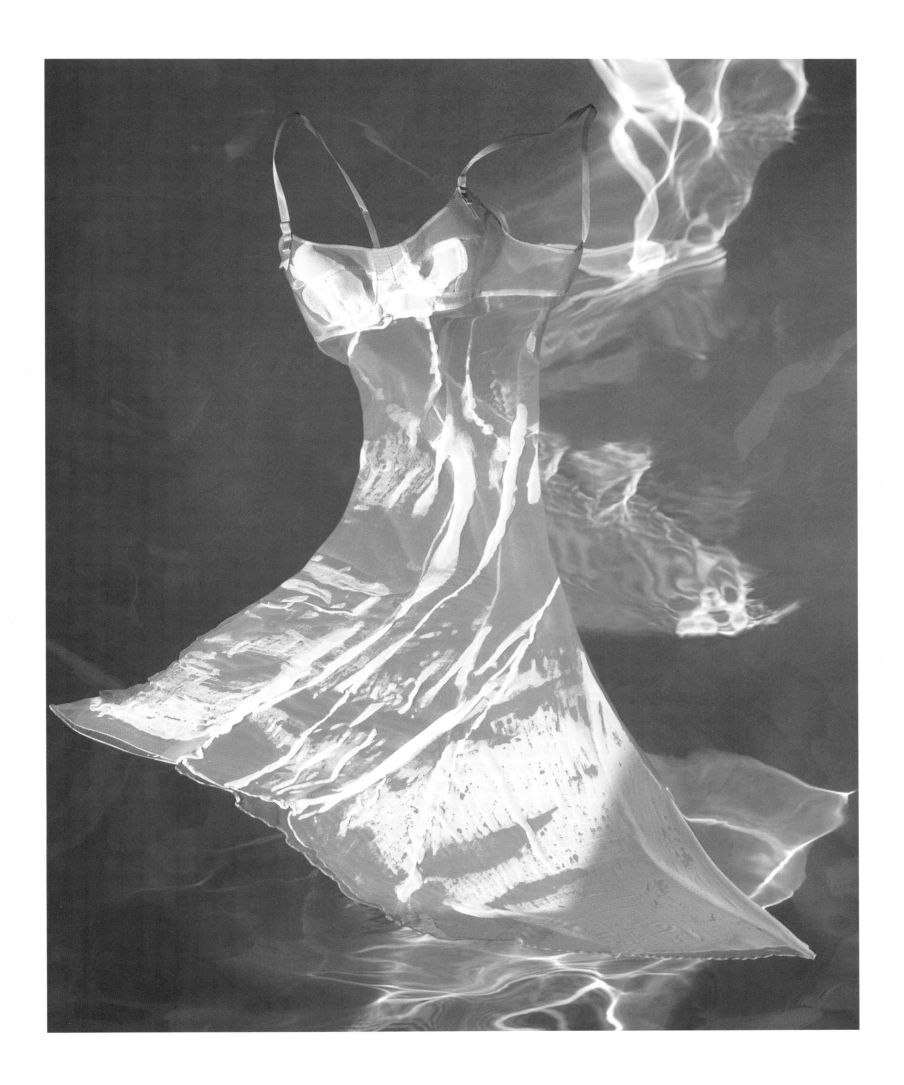

158

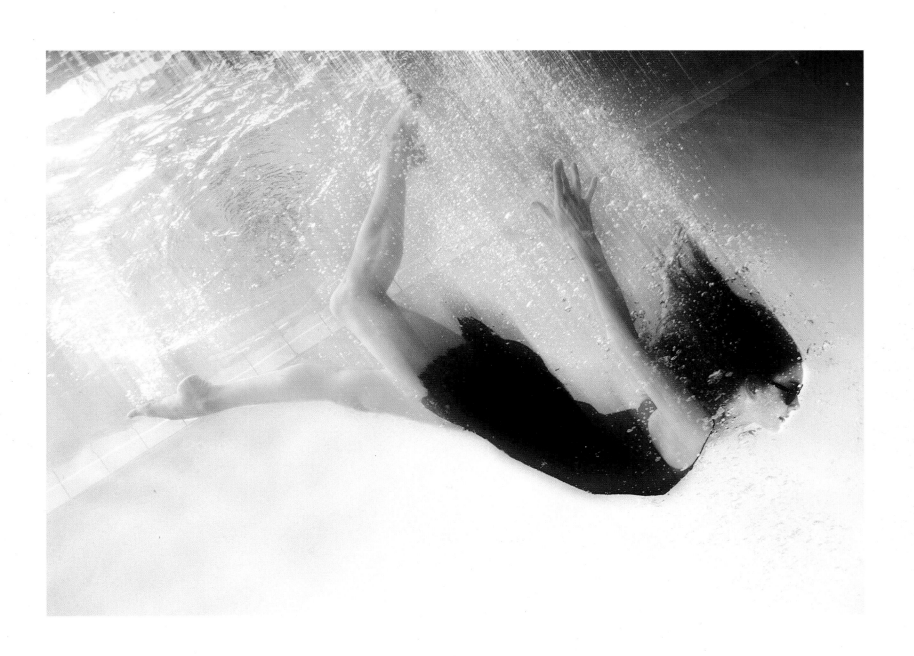

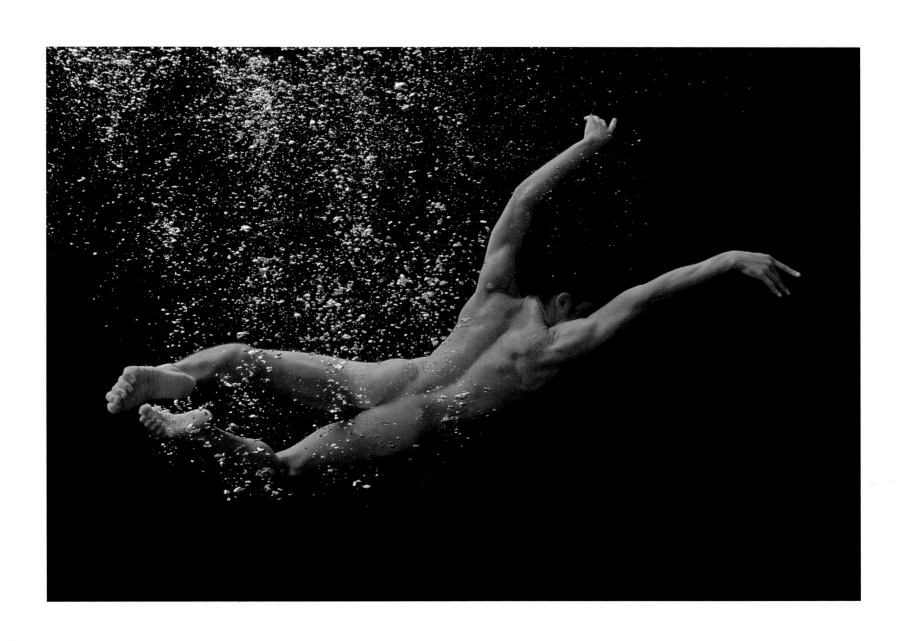

162

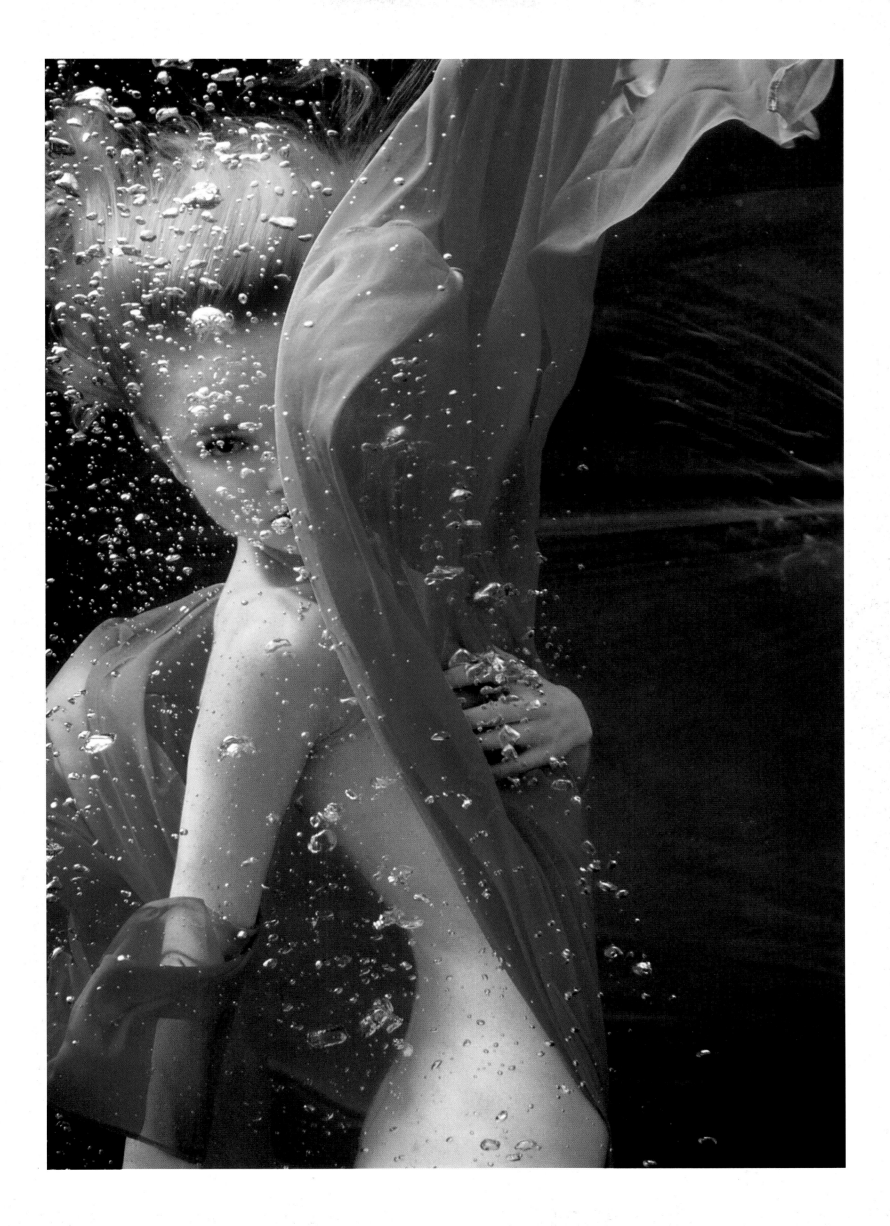

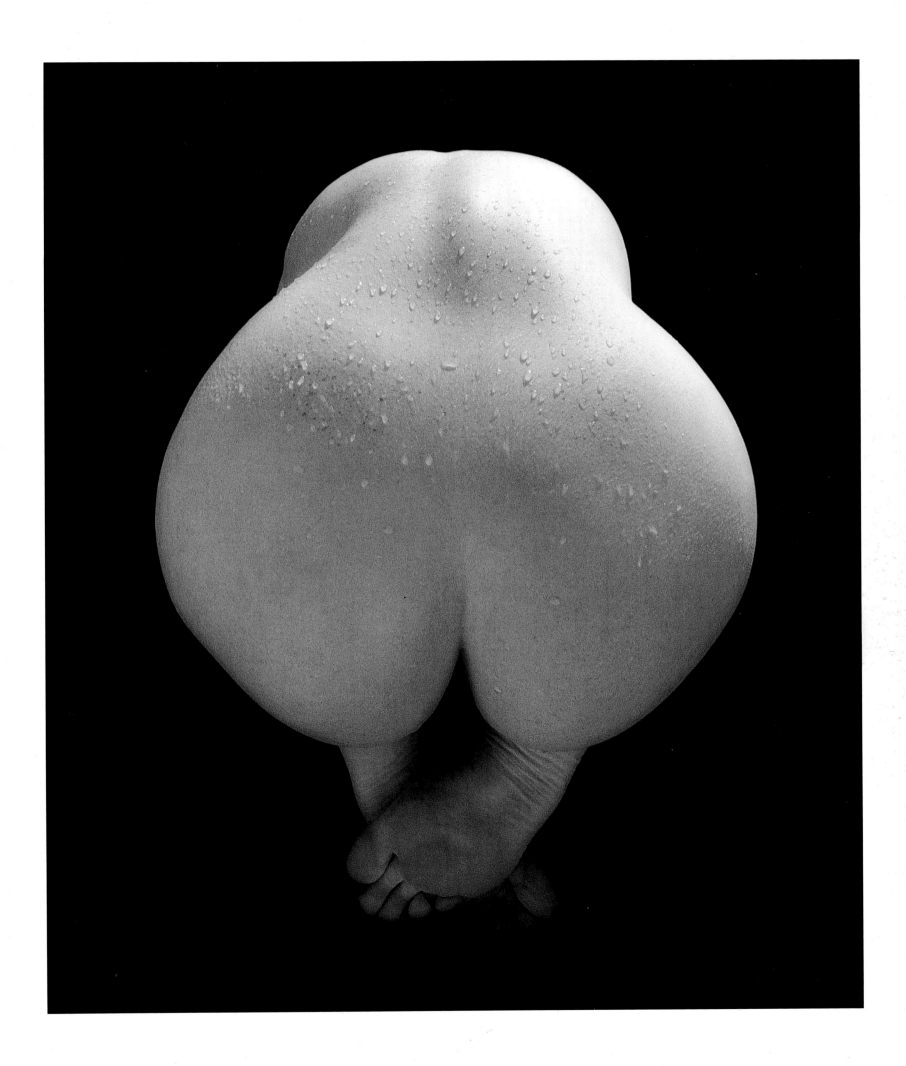

166

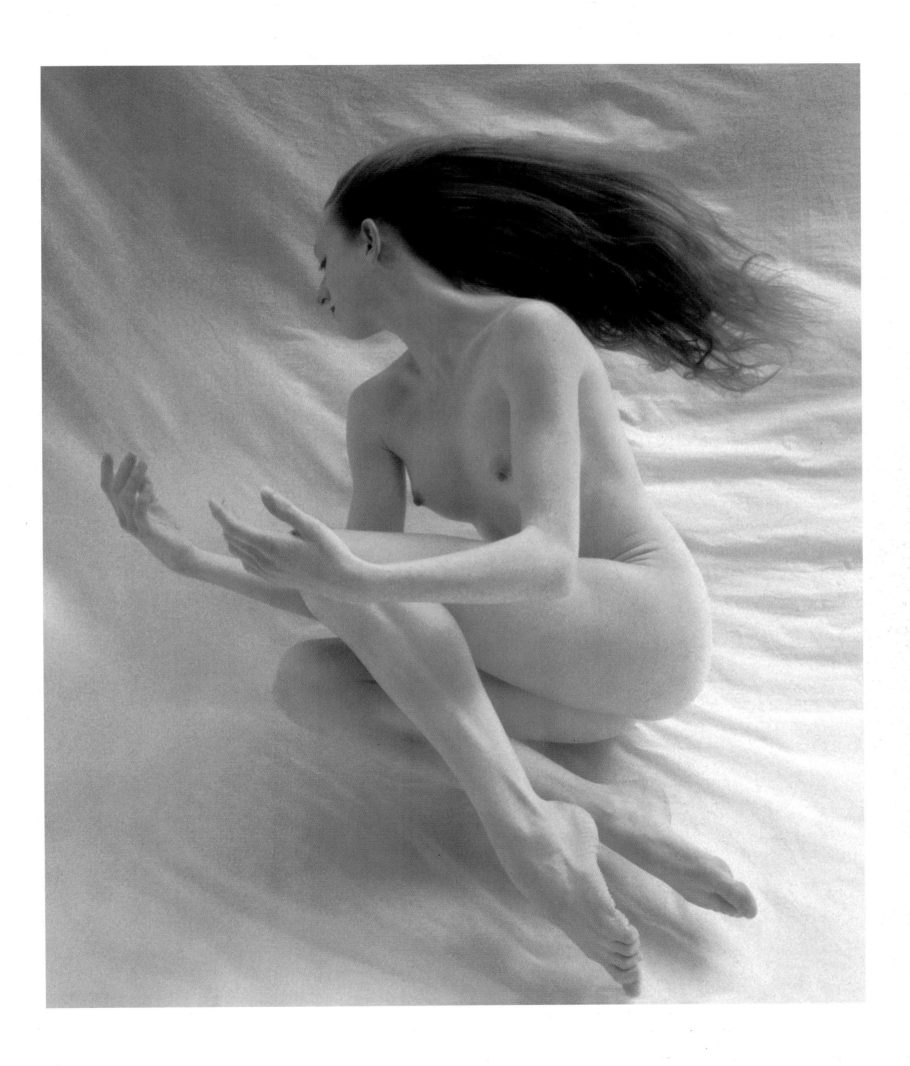

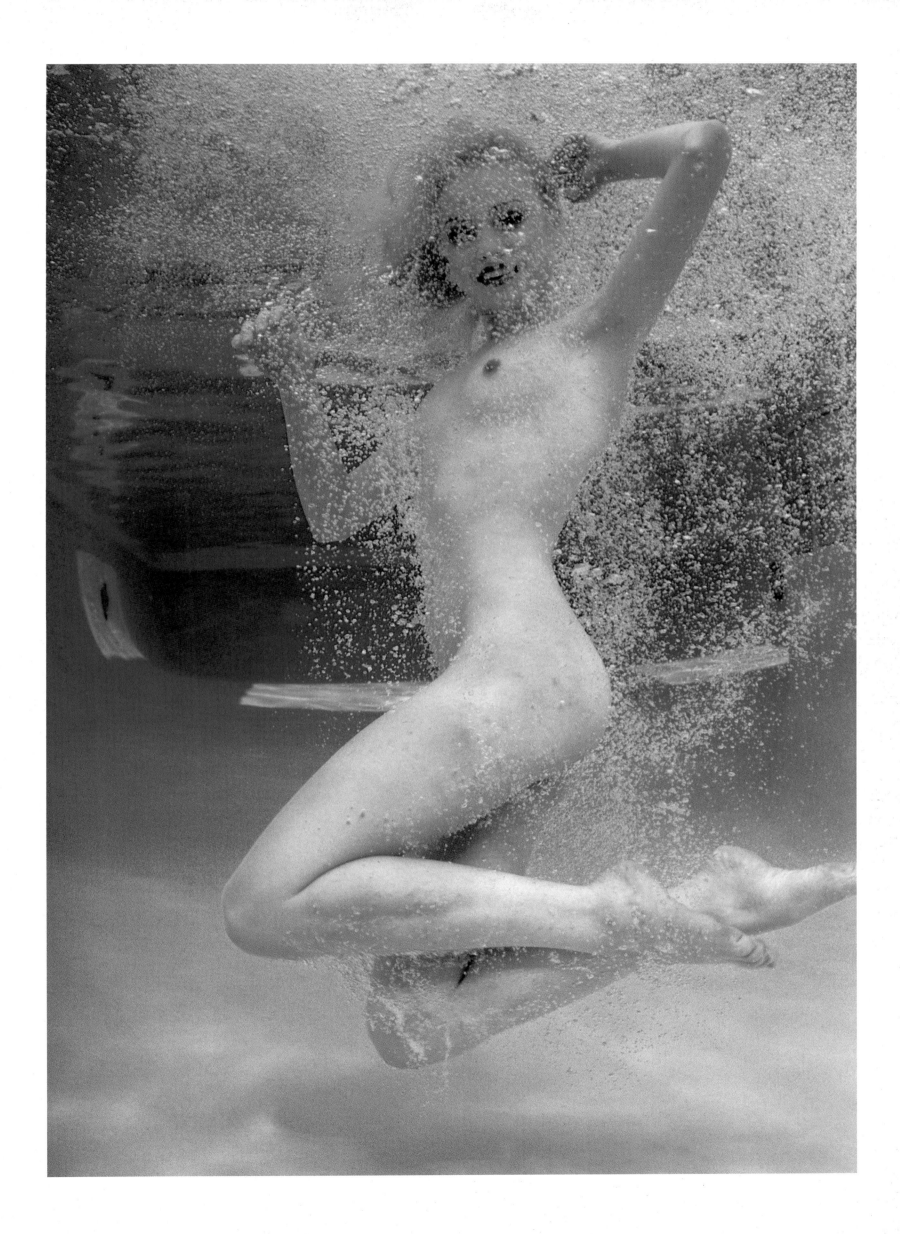

170

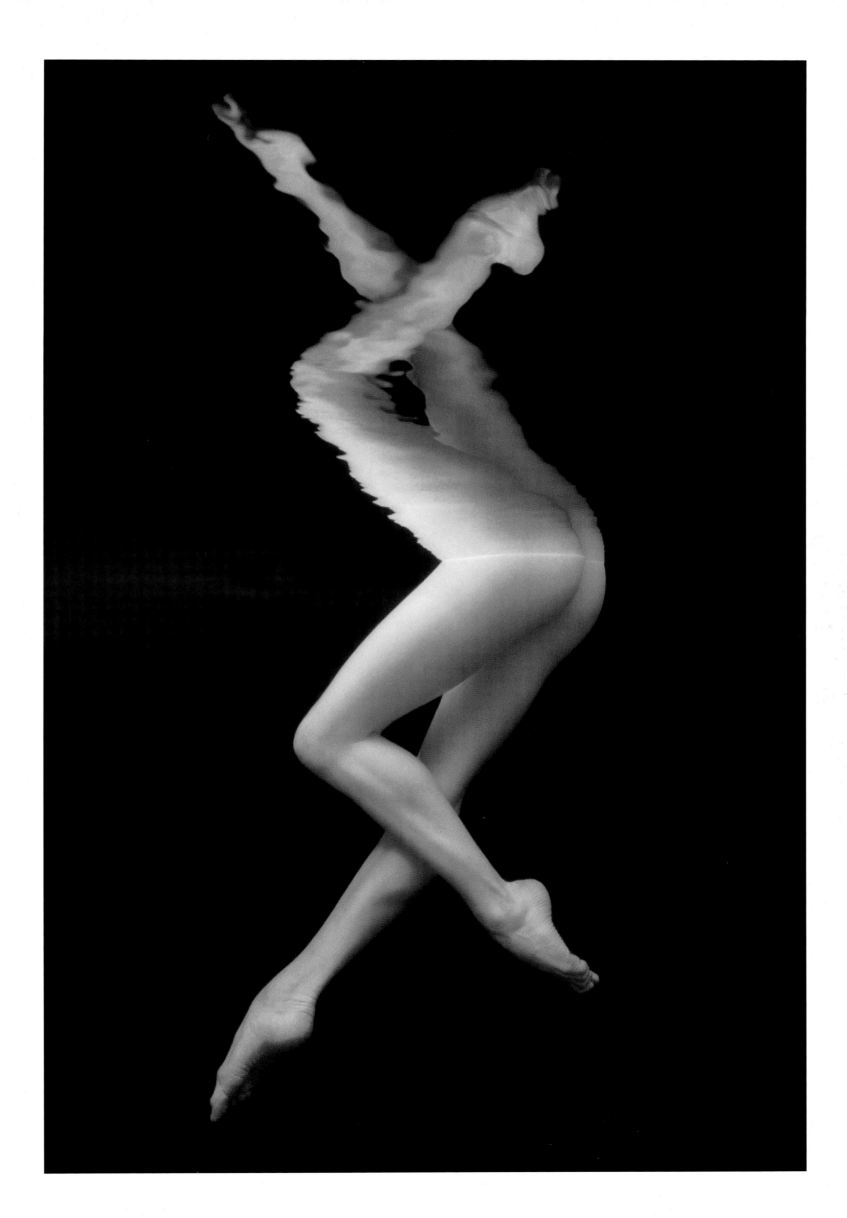

172

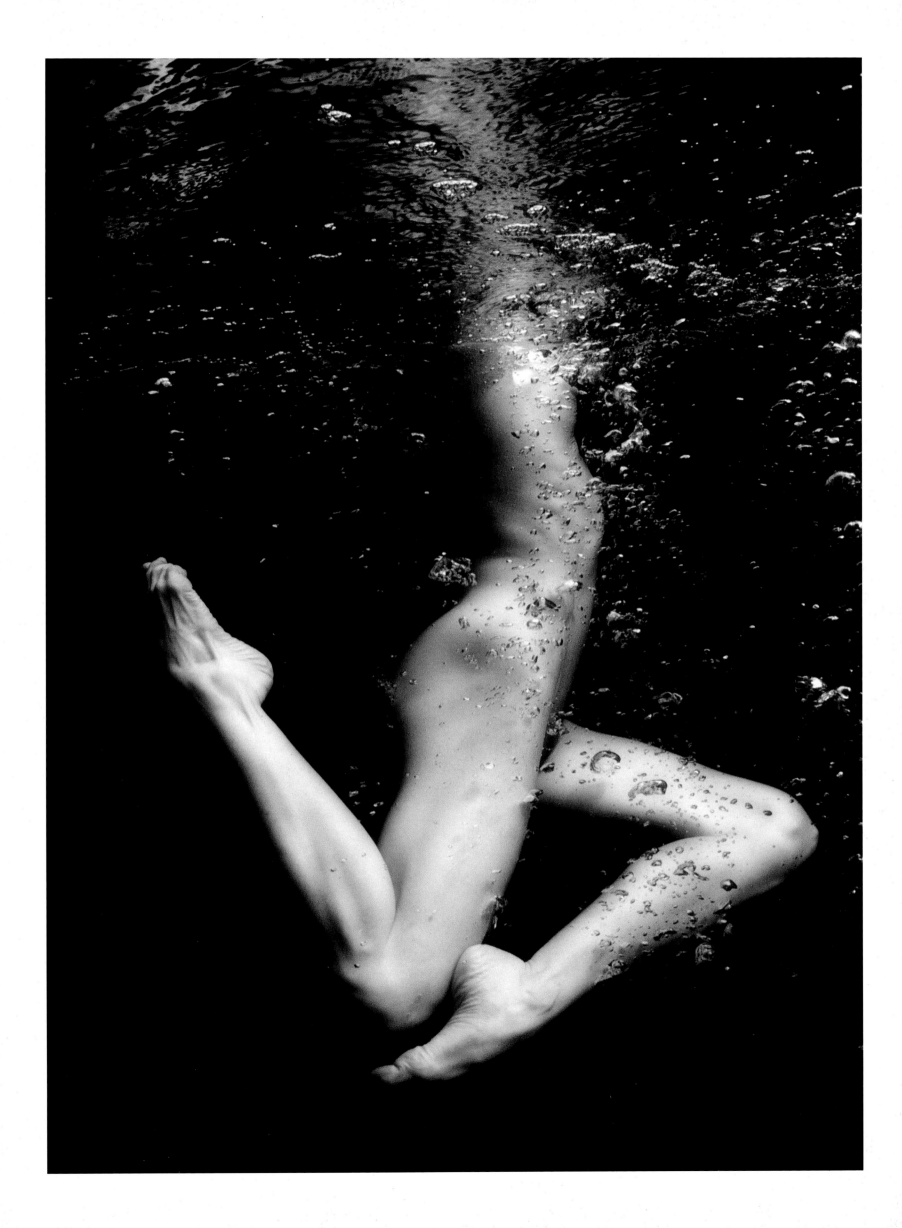

174

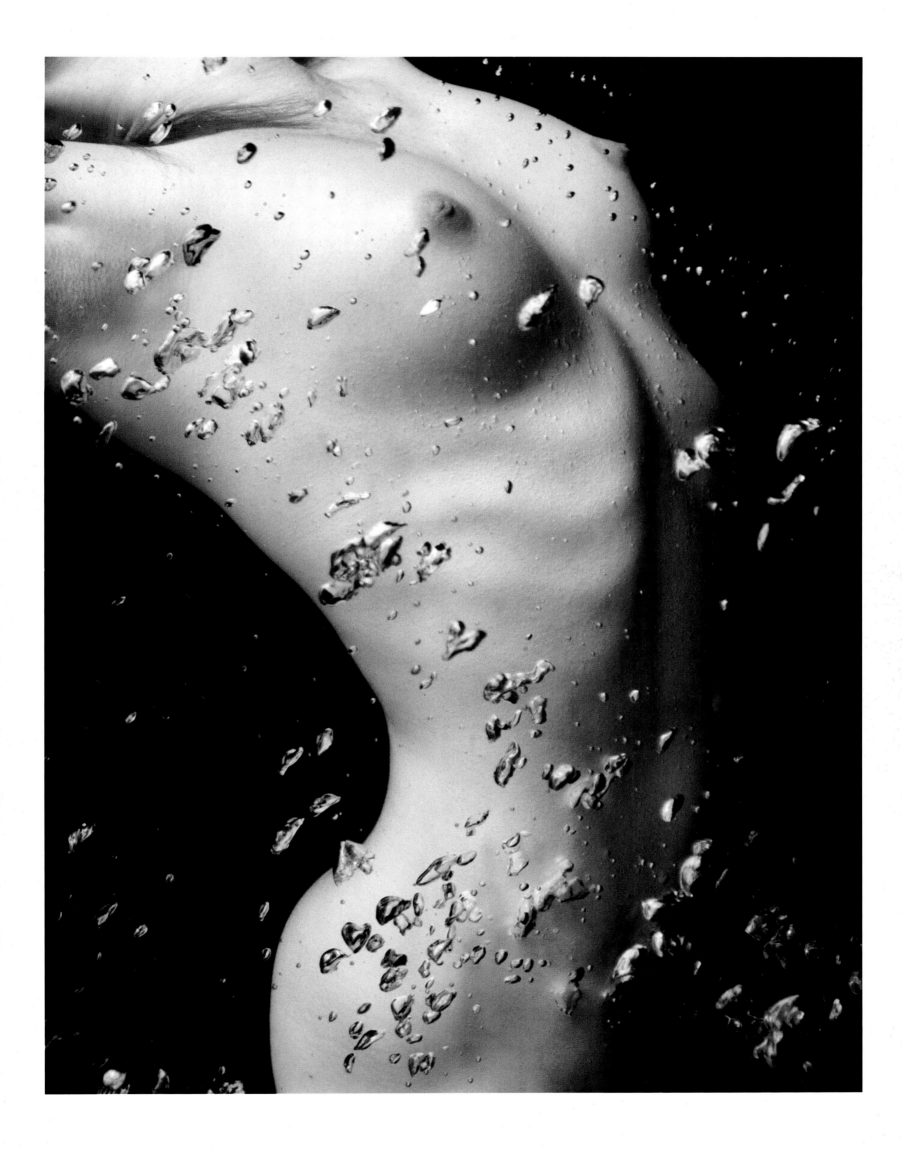

176

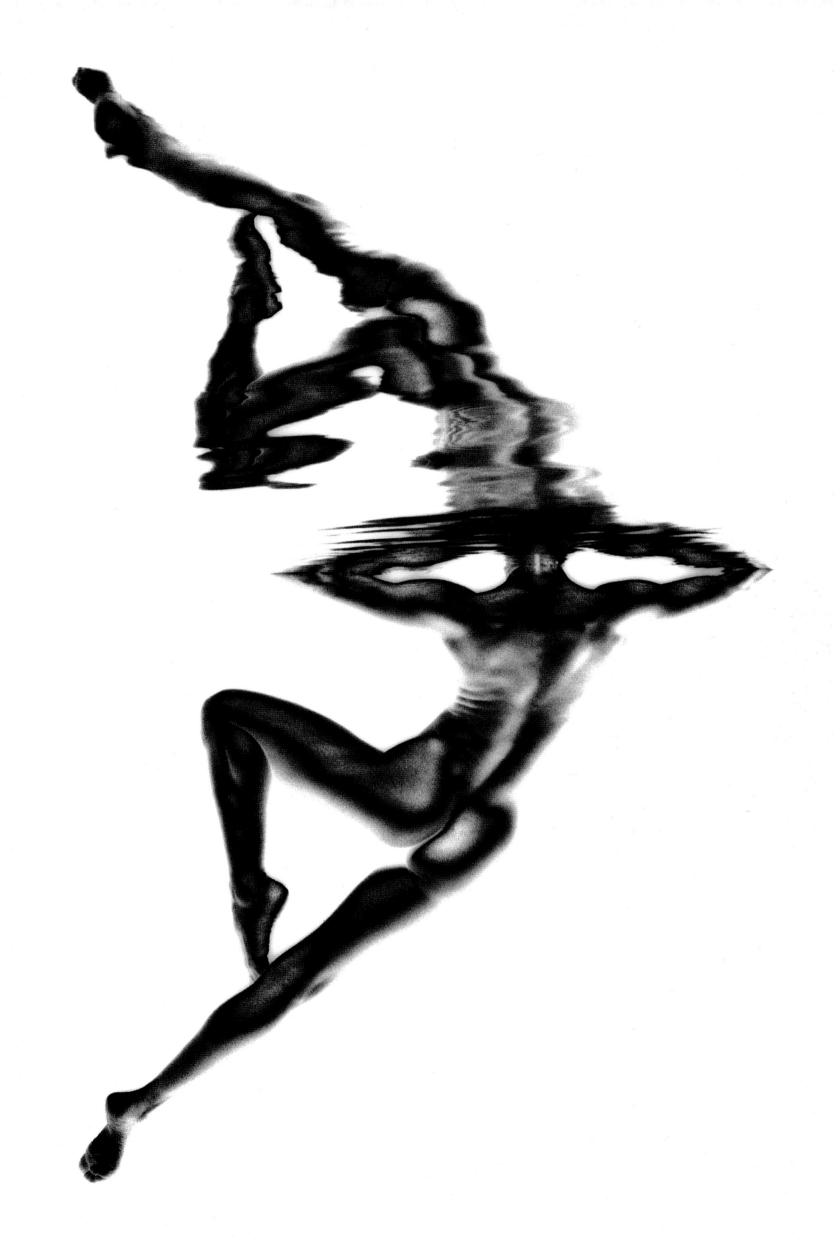

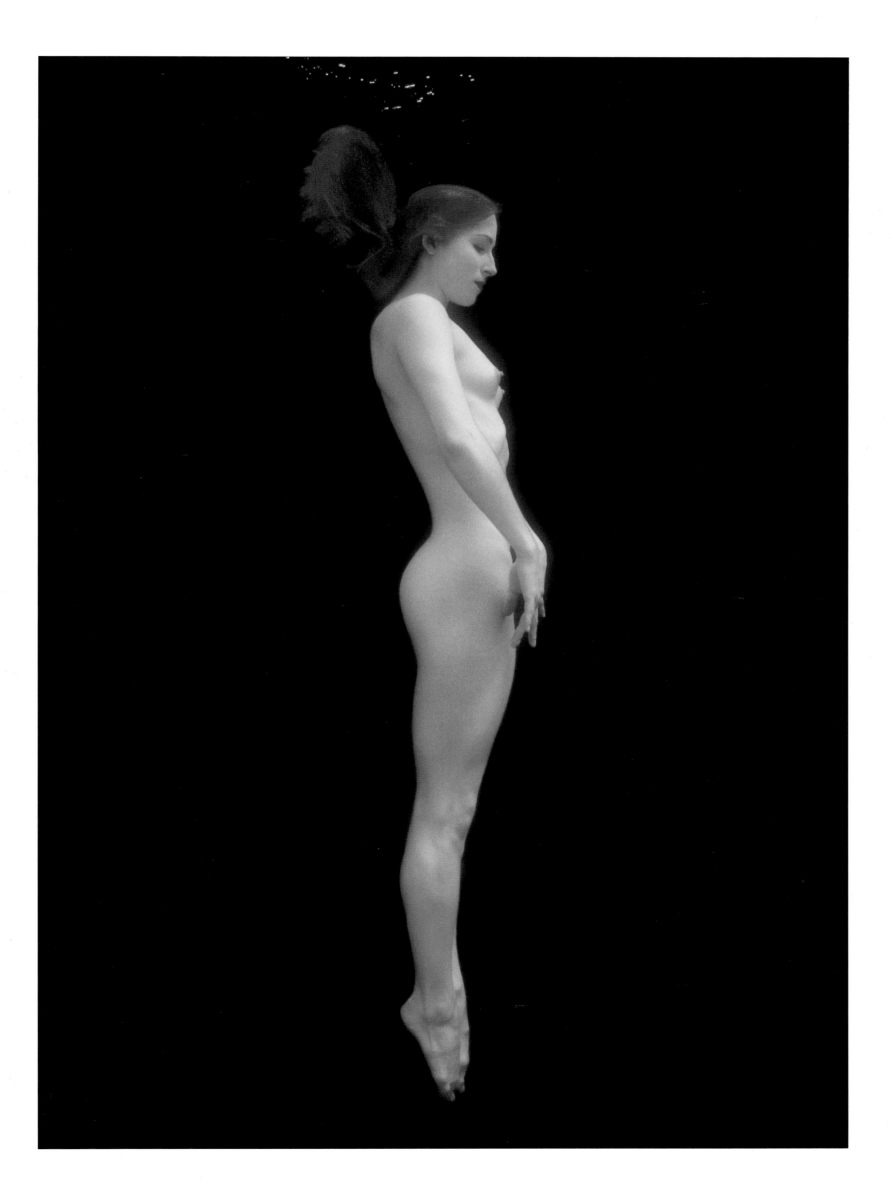

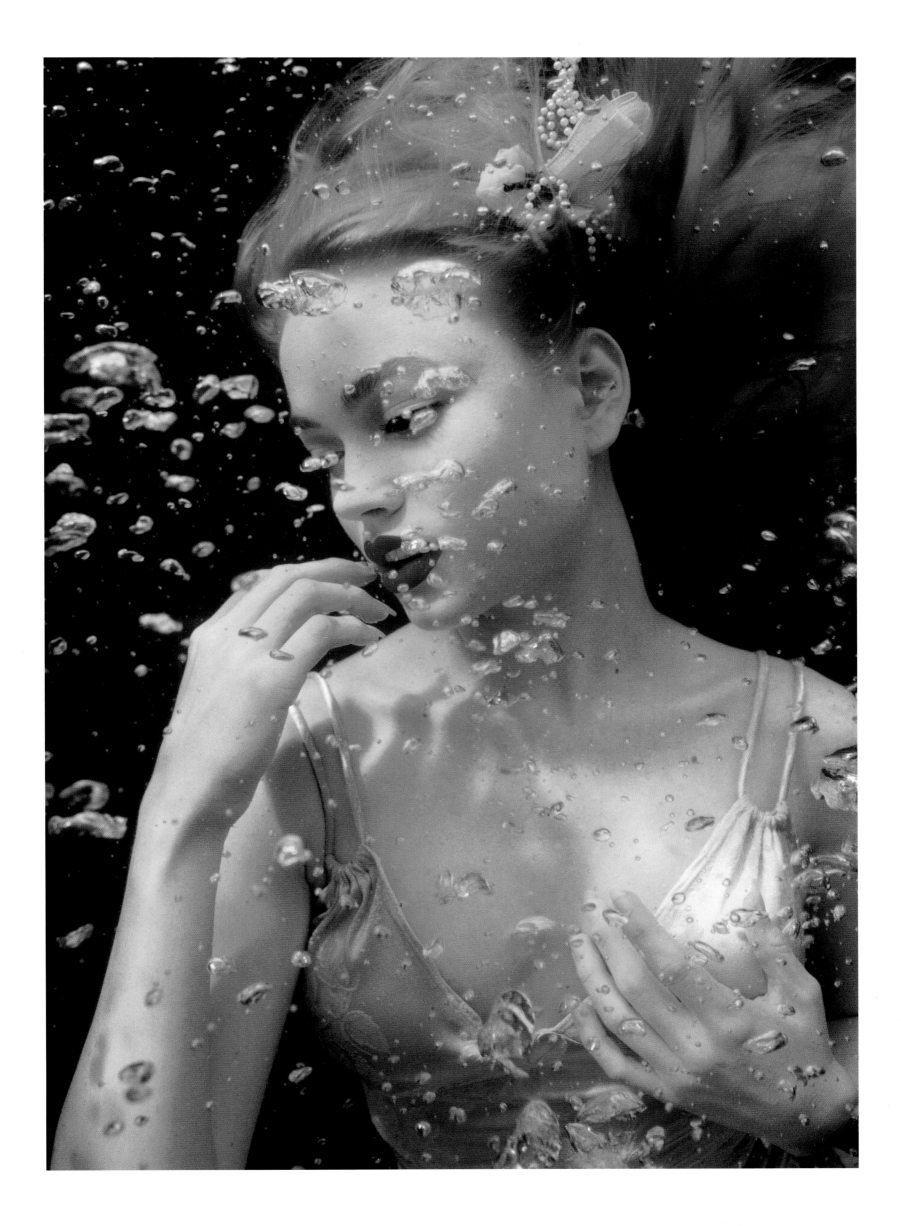

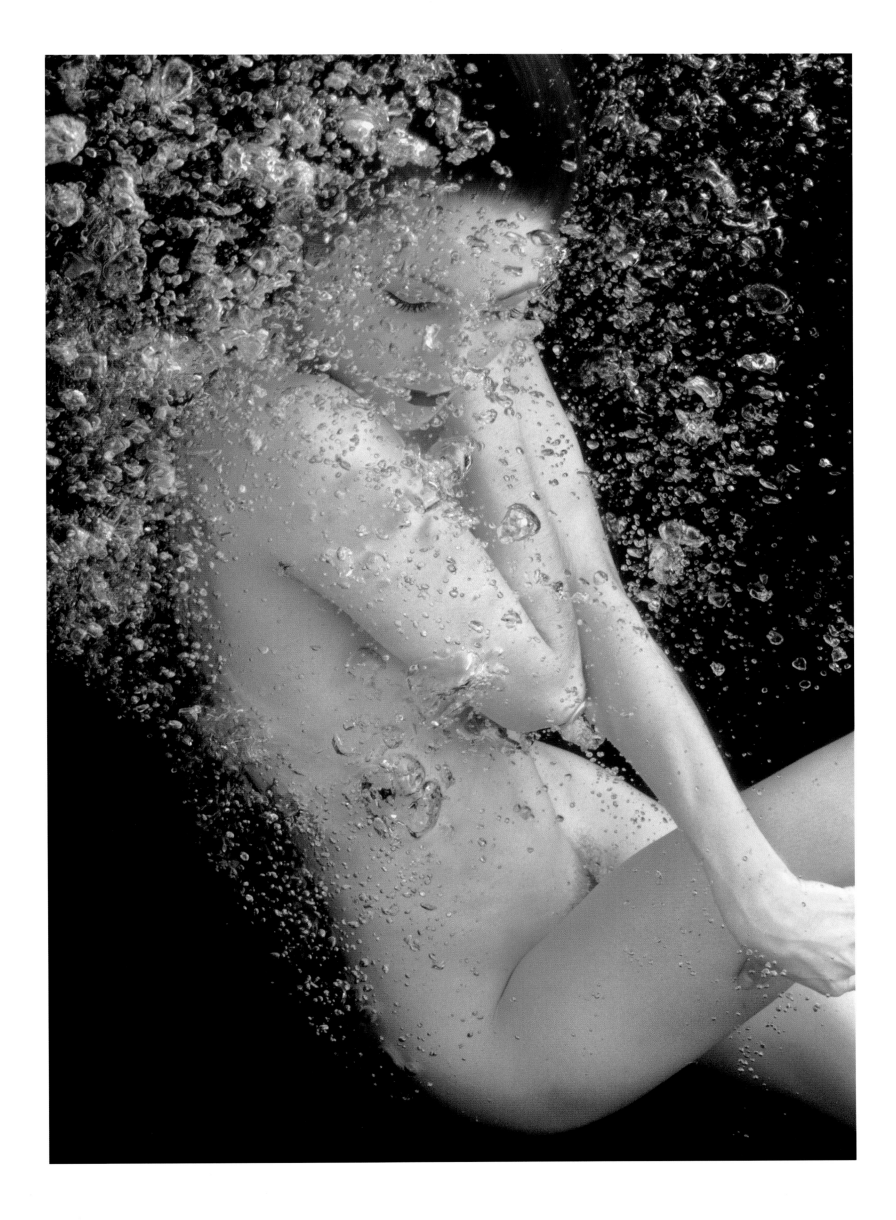

184

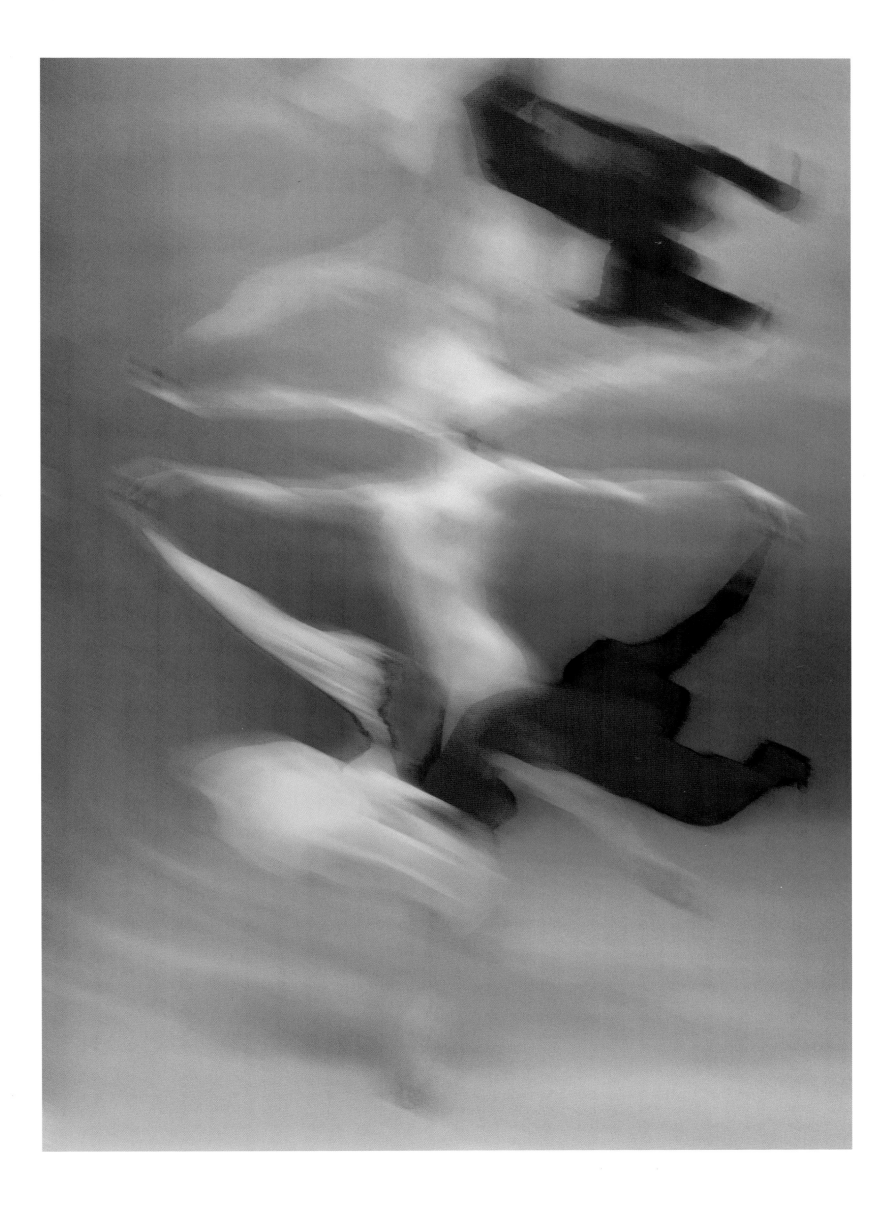

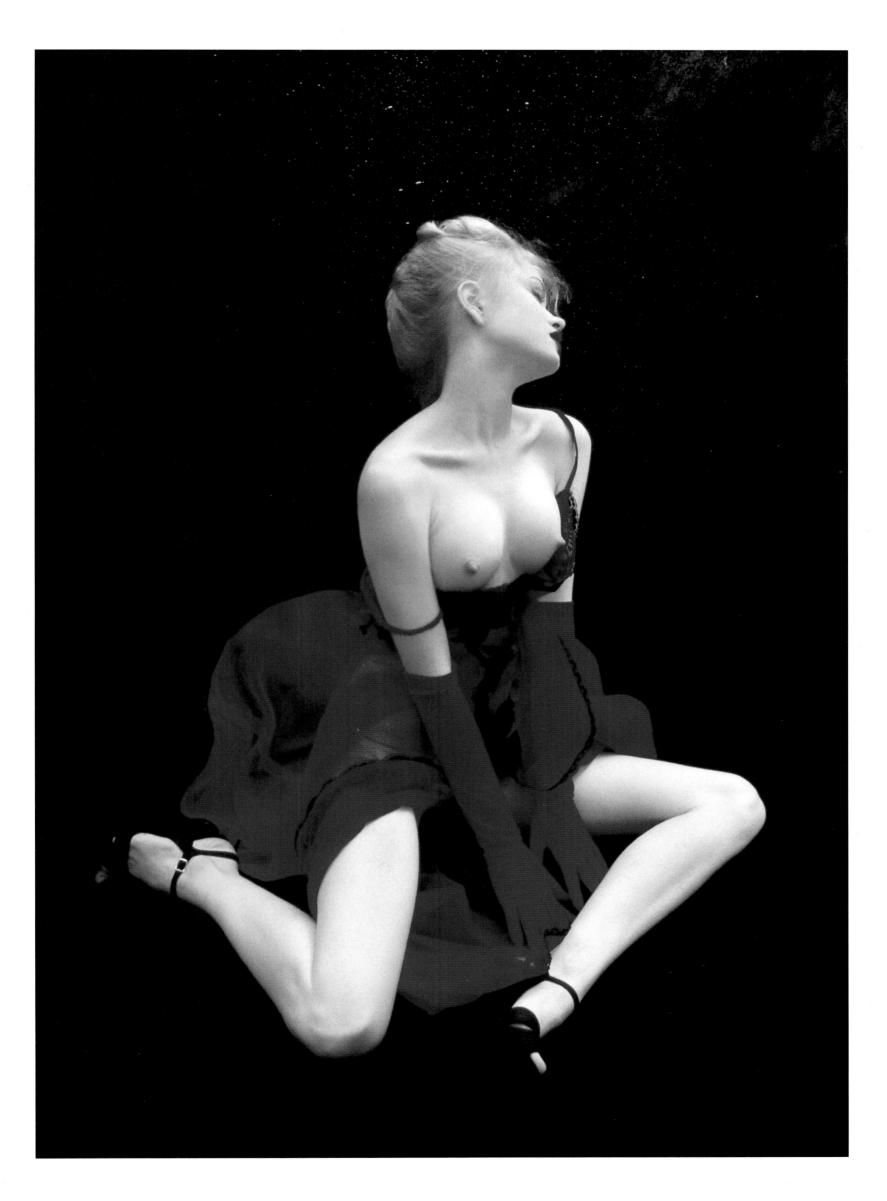

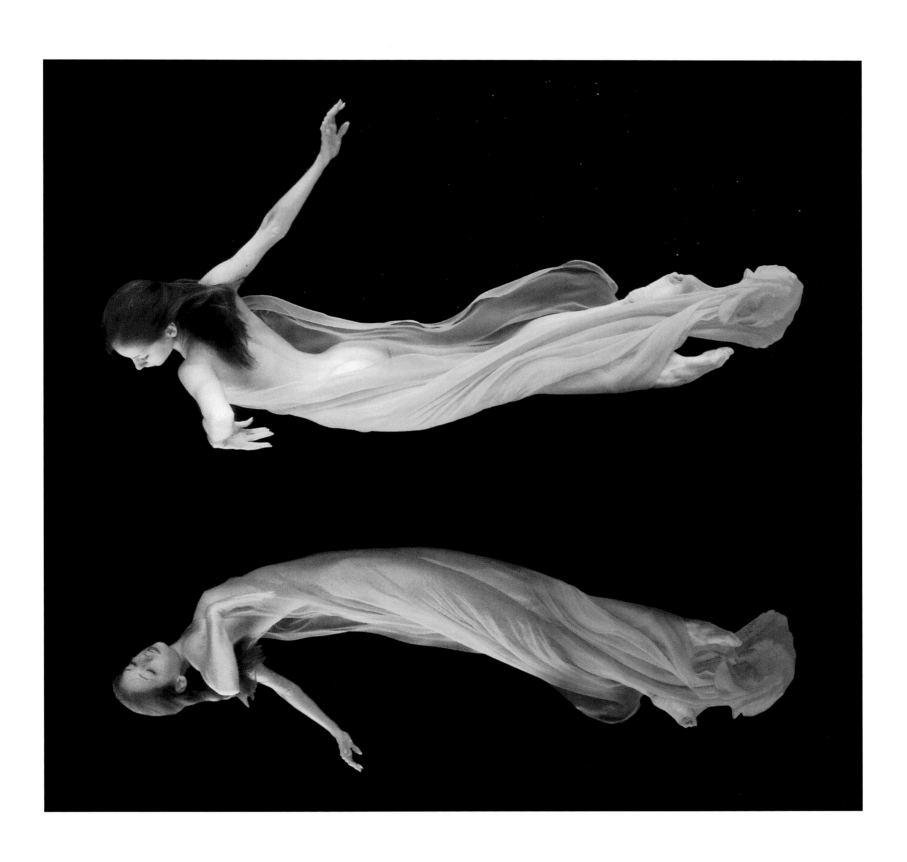

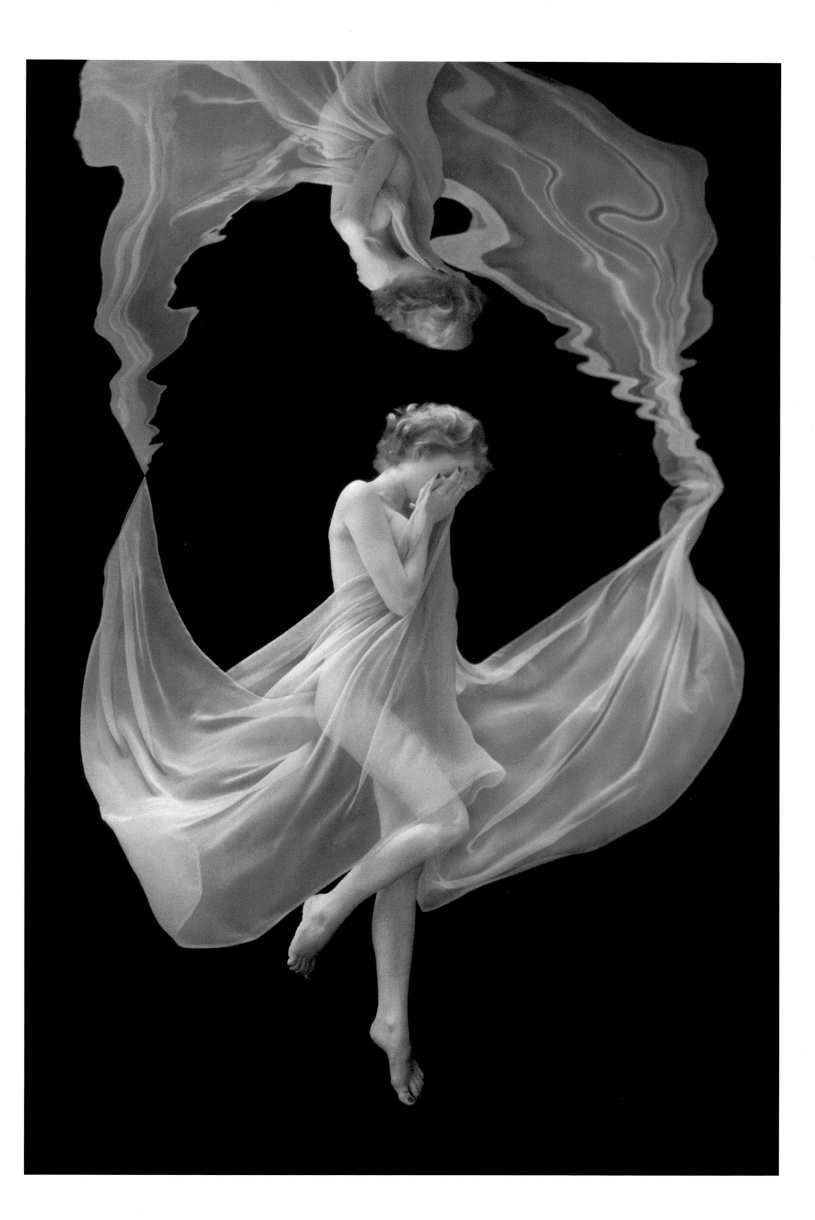

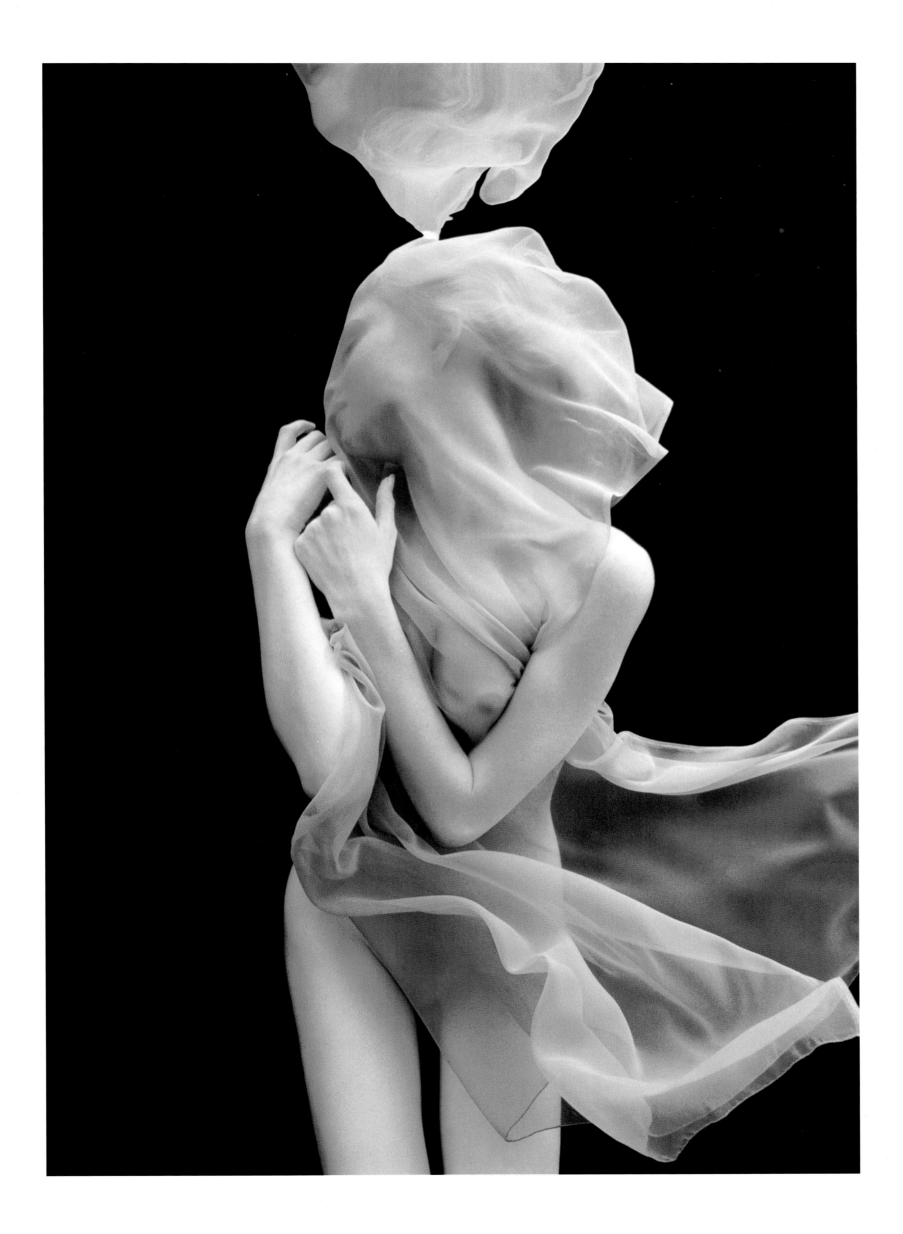

194

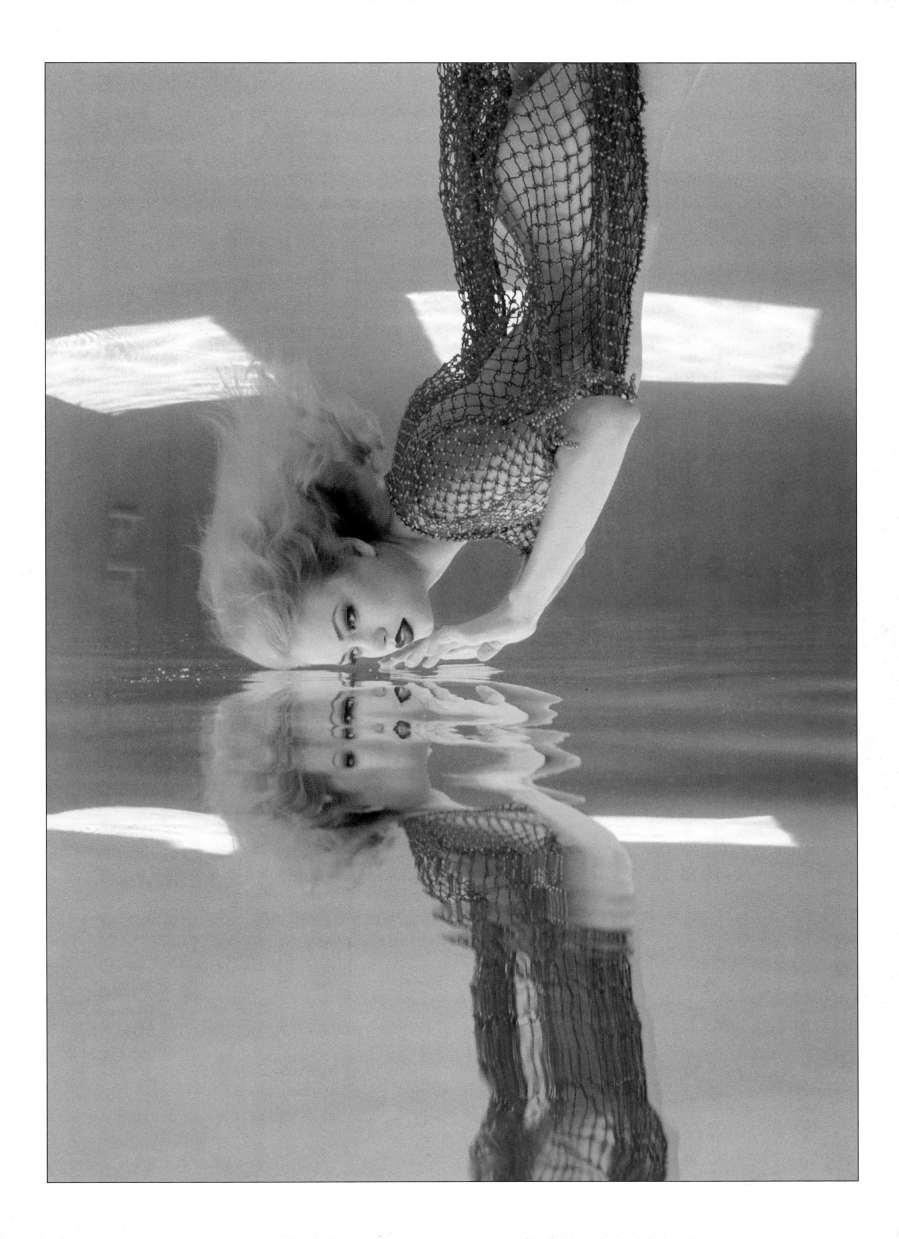

196

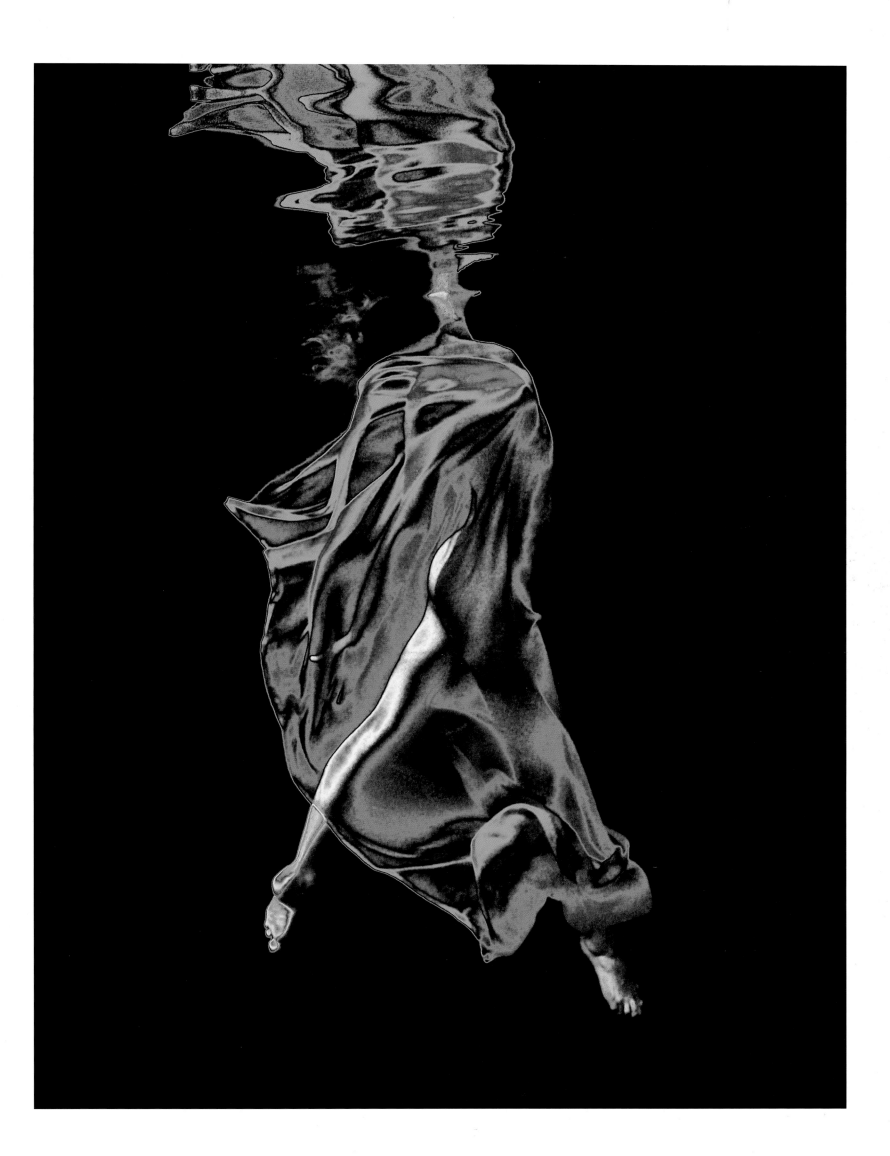

198

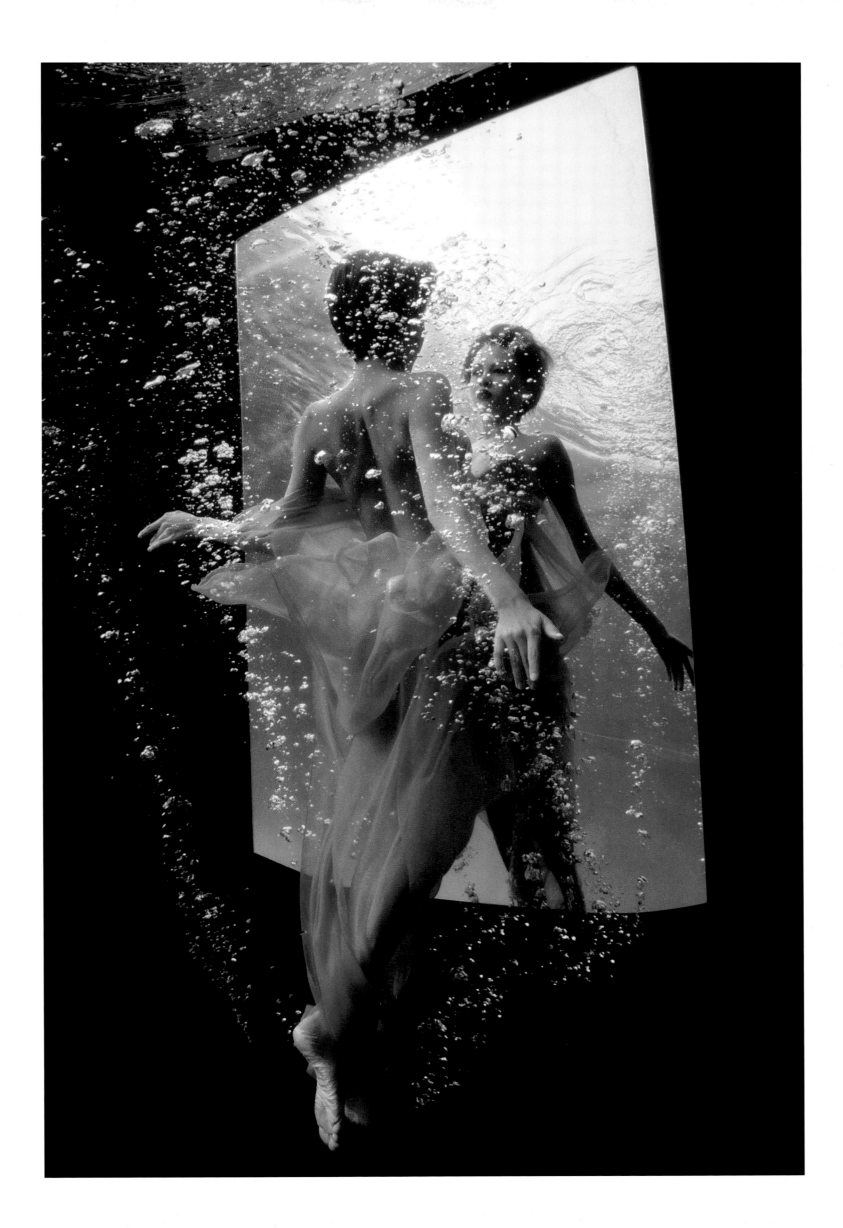

200

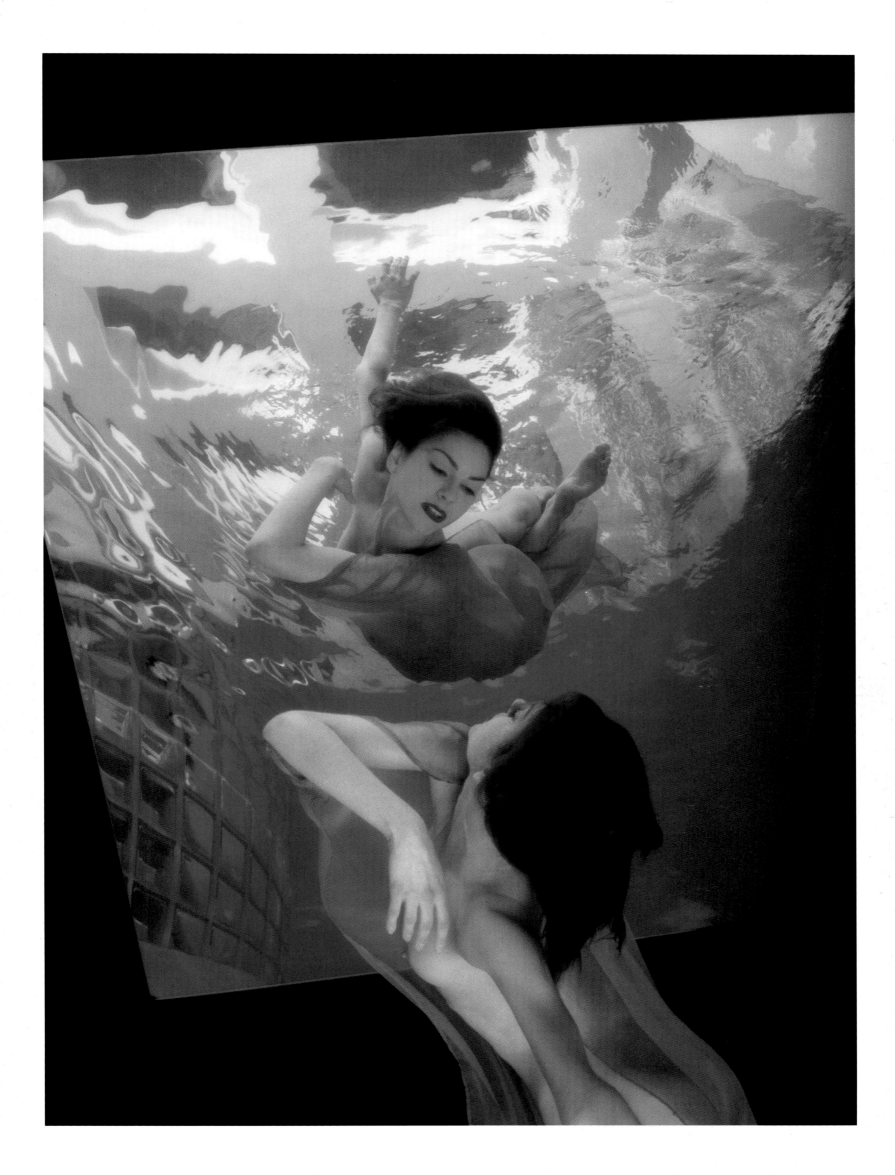

202

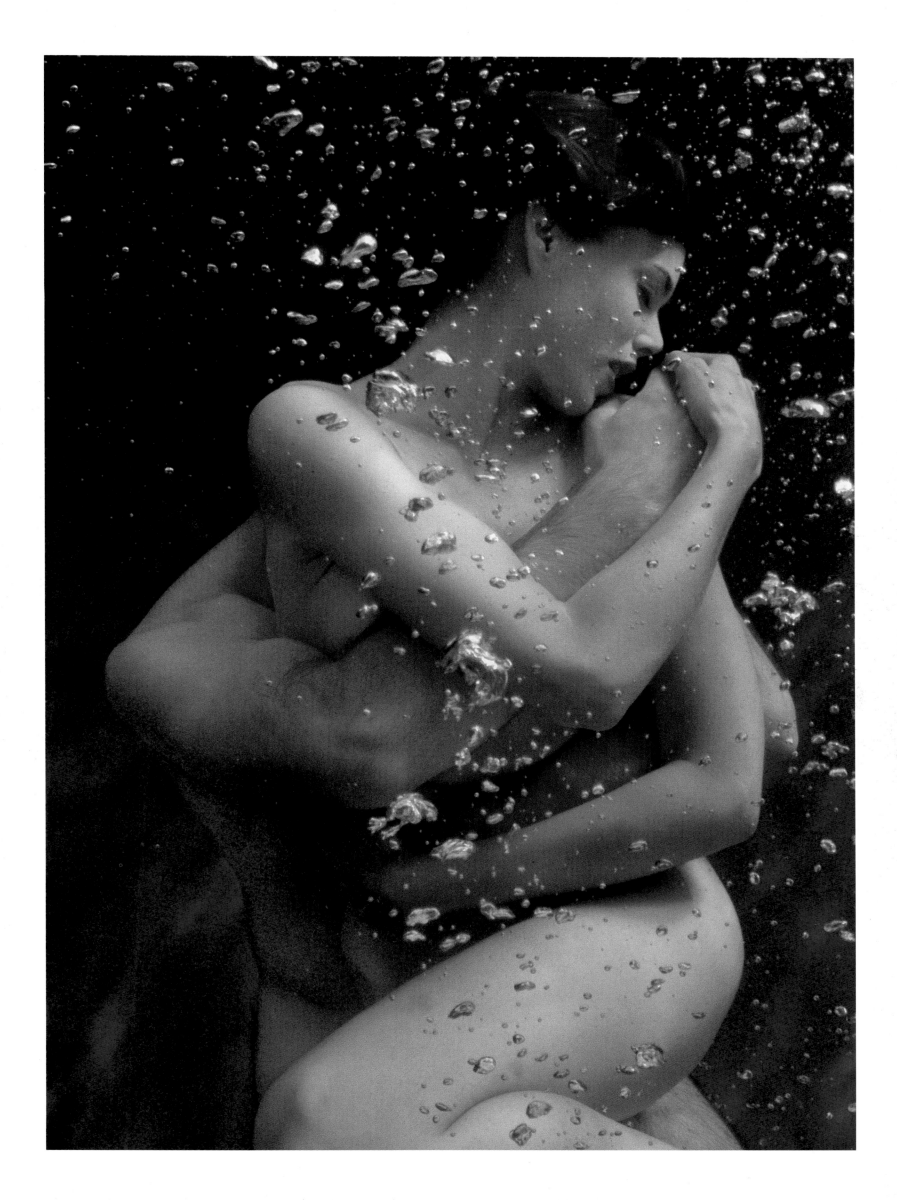

204

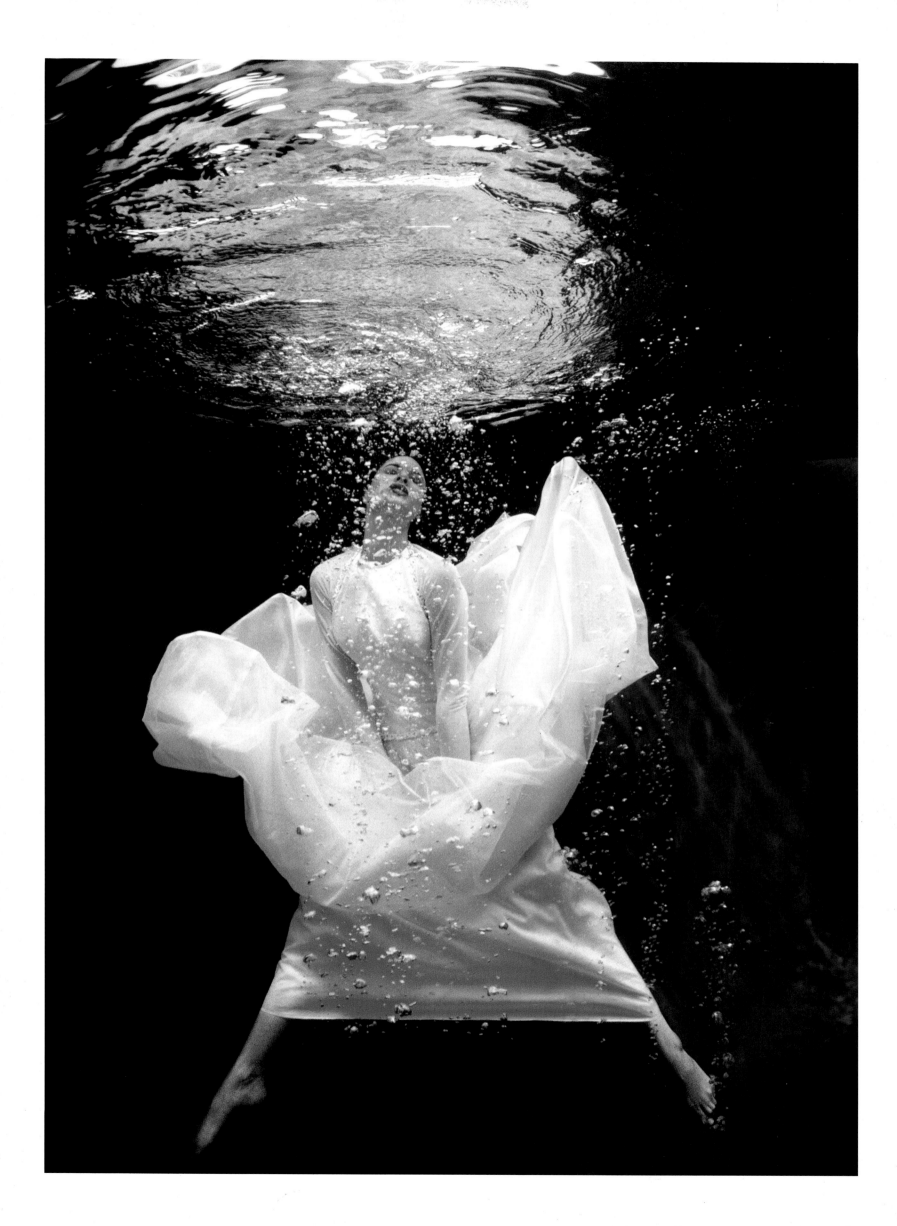

206

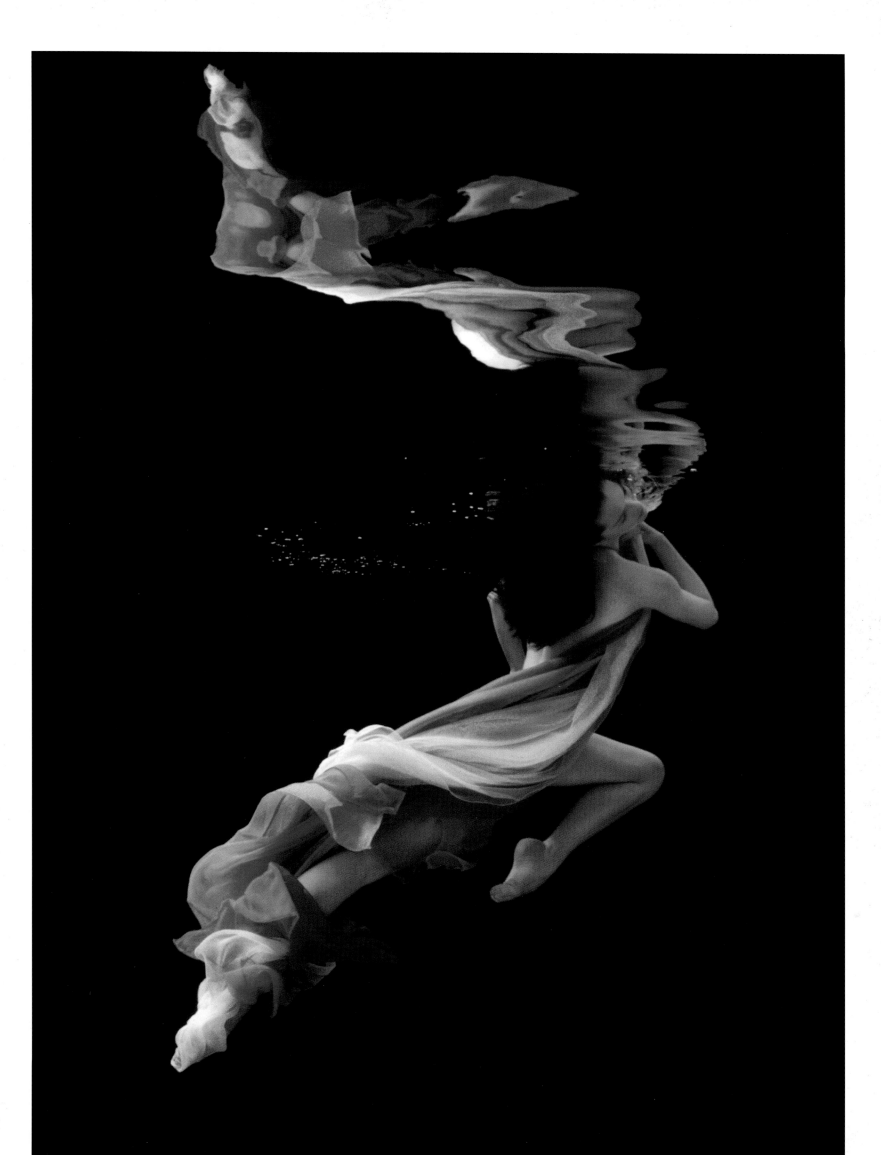

208

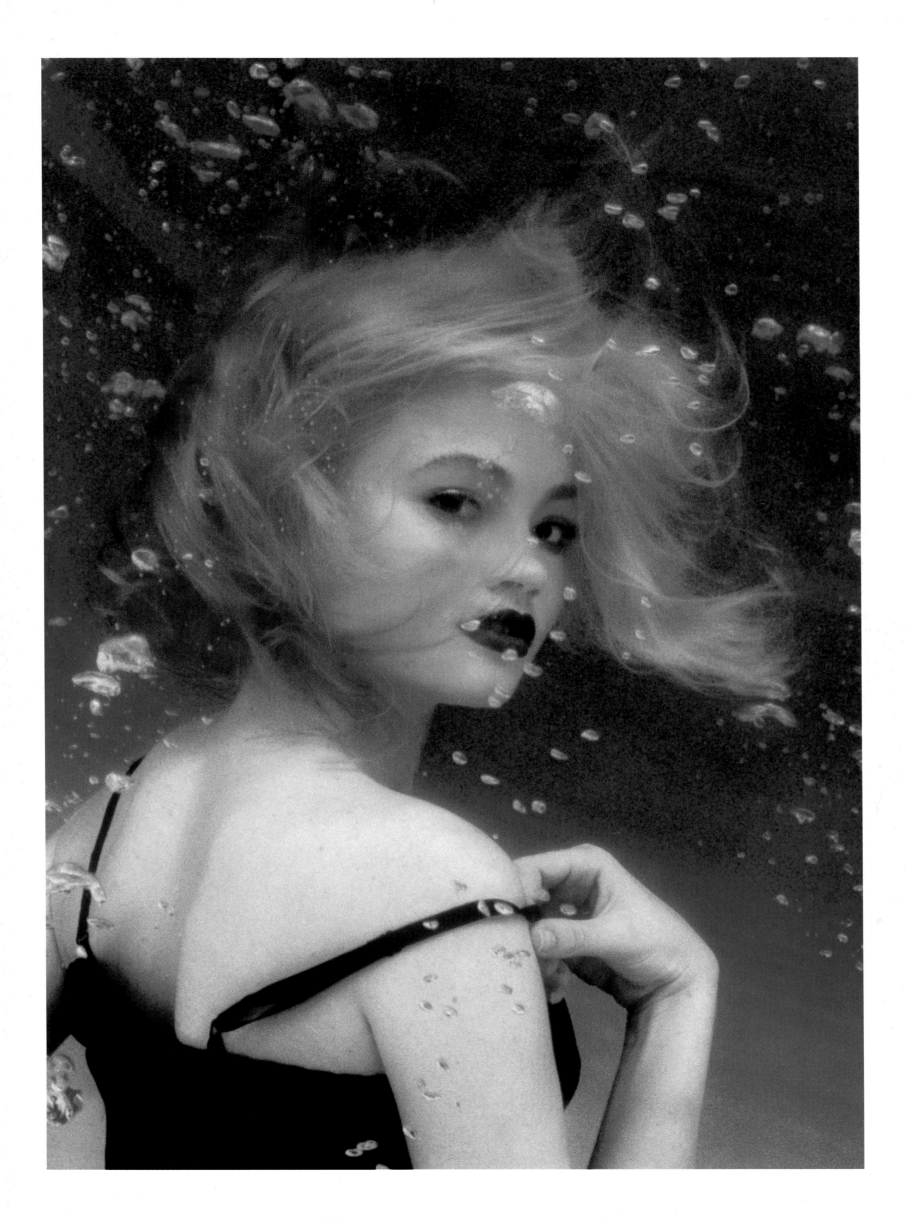

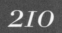

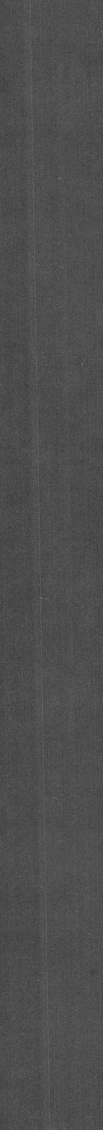

212

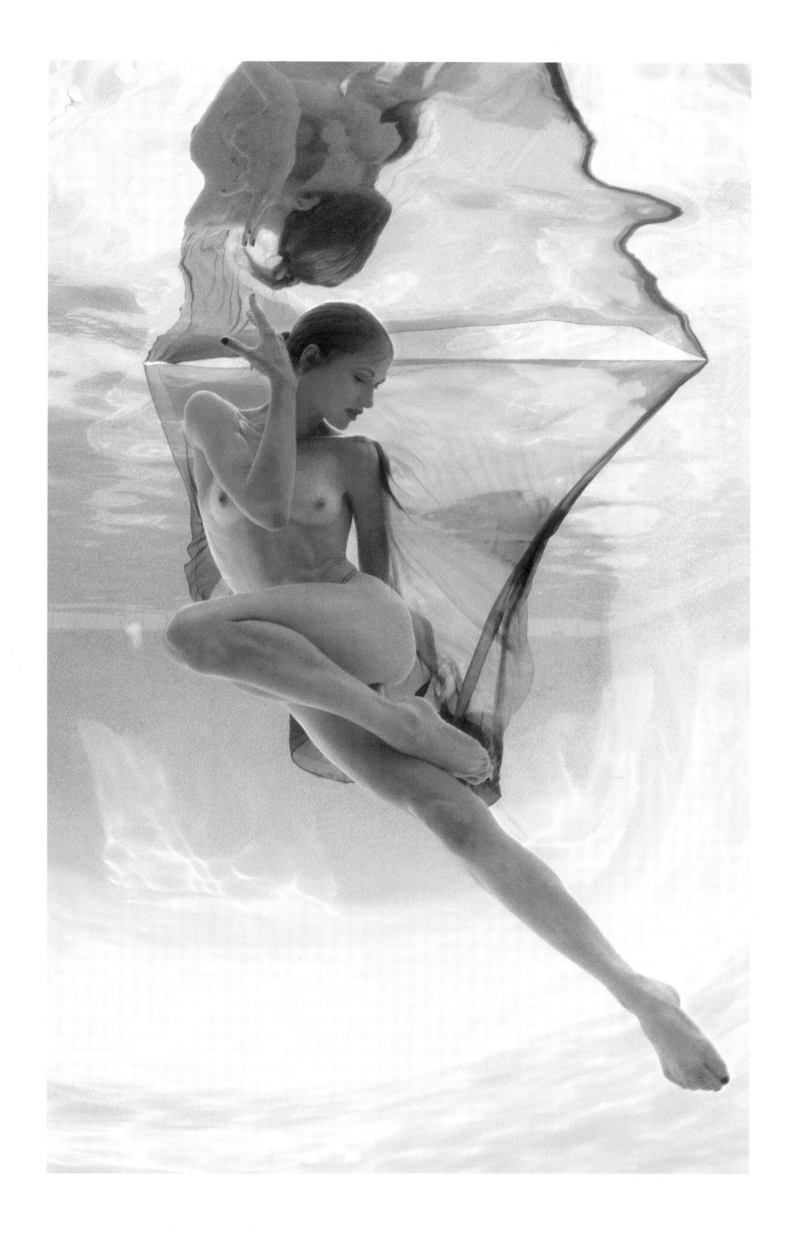

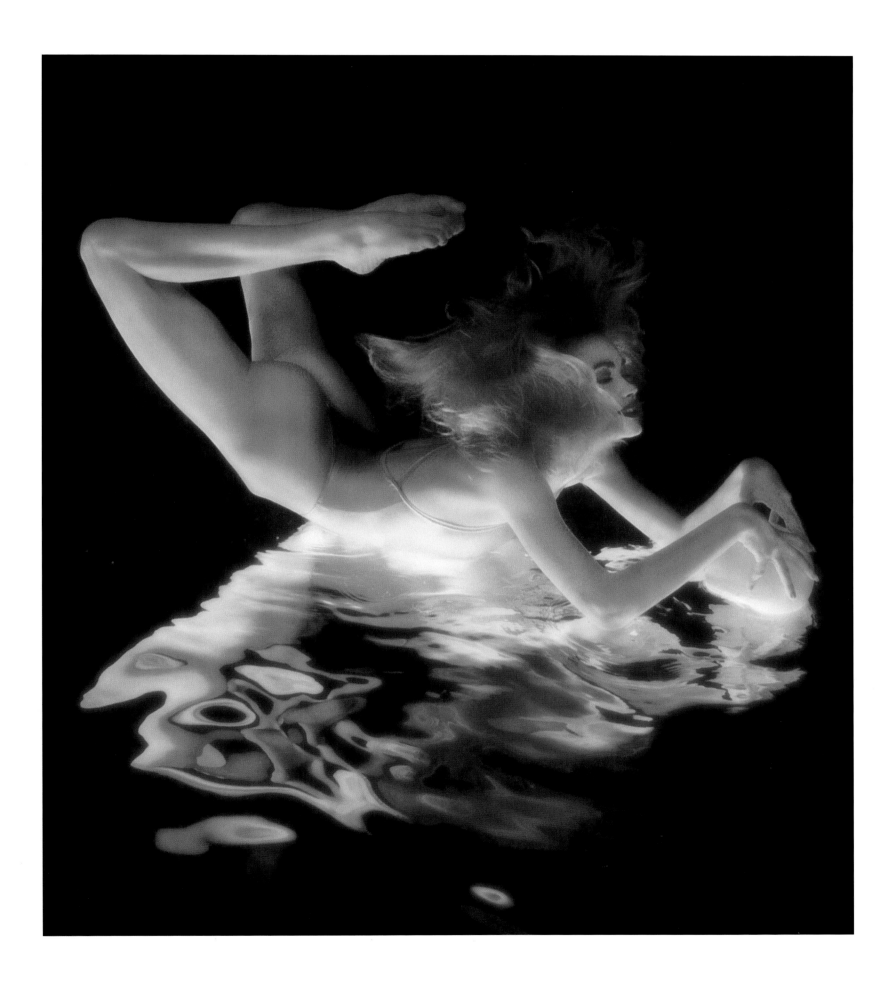

216

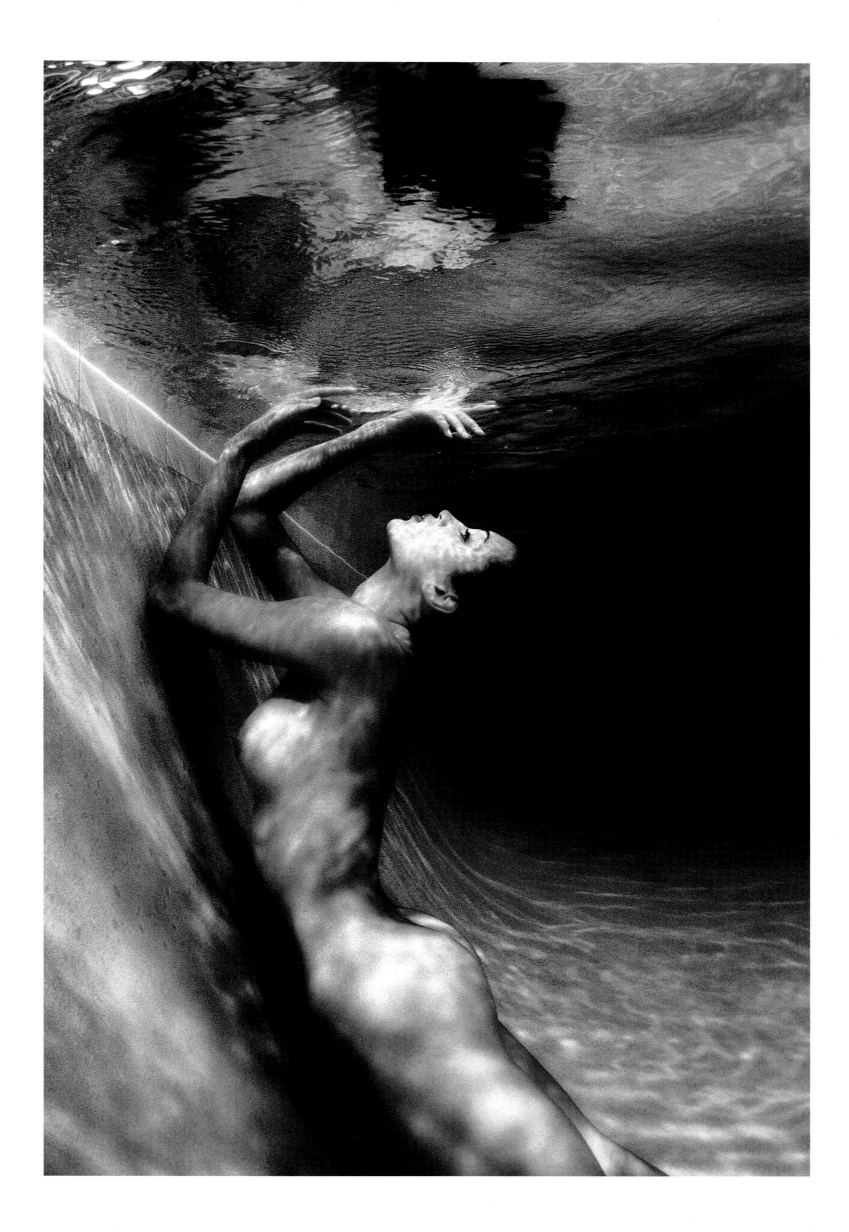

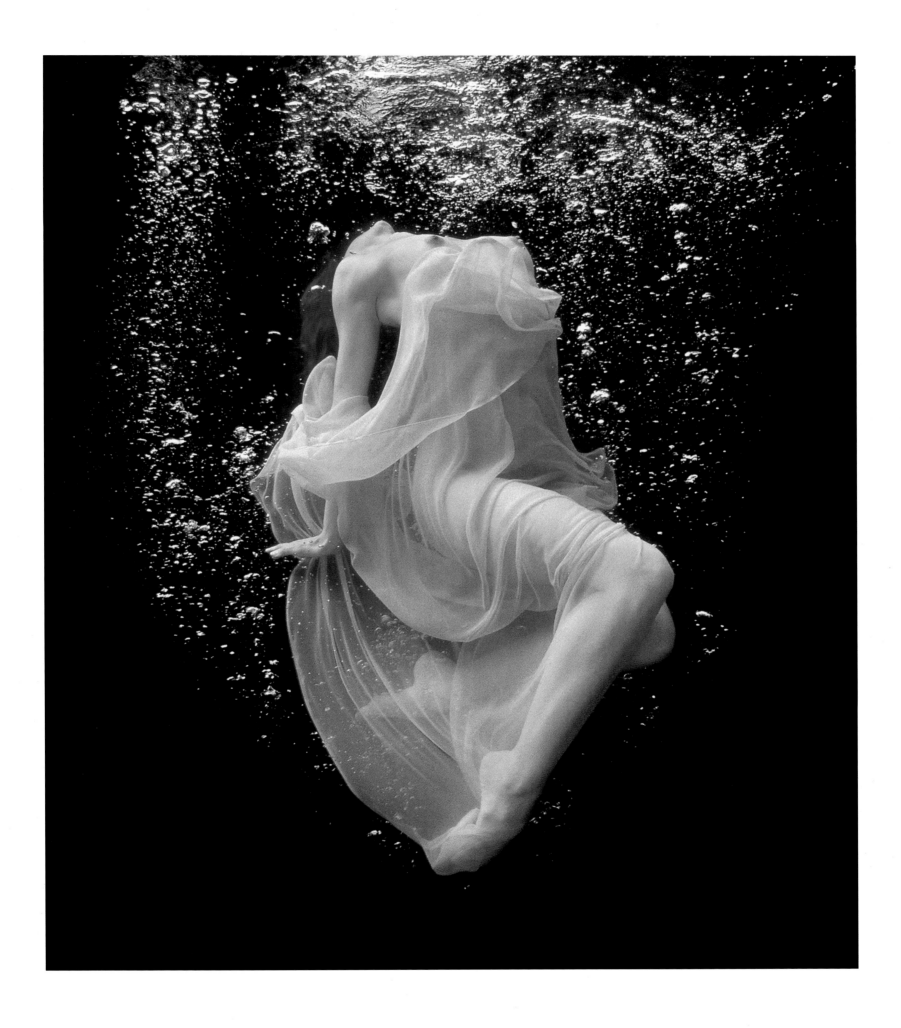

220

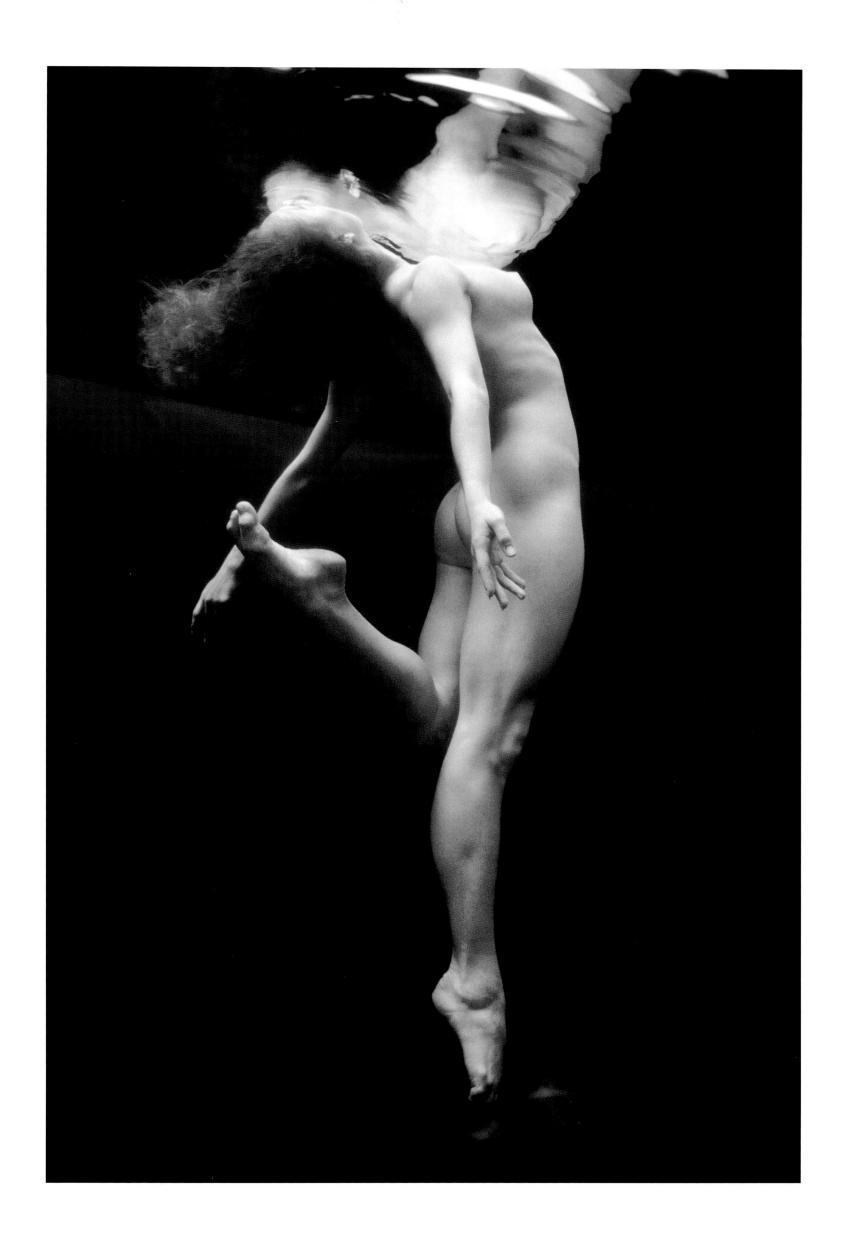

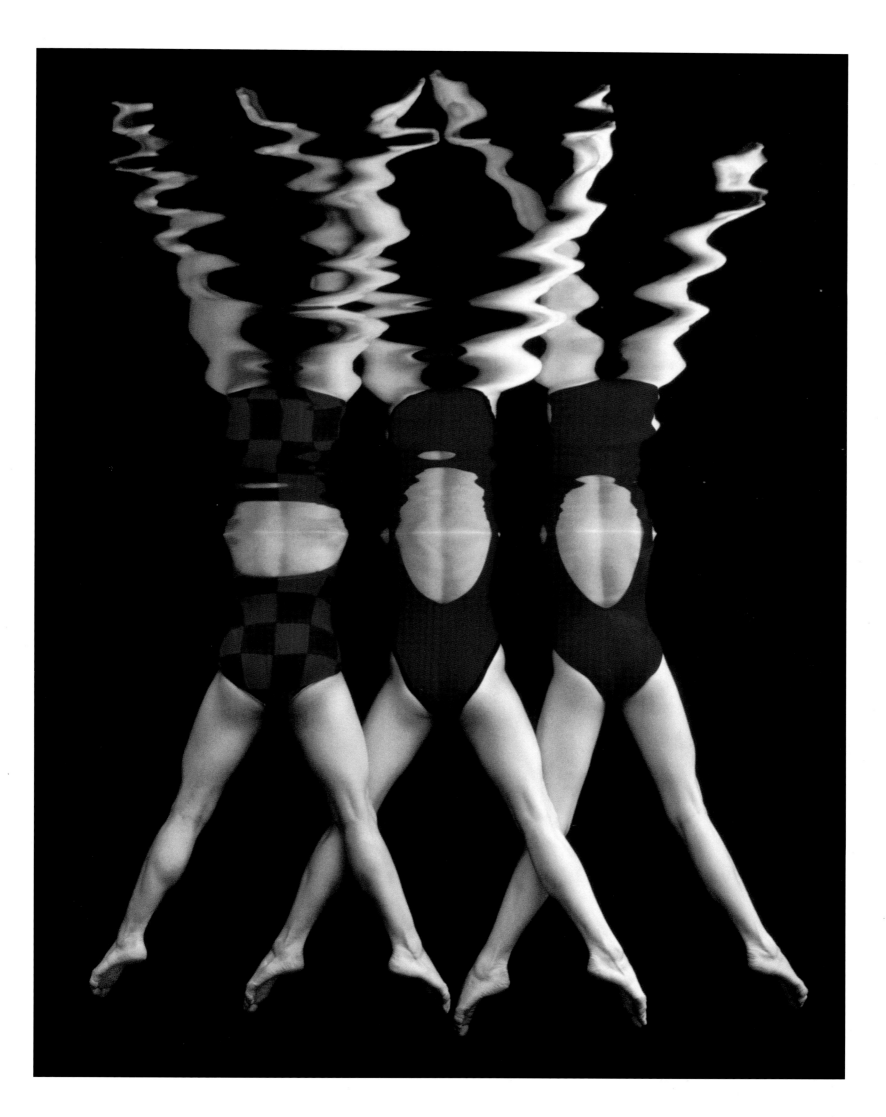

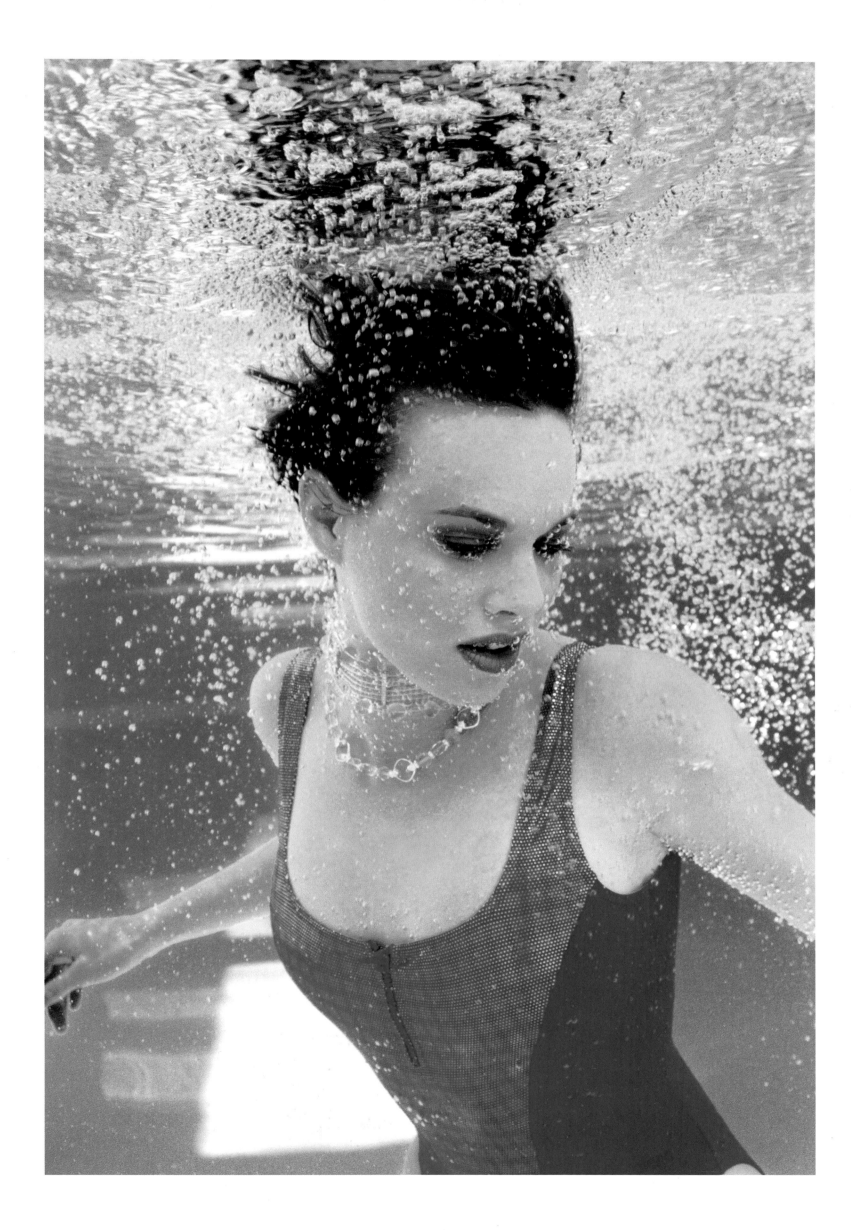

226

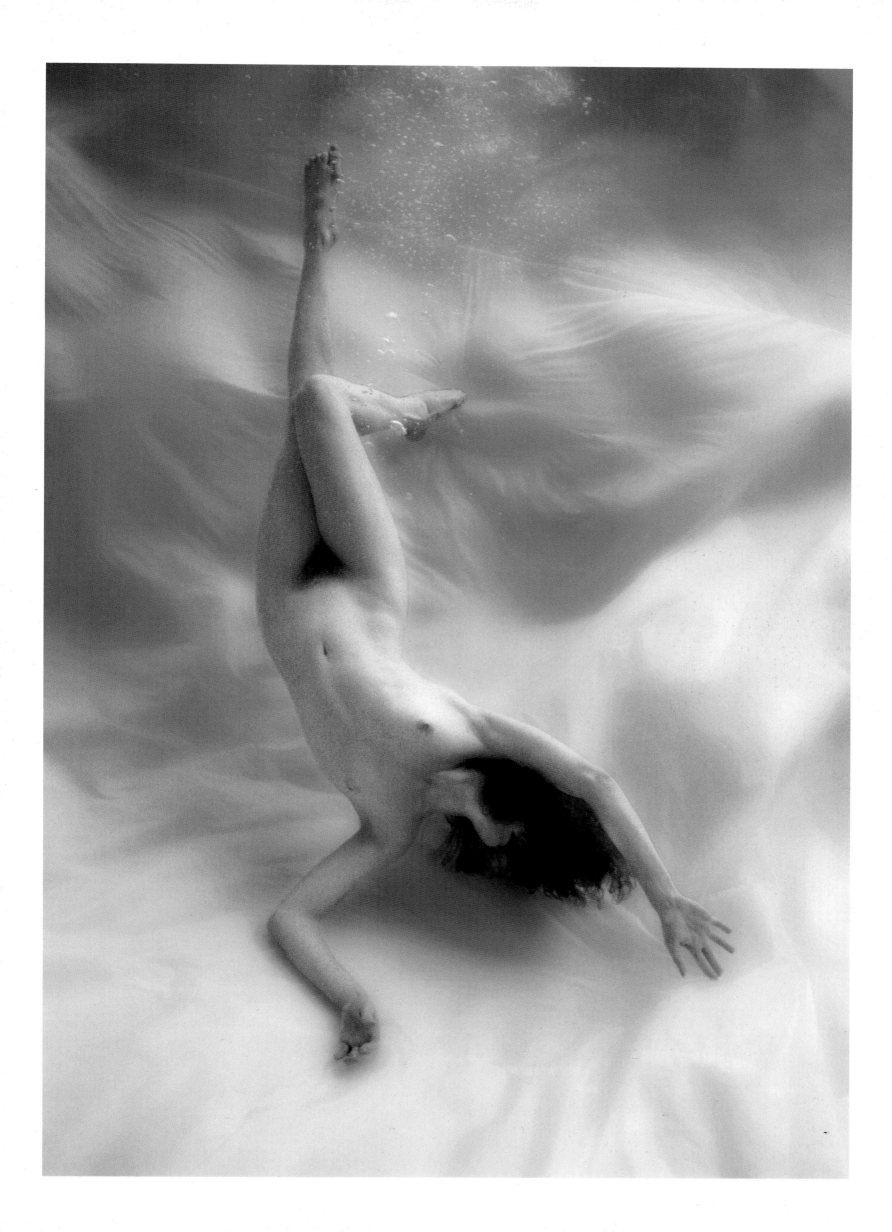

228

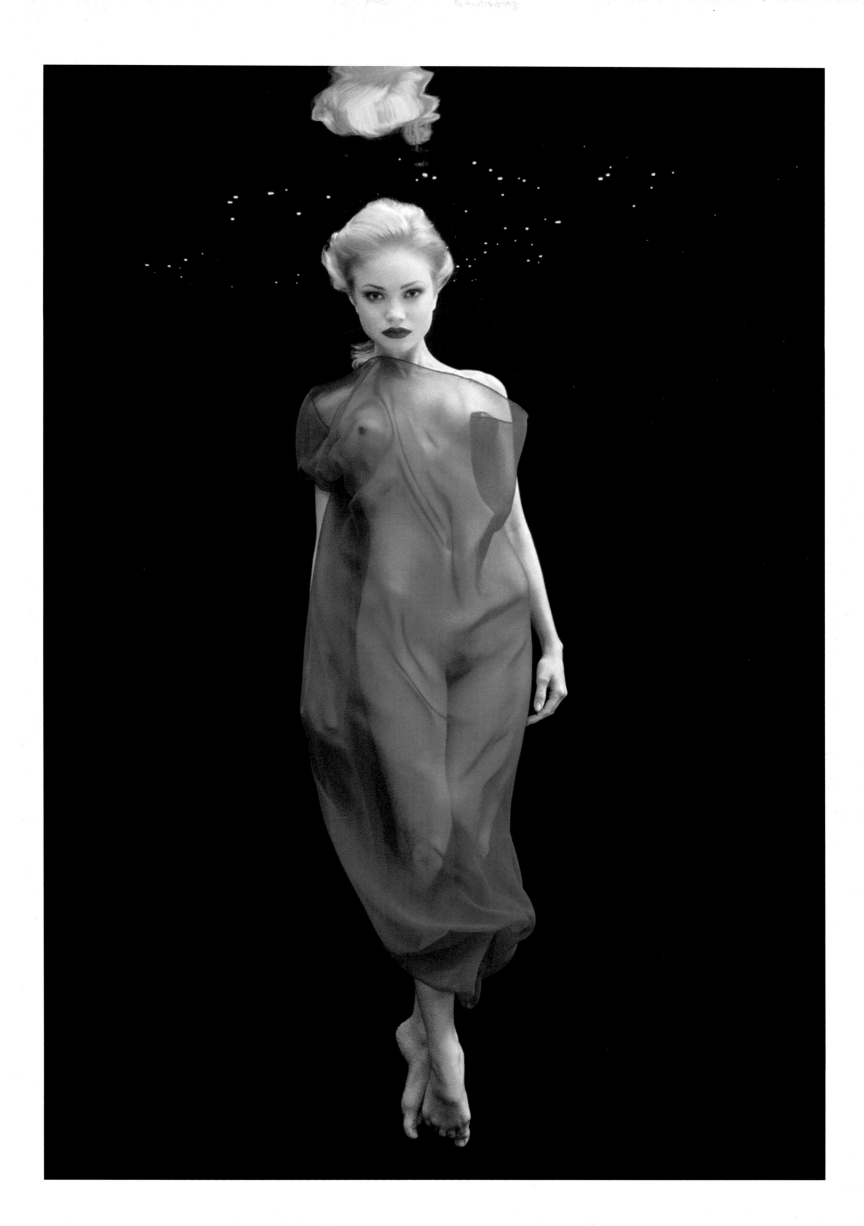

230

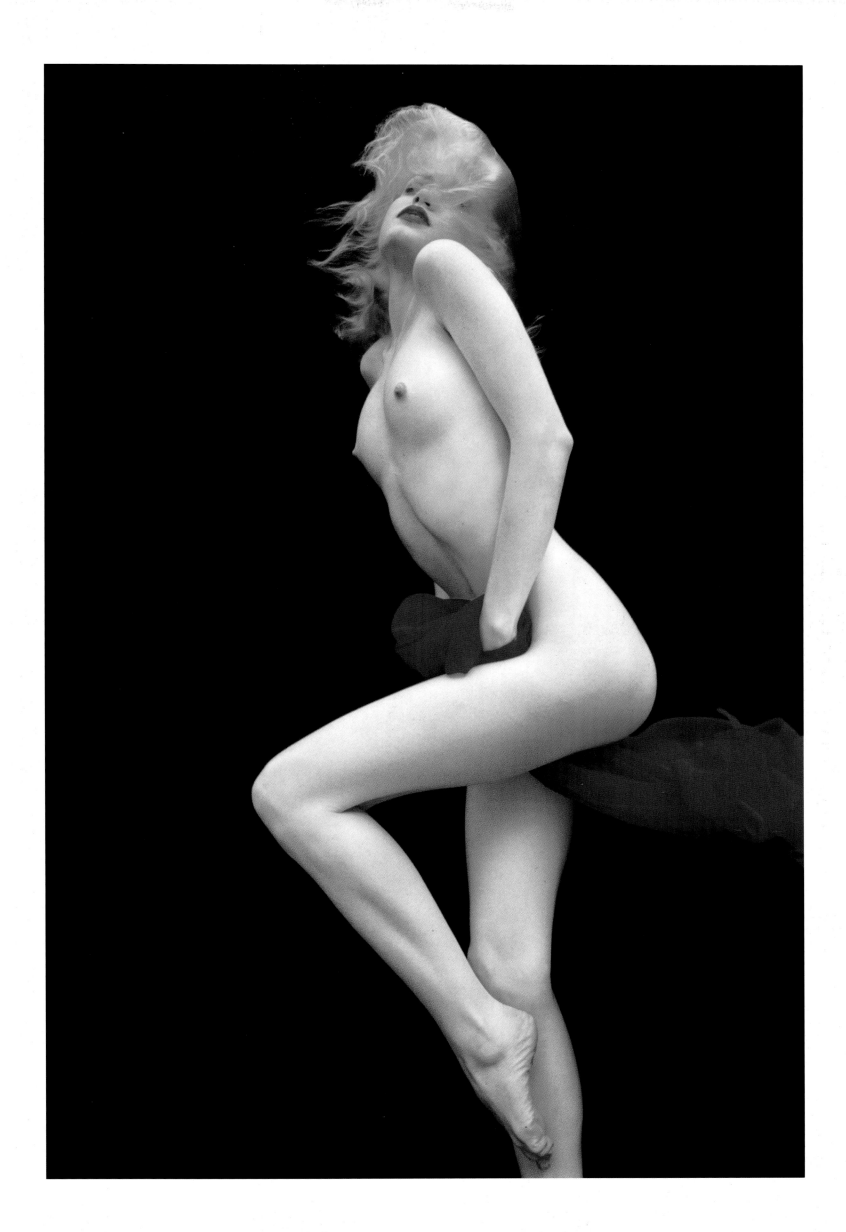

232

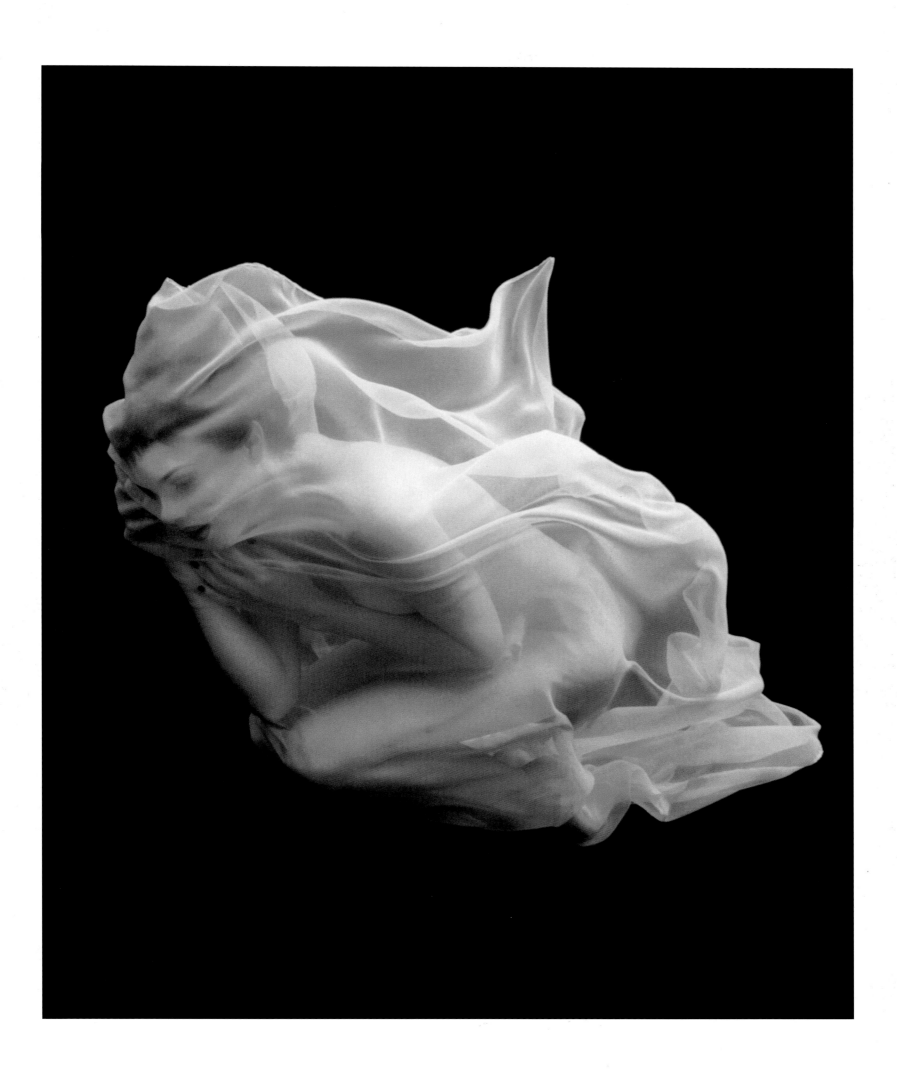

234

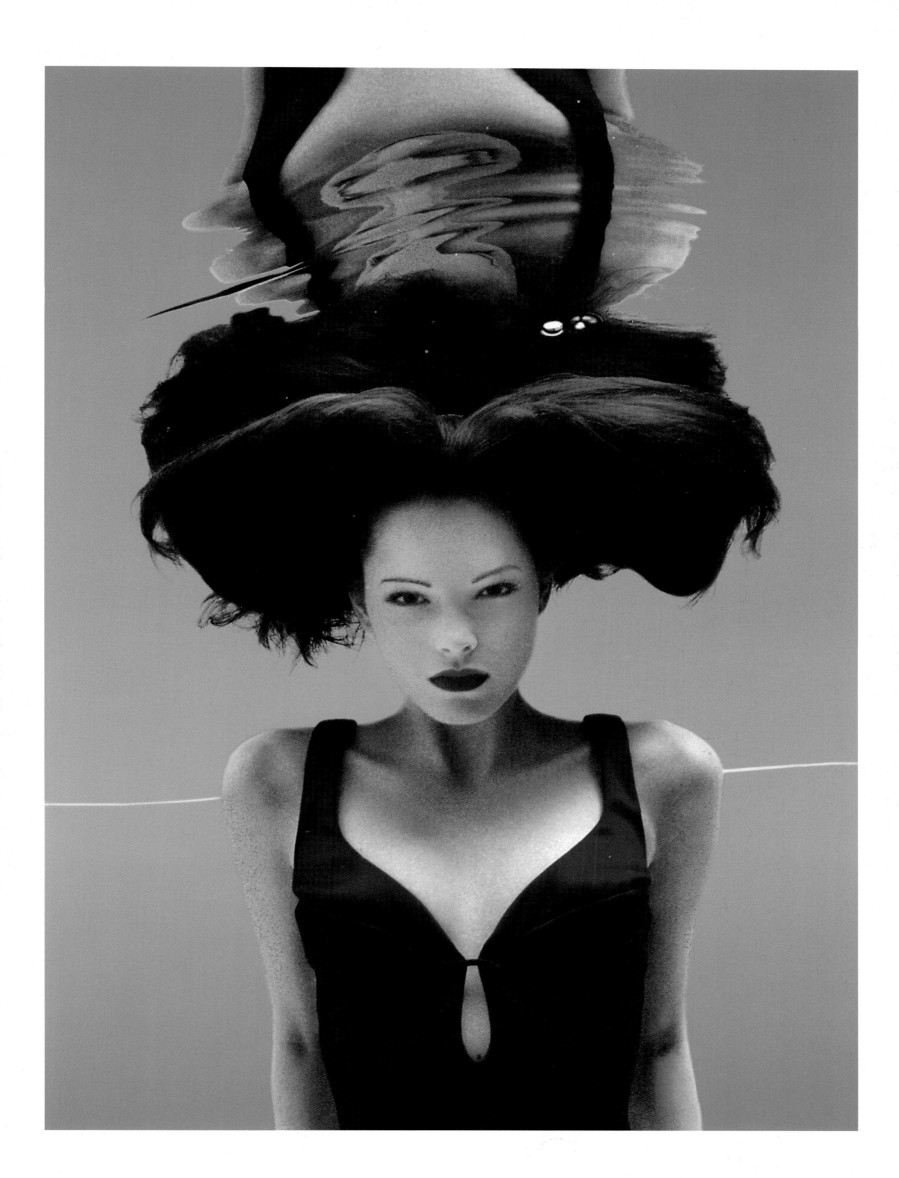

236

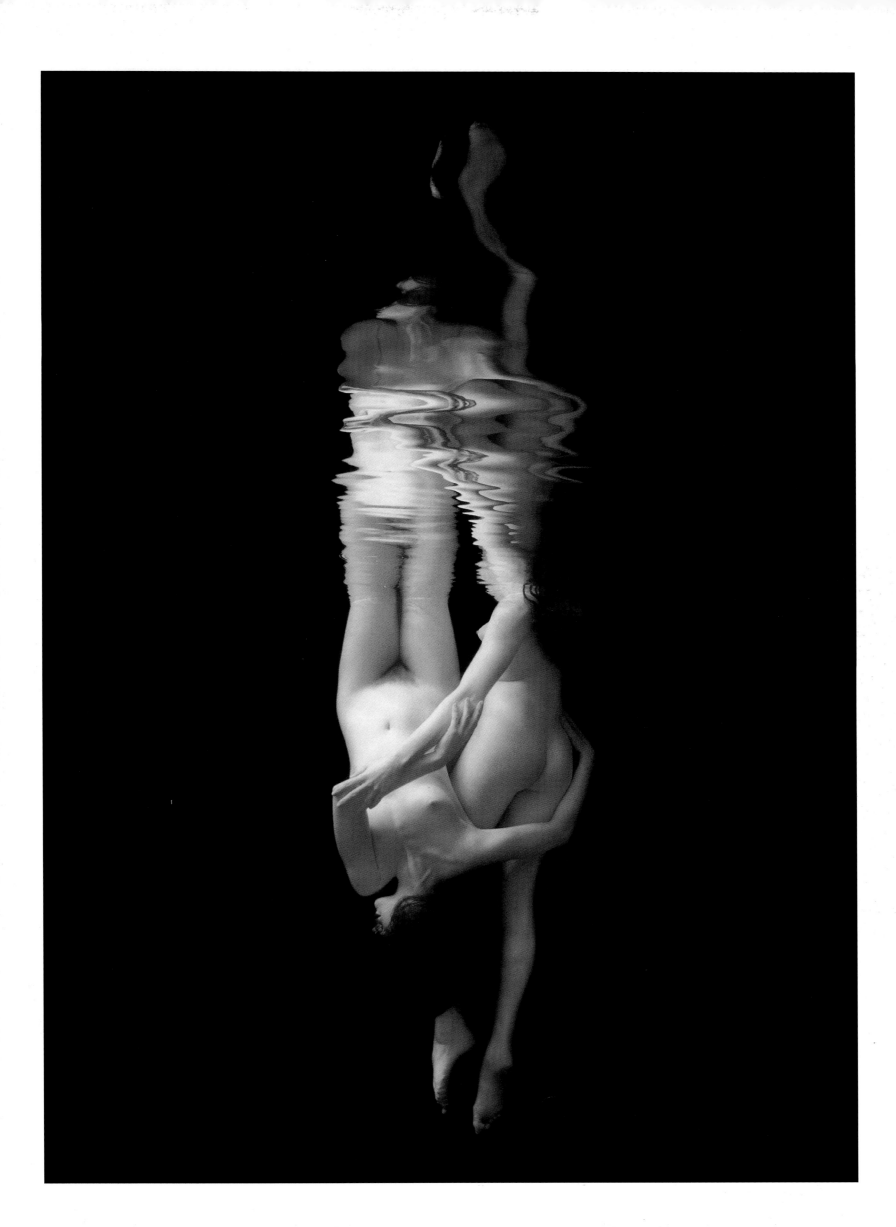

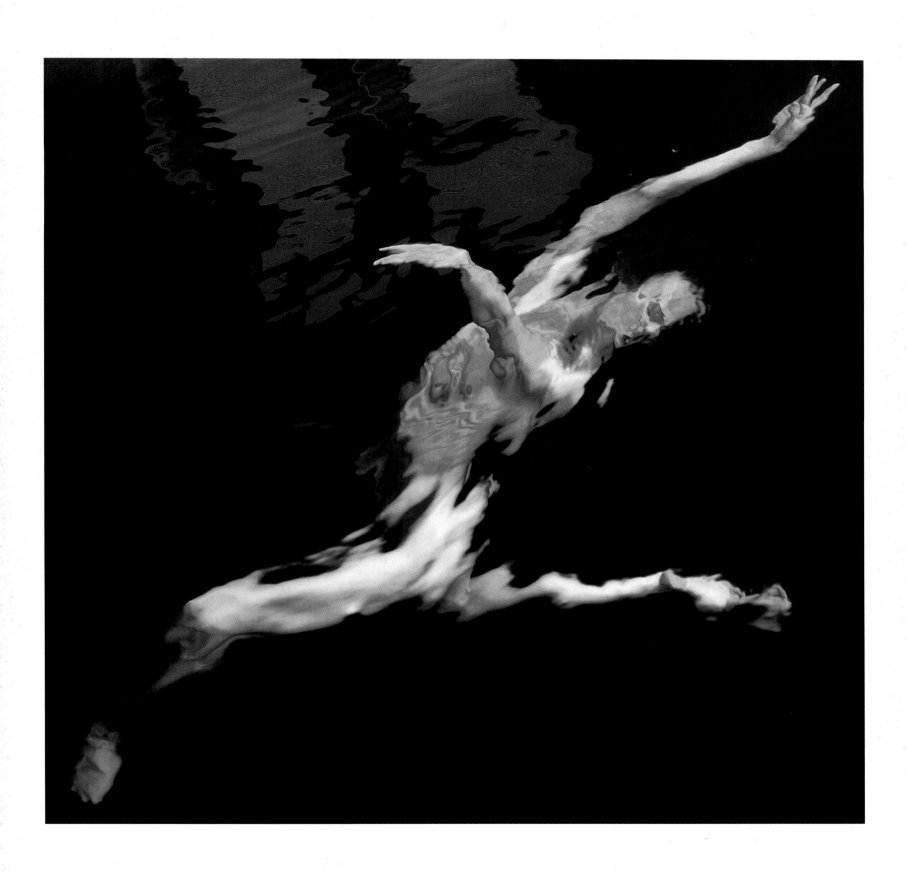

240

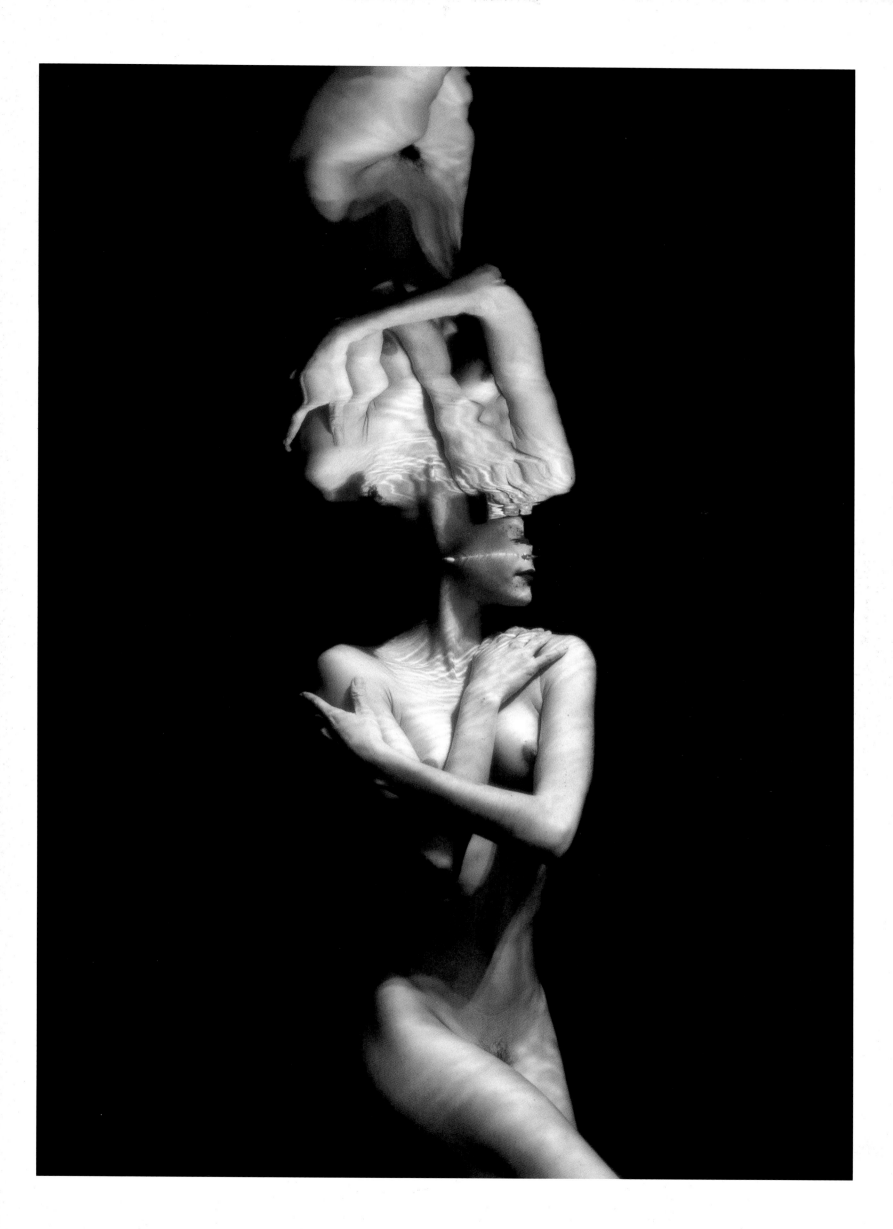

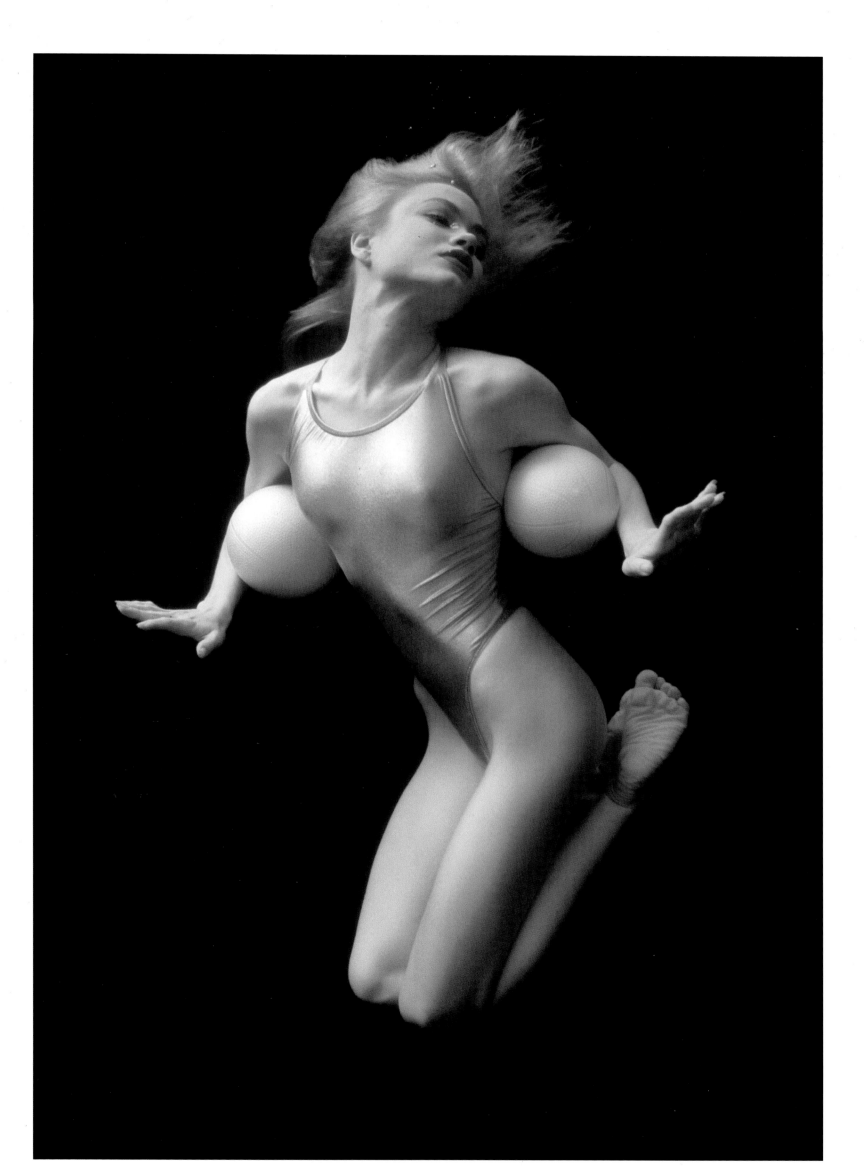

244

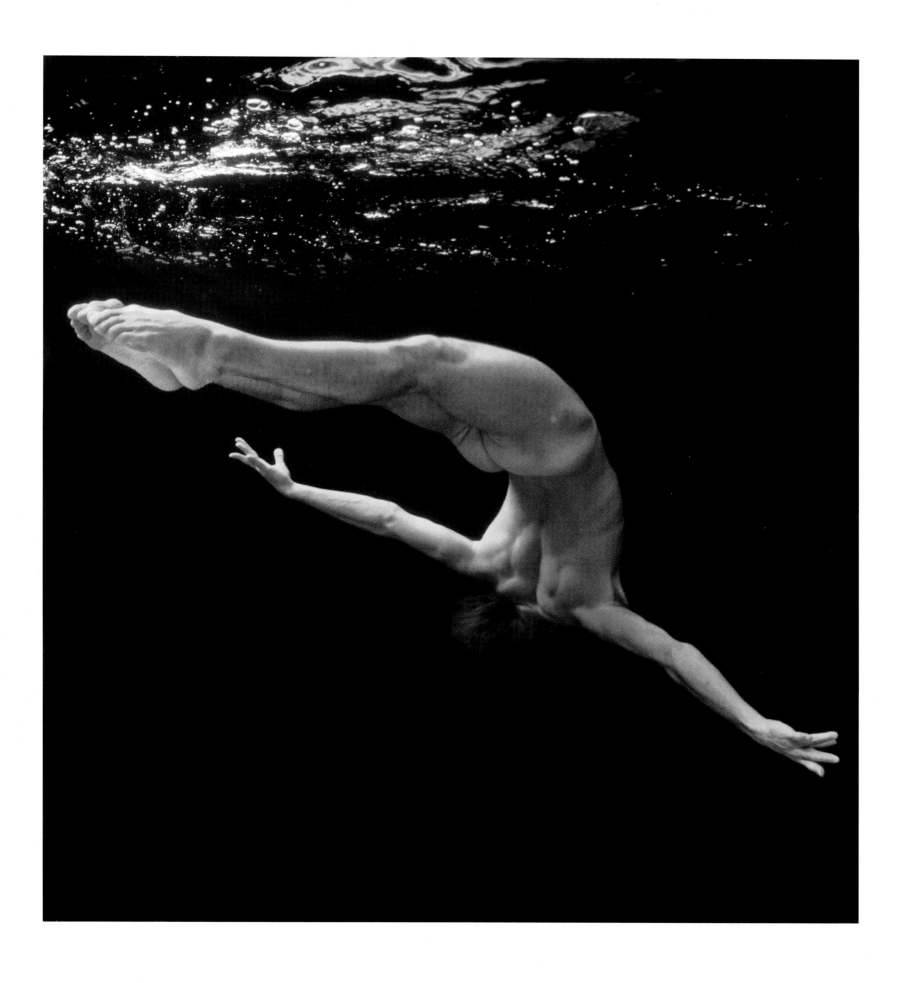

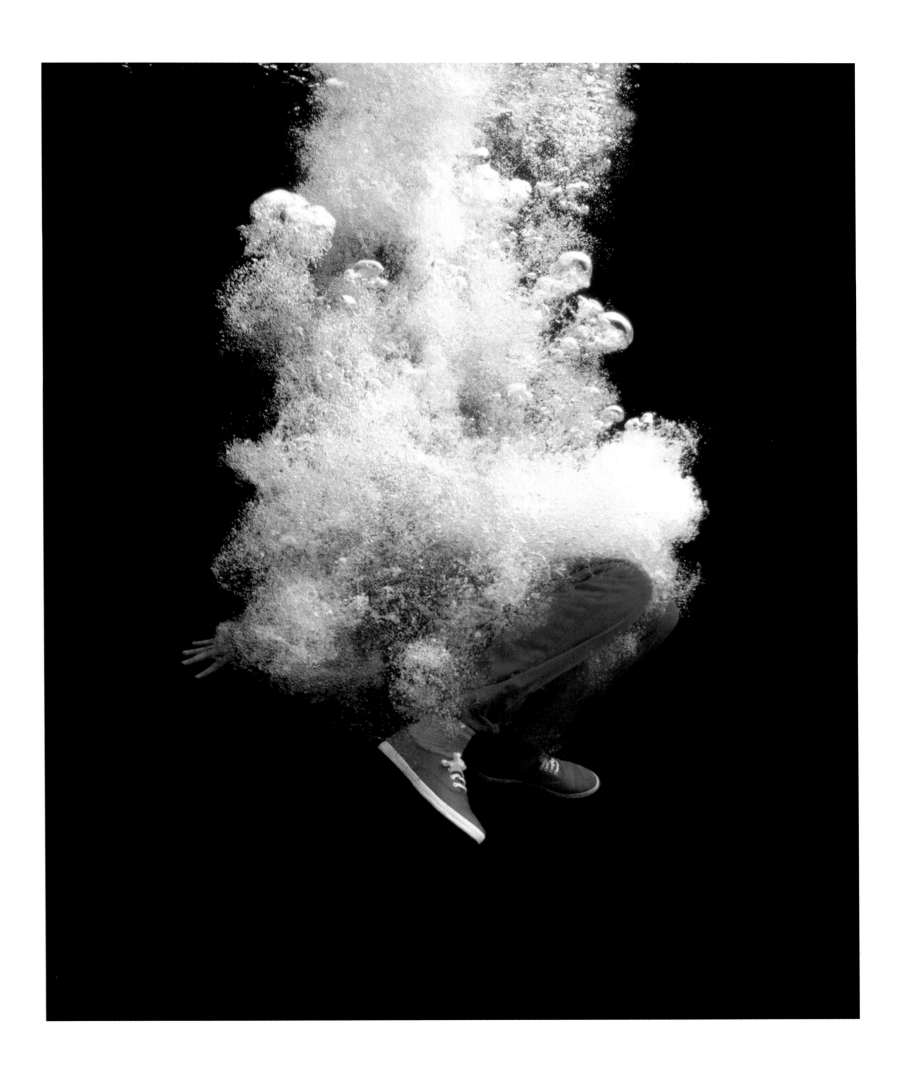

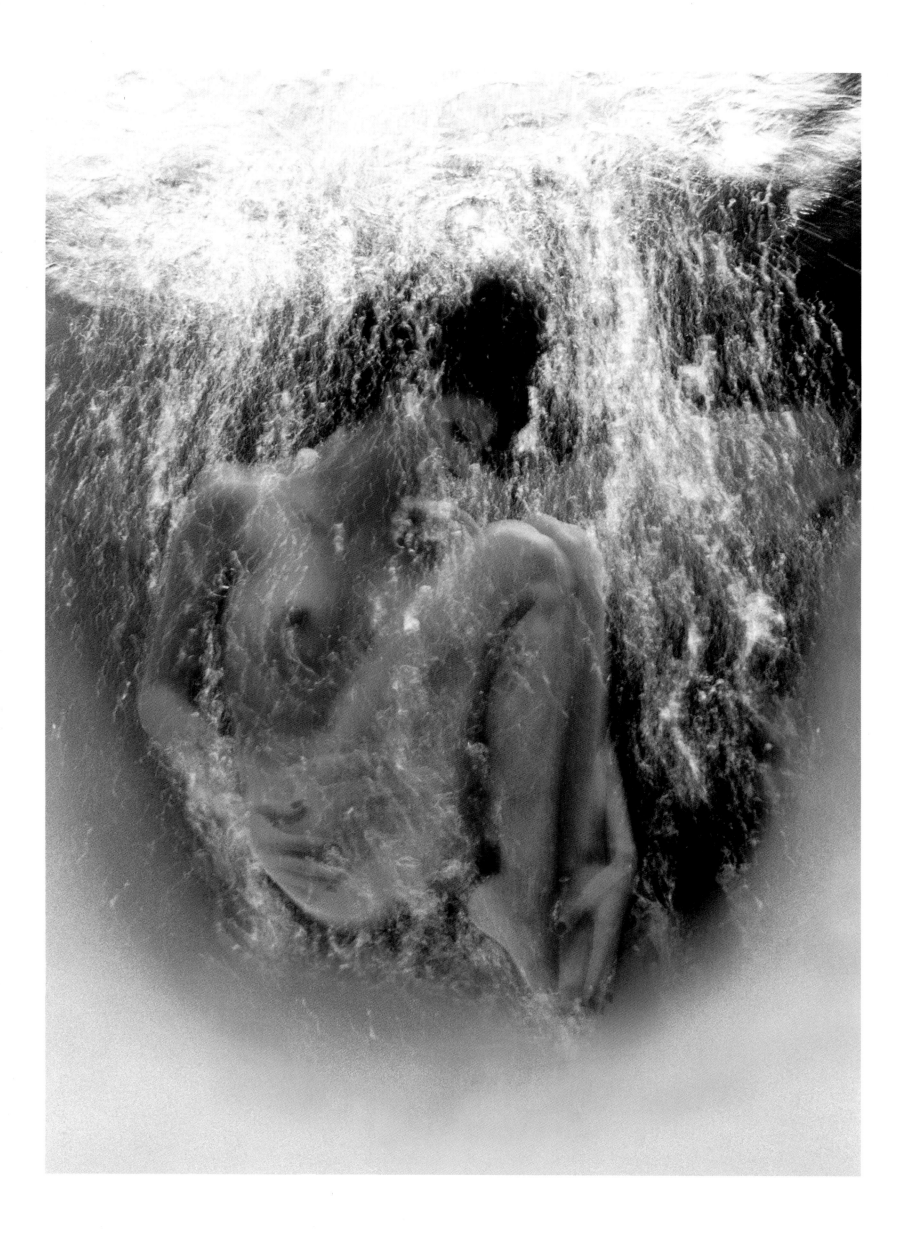

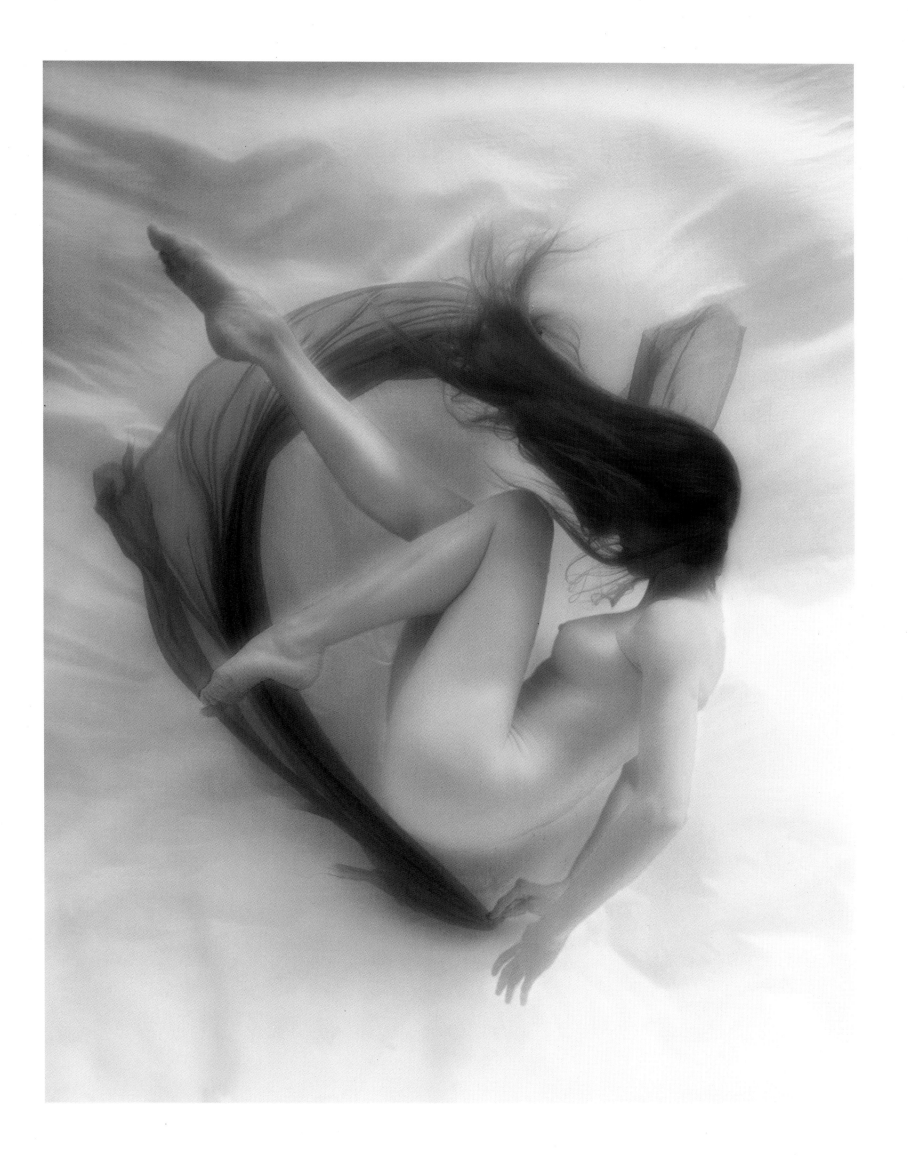

About the making of Pool Light

When you look at the images in this book, they seem so effortless. The clarity of the water, the repose of the models and dancers, the natural skin tones, the beauty of the compositions—they all contribute to a sense of inevitability: it's almost as if you photographed someone in the water who just happened to look like one of these models, the resulting image would be the same. But, the making of these images is a complex and multifaceted undertaking. You don't just jump in a pool and go. In order to make images like those you see here, you need total control of every variable, from the temperature and the chemistry and clarity of the water to the lighting and the film, the quantity of air in your lungs , and the ability to fight the tendency of your body to relax in the warm comfort of soothing water in a beautiful swimming pool.

The pool in which we work is ozonated, not chlorinated, so the eyes won't burn. The chemistry is tested almost hourly several days prior to shooting, to make sure the pH level is exactly 7.4. The temperature of the water is kept at 90-92 degrees farenheit to ensure that the models (and the photographer) can work comfortably for hours in the water. Ten-thousand watt-seconds of strobe light are flashed into the pool through a system of radio transmission synch-triggered by the underwater camera. The makeup for the models must be checked with every dip. The fabrics and the clothing have to be steamed because, yes, wrinkles do show in the water.

And then there are the models. It looks so easy when you see the end results in these pictures, but there are very few people who can do this; imagine yourself standing on the bottom of the swimming pool, hands on your hips like a model walking the runway, smiling at the camera which you cannot see because, although you have your eyes open, you aren't wearing goggles—you're only pretending to look at and smile for the camera.

Indeed, we have been privileged to work with a group of extraordinary models. In particular, Katita Waldo and Sarah Sessions of the San Francisco Ballet, who were the first to realize with us the potential of this medium, and who, along with a group of amazing dancers, realized it in our first book of underwater images, *WaterDance* (Graphis Press, 1995). In the underwater work we have created since the publication of *WaterDance*, two other models in particular have made an enormous contribution to the evolution of this imagery: Shawnee Free Jones and Julie Montgomery. Again, it's hard to understand just by looking at the images how difficult and demanding the process is. But through their determination to make the best images possible, they brought remarkable beauty and glamour to this underwater fantasy.

All of this is orchestrated and driven by the relentless energy of Howard Schatz. He demands the best, and asks of everyone on the set (in and out of the water) that they consistently give 100% for every take.

His enthusiasm for making the photographs is equaled only by an insatiable appetite for the pursuit of the most beautiful images. Over and over again I have heard him say, "I want to look through the view-finder of the camera and fall in love. I want to look through my view-finder and see an image I've never seen before anywhere else."

In his desire to reach beyond the beautiful world of images which constitute *WaterDance*, Howard poured his heart into the finding of something truly new. He would always talk about climbing up the many branches of a tree looking for the most luscious fruit: some branches had no fruit at all; some branches had fruit to pick—but it tasted no different from the fruit he had found before. He was always ready to climb out onto the thinnest and most precarious-looking limb, taking the chance of falling off, in the hope that at the very end of that tenuous branch he would find the most delicate, delicious, sweet and astonishing fruit imaginable.

Not only do the models, hair stylists, makeup artists, and clothing and costume stylists find a working partner who demands the best of them but the resulting images have spurred the imaginations of models and assistants alike to help invent new ideas. Howard's drive to make astonishing images is barely tempered by the fact of having made them. The momentum and the passion which he brings to the enterprise carry everyone along for the remarkable ride.

Beverly Ornstein

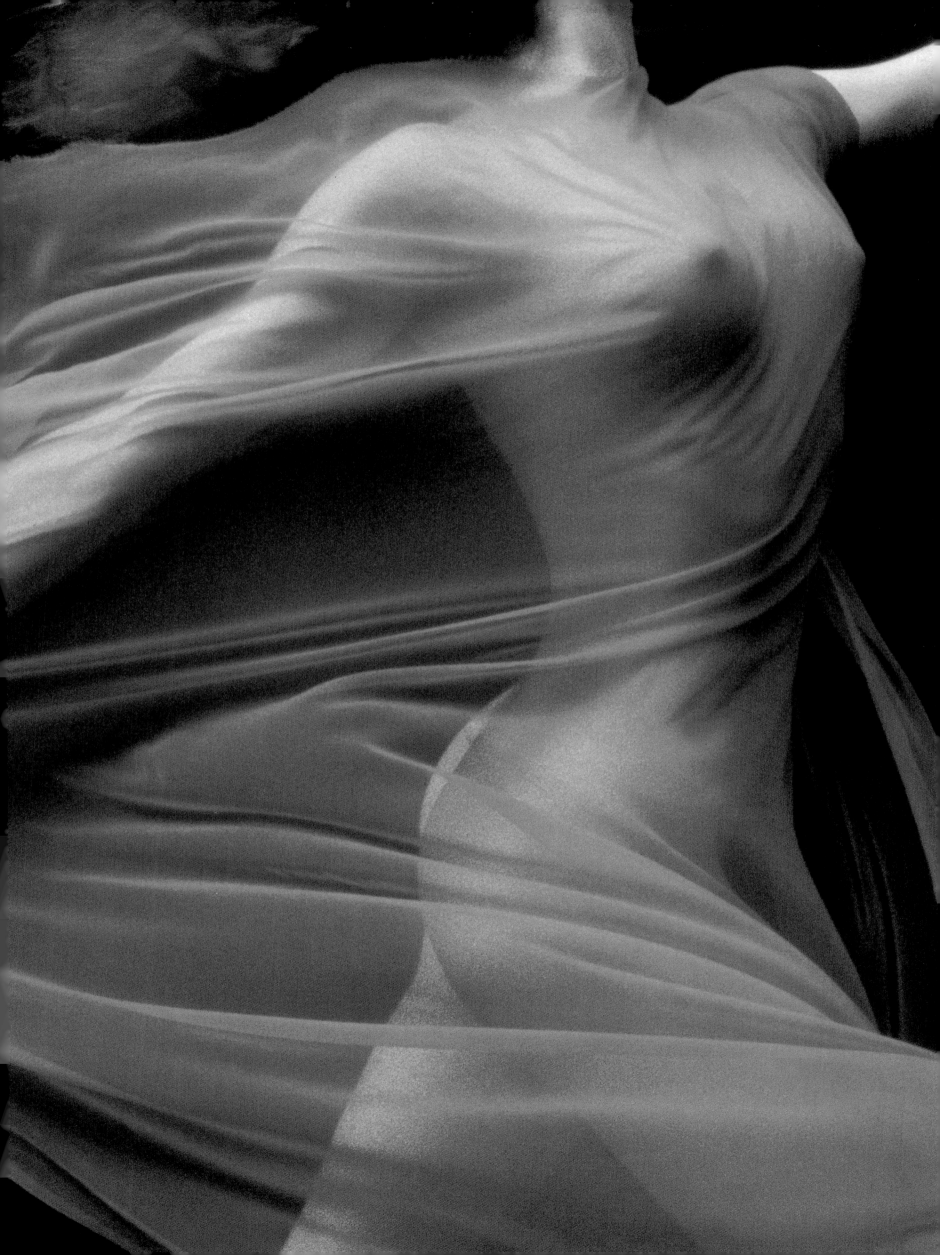

Three individuals contributed their time selflessly to help with the editing of the images in this collection. We owe them a special debt of gratitude:

Linda Ferrer
Photo Editor, New York, NY

G. Ray Hawkins
Owner, G. Ray Hawkins Gallery, Santa Monica, CA

B. Martin Pedersen
Publisher, Graphis Press, New York, NY

The images in this book could not have been made without the work of dozens of contributors from many different disciplines. We acknowledge their superb professional work and give our heartfelt gratitude to each of them.

Models
Mary Arnett, *Stars Models*
Jennifer Beaty, *Look Models*
Rolana Brumley, *City Model Management*
Kristie Ford, *Look Models*
Tabitha Garza, *Look Models*
Shawnee Free Jones,
Julie Montgomery, *Look Models*
Natasha Pruitt, *Look Models*
Joe Puccio, *Look Models*
Marita Schaub, *City Model Management*
Hilary Smith, *City Model Management*

Dancers
Claudia Alterieri, *San Francisco Ballet*
Rachel Berman,
Paul Taylor Dance Company
Laura Bernasconi, Deirdre Chapman,
San Francisco Ballet

Emily Cook, *Smuin Ballets, SF*
Cecilia Dangcil, Osmani Garcia,
Smuin Ballets, SF
Tiffany Heft, *Forever Tango*
Eric Hoisington,
Jennifer Kulz-Smith,
Marilyn Miller,
Augusta Moore, Heather Nahser,
San Francisco Ballet
Felipe Sacon, Jessica Schatz,
Sara Sessions, *San Francisco Ballet*
Dana Stackpole, Askia Swift,
San Francisco Ballet
Susan Tidball, *Oakland Ballet*
Katita Waldo, *San Francisco Ballet*
Kevin Ware, *ODC San Francisco*
Jennifer and Lisa Wymore

Swimmers
Dante Cernobori
Dan Veatch

Kids
Danny Freisinger
Bennett Gitler-Gershkow
Max Goshay
Jasmine Howe

Hair and Makeup Artists
Bernadine Bibiano, *Artists Untied*
Wallet Luburich, *Koko Represents*
John Lucca, *Artists Untied*
Charla Miller, *Zenobia*
David Mischaud, *Koko Represents*
Patrick Tumey, *Artists Untied*
Eddie Valentine, *Koko Represents*

Stylists and Designers
MaryBeth Alessandri, *Zenobia*
Michael Casey Couture
Lauren Ehrenfeld, *Artists Untied*

Esmerelda Kent,
Carrie L'Esperance, *Zenobia*
Jani Mussetter, *Koko Represents*
Wolford SwimBodies

Assistants
Virginie Blachere
Michal Blech
Marren Caruso
Phoebe Lichty
Pamela Palma
Pascale Treichler
Barbara Traub

Printers and Post-Production Team
Dimitris Dristas
Russ Gorman
Phoebe Lichty
Robert Mills
Monique Reddington
Olivier Robert

Art Directors and Art Buyers
Kevin Amter, *Art Director*
Anna D'Andrea, *Art Buyer,*
Fallon McElligott
Lise Baadh, *Art Director,*
Stimson Lane Vineyards
Jean Bailey, Jeannette Prestia,
MaryBeth Jantzen,
all formerly with Helene Curtis
Professional Division
Alexander Duckworth, *Art Director,*
Shepardson Stern Kaminsky
(frm. with Merkeley, Newman Harty)
Gino Gianneschi, *Art Director;*
Jayne Horowitz, *Art Buyer,*
Grey Advertising
Barbara Larcher,
Fashion Editor;
Wolfgang Behnken, *Art Director,*

Stern Magazine, Germany
John Marin, *Art Director,*
D.S.W. & Partners
(frm. with Cramer-Krasselt)
Jon Miwa, *Art Director,*
Poppe-Tyson
Analisa Milella, *Fashion Editor,*
Io Donna Magazine, Italy
Michael Malatak, *Art Director;*
Patti Killacky, *Art Buyer,*
Leo Burnett, Inc.
Ralph Palamidessi, *Art Director,*
Creative Director, DDB Needham
(frm. with Ammirati Lintas Puris)
Stephanie Perrot, *Art Buyer,*
Ammirati Lintas Puris
Nancy Spector, *Art Buyer,*
Cramer-Krasselt
Mimi Steurer, Chantal Thomass,
Wolford International

Equipment and Services
Adobe: John Warnock,
and Mary Wright
Calumet: Kathleen Houde,
Peter Biasotti, Christopher Brown
Camera Tech: Geoff Semorile
Chimera: Eileen Healy
Hasselblad: Bengt Forssbaeck,
Skip Cohen, Tony Corbell,
Ernst Wildi, Soren Gunnerson
JCX Expendables: Janet Cole
Kodak: Darcie Eggers,
Scott DiSabato
New Lab, *San Francisco*
Nikon: Frank Fennell
Pool Scene, *Novato, California*
U.S. Color, *New York*
Werner Schneider Construction:
Ted Bissell, Werner Schneider
and Ole Hanson

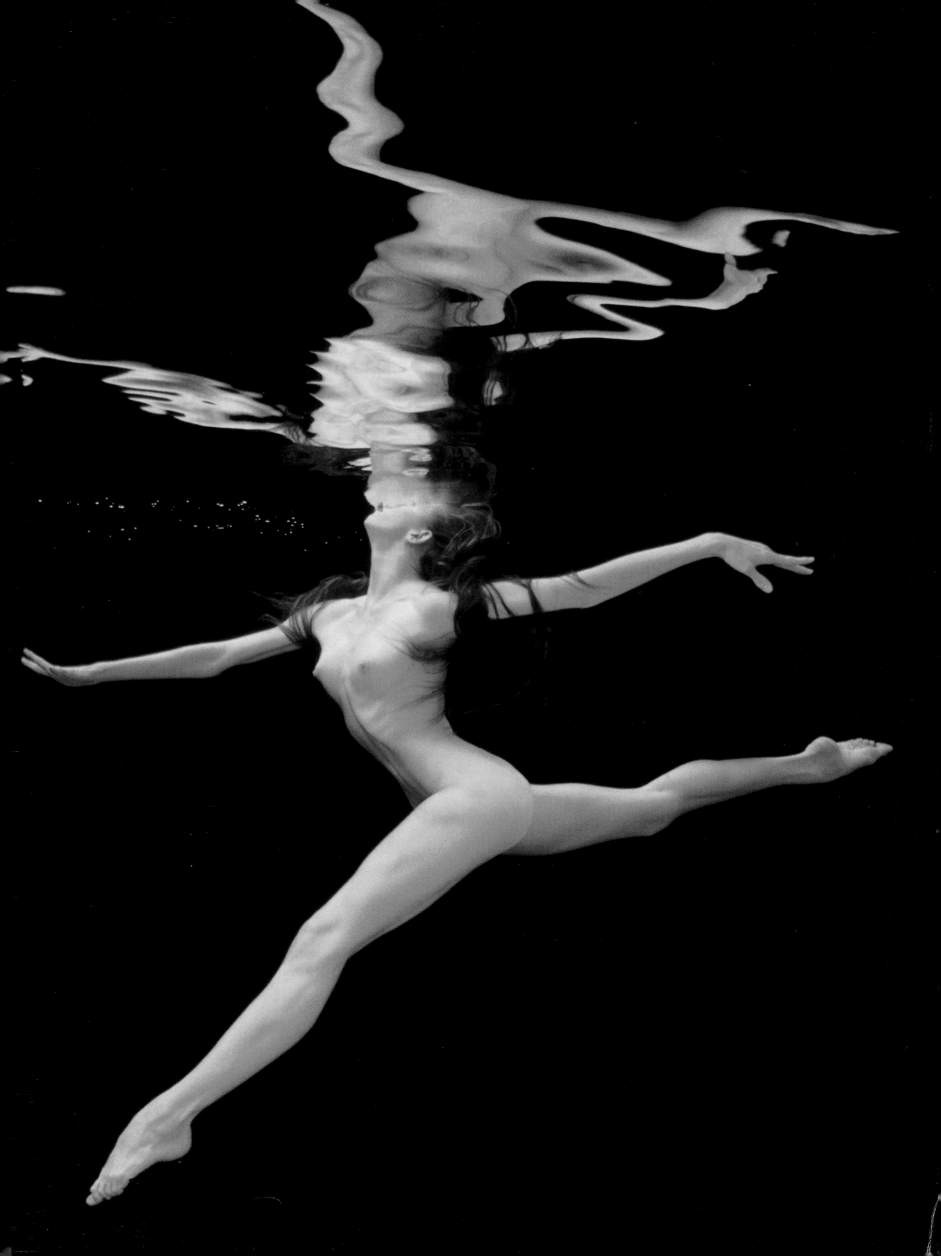

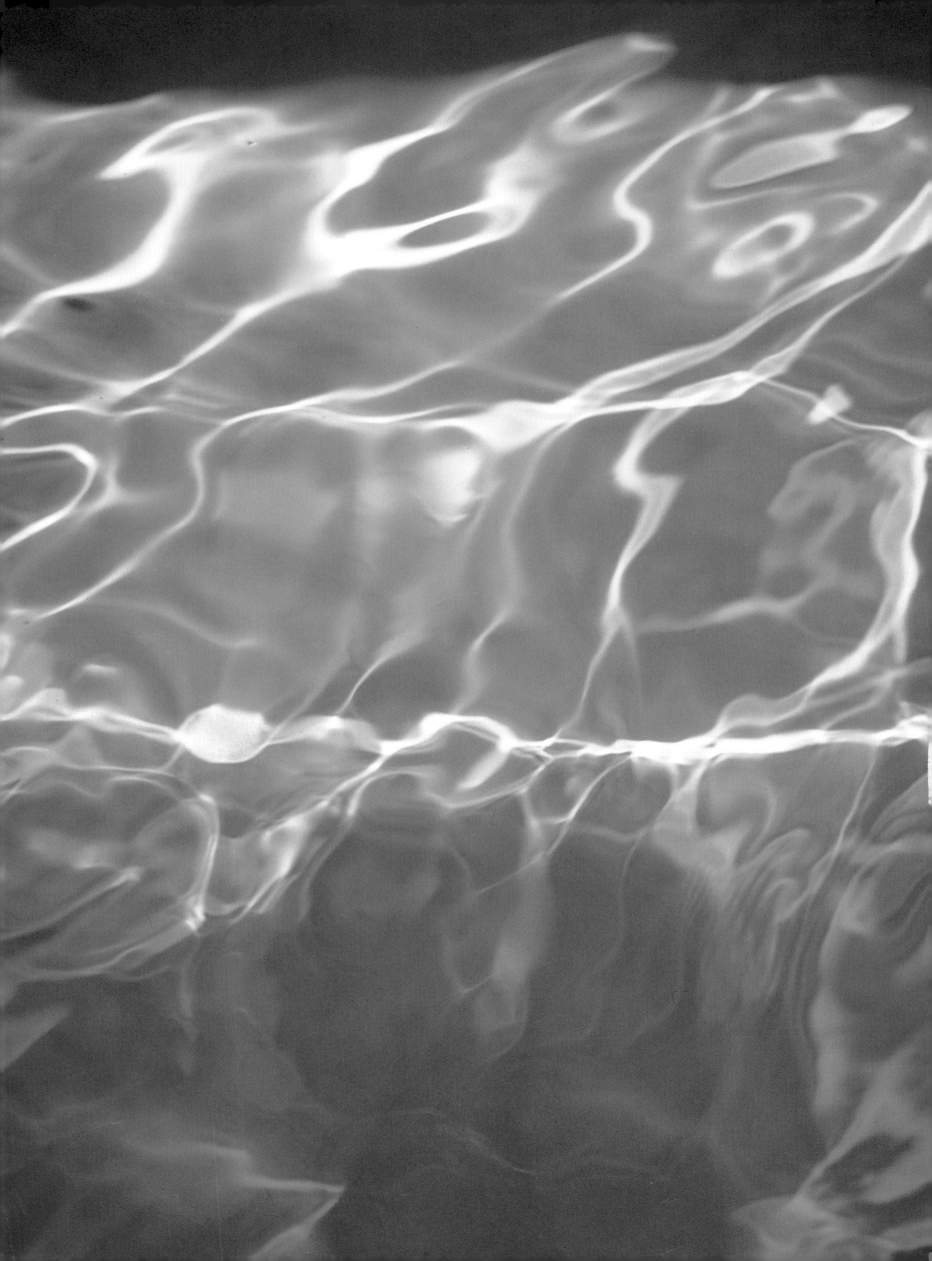